GEORGE WASHINGTON WILSON

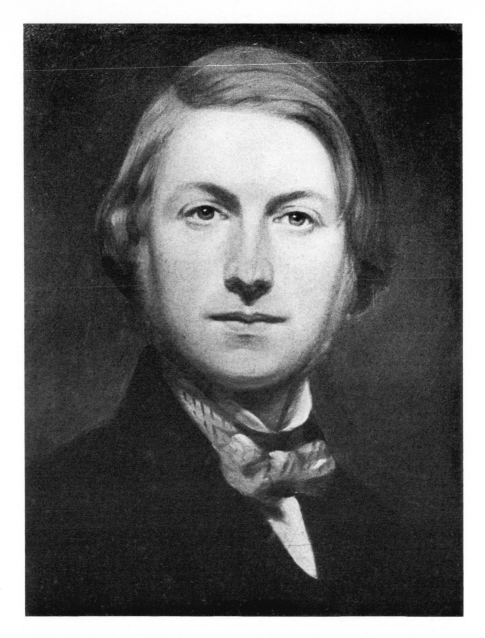

Self-portrait by G. W. Wilson, c.1849

George Washington Wilson

Artist and Photographer 1823–93

ROGER TAYLOR

Published by
ABERDEEN UNIVERSITY PRESS
in association with the
UNIVERSITY OF ABERDEEN

First published 1981
Aberdeen University Press
A member of the Pergamon Group

The financial assistance of the Scottish Arts Council
in the publication of this volume is gratefully acknowledged

Design by David Macneil

British Library Cataloguing in Publication Data
Taylor, Roger
George Washington Wilson.
1. Wilson, George Washington 2. Photography
—Scotland
I. Title
770.92'4 TR140.W/

ISBN 0-08-025760-7

PRINTED IN GREAT BRITAIN
THE UNIVERSITY PRESS, ABERDEEN

Contents

Foreword

by Peter L. Payne
Professor of Economic History and
Director of the Centre for Scottish Studies,
The University of Aberdeen

As my only direct contact with commercial photography was during my national service in the mid-'fifties when I took, processed and sold photographs at a Sergeant's Mess Dance at the Military Corrective Establishment ('the Glasshouse') at Colchester, it might be thought that I am singularly unqualified to provide a Foreword to Roger Taylor's remarkable study of George Washington Wilson. But this is *not* just another book of Victorian photographs, it is an examination of how a minor Aberdeen portraitist, having perceived the commercial potentialities of photography, built up a highly profitable business and by artistic integrity, technical innovation and entrepreneurial ability extended both its operations and its markets far beyond the northeast of Scotland.

It was for this reason that I strongly recommended both Aberdeen University Press and the University's Library Committee to publish this work when the author presented it to the Press. The manuscript—a product of great enthusiasm—immediately captured my interest. The exploitation of the opportunities which stemmed from Wilson's commissions by Prince Albert to photograph the construction of Balmoral Castle and later by Queen Victoria to photograph members of the Royal Family; the technical complexity and difficult handling problems—unknown to modern photographers—posed by the wet-collodion process; the minute division of labour involved in the mass production of landscape views; the role of changing fashion in both the rise and decline of a business devoted to the provision of visual representations of people and landscapes: all these and many other technical, economic and social themes are considered by Roger Taylor. They are each worthy of extended discussion—in which I would now seize the chance to join were I not loath prematurely to reveal the more fascinating aspects of his comprehensive and compelling story.

Instead, I shall use this opportunity to explain why the author has

not made fuller use of the University of Aberdeen's collection of George Washington Wilson negatives and to outline the University's plans to encourage a greater awareness of the riches of this 'most valuable storehouse of topographical material', as it was described by G. H. Martin and David Francis, the authors of 'The Camera's Eye' in that indispensable symposium, *The Victorian City* (ed. by H. J. Dyos and Michael Wolff). In addition to a range of photographic prints by George Washington Wilson (part of the McBain Collection), the University Library possesses what was essentially the stock in trade of George Washington Wilson & Co. when that company went into liquidation in 1908. This consists of 45,000 glass plate negatives, or about 70 per cent of all those owned by the concern at the time of the auction sale which effectively ended the firm's existence. The negatives were purchased by Fred Hardie (a photographer who was at one time an employee of the company), housed in the basement of 416 Union Street, Aberdeen, and until 1920 used by Hardie to make postcards. The entire collection of negatives subsequently passed into the hands of Mr. Archie Strachan, an Aberdeen photographer, who with great generosity presented them to the University in 1954. The point to be emphasized here is that it was believed that very little material in what might be called the Strachan gift dated back to George Washington Wilson, for it was known that long before 1908 most of the views to which he owed his affluence and fame had become outdated and removed from the portfolio of negatives held by the limited companies that succeeded his original partnerships.

Hence, when the author of this book, indefatigable in his search for Wilsoniana (as even a glance at the Bibliography will reveal), sought access to the University's collection, it was believed that few of the thousands of glass plates stored in King's College were the work of George Washington Wilson himself. Although a provisional catalogue existed, it had been compiled by students who had no way of knowing that among the materials they listed were a large number of stereographic negatives which would undoubtedly have been of value to Roger Taylor, and such was the fragility of these varnished collodion plates that he could not at that time be given permission to sort through the enormous collection himself. Not until the University, with the aid of a grant from the British Library, appointed Ms Elizabeth Bennett to catalogue and arrange for the proper preservation of each of the heavy, brittle plates have items of potential value to Roger Taylor come to light and been rendered accessible. Ms Bennett's work is still in progress.

It is planned to follow Roger Taylor's study of George Washington Wilson, an earlier version of which was submitted in part-fulfilment of an M.A. in Victorian Studies at the University of Leicester in 1977, with a series of booklets illustrating several of the major themes and principal subjects photographed by Wilson and Co. To achieve this objective, the University Library Committee recently created the George Washington Wilson Publication Committee, and appointed me General Editor of the series. A number of booklets have already been commissioned and are in preparation. It is hoped that their appearance will deepen our knowledge of this pioneering firm, indicate the great historical and sociological value of the Wilson collection, and provide a fresh viewpoint on the life and landscape of late Victorian Britain and those parts of the world 'covered' by the photographers employed by the firm.

But without Roger Taylor's unique study the University's plans would have been much more difficult of realisation and certainly less interesting. His comprehensive biography will make it possible to put the significance of the Wilson collection into proper focus. It is for these reasons that I gladly accepted the invitation to introduce this book. I trust that the reader will enjoy it, and learn as much from it, as I have done.

Acknowledgements

In 1973, I was browsing in one of those marvellously friendly bookshops where practically every shelf, one felt, concealed treasures of second-hand books, when the owner, knowing of my interest in photographic history, thrust a large green folio of photographs into my hands with the comment 'Someone ought to do something on this fellow. His work is too good to be ignored and the general histories only give him a passing mention.' This was my first proper introduction to 'G. W. Wilson, Aberdeen', whose name was thus goldblocked onto the front of the folio. On my way home that evening I toyed with the idea proposed by the bookdealer and, having nothing pressing to do, I innocently and impetuously began that evening. My first thanks go to Alf Baker of Bloomfield Books for his introduction to and subsequent gift of the Wilson material.

I began by relying upon the work of others, to give me both facts and a starting point. I went first to Helmut Gernsheim's *History of Photography* to discover that he had known and been in long correspondence with Wilson's youngest son Charles during his own researches in the 1950s. From the invaluable contact with the Wilson family I have drawn much valuable material, and I am especially grateful to Helmut Gernsheim for the help and friendly encouragement he has given me. I must also extend my thanks to the University of Texas at Austin for their part in gaining me access to the Wilson/Gernsheim correspondence.

Various institutions in Aberdeen gave me valuable help with access to their collections of Wilson material and associated documents. At the head of this list must come Peter Grant and his staff at Aberdeen Public Library where the largest public collection of Wilson memorabilia is deposited. As a result of their generous help and guidance through the intricacies of their holdings, I discovered a great deal of valuable information about Wilson.

Aberdeen University Library has a very large collection of original Wilson negatives that were undergoing archival treatment during the early period of my research. Prolonged access to the negatives was not possible and this book has been prepared largely without reference to this material. More recently, the appointment of Ms Elizabeth Bennett to catalogue the Wilson Collection has resulted in much new information being made available, and I am indebted to Ms Bennett for all the help she has given me. Elsewhere in the Library is a fine collection of original photographs by Wilson and Valentine that were of particular use to me, and I am grateful to the Librarian, Mr J. M. Smethurst, for co-operation and for his permission to reproduce a number of them.

As Wilson was a photographer of Queen Victoria it was natural that I should go to the Royal Archives at Windsor Castle where I was richly rewarded by finding more Wilson material. My thanks go to Sir Robin Mackworth-Young; Miss J. Langton, the Registrar; and especially to Miss F. Dimond who is responsible for the photographic archive. From Windsor it seemed appropriate to go to Balmoral Castle in search of more material. Here my requests were sympathetically heard by the Factor, Colonel McHardy, who subsequently discovered a hoard of photographic material that vastly enriched the book. The plates from the Royal Collection are reproduced by gracious permission of Her Majesty the Queen.

Other collections at the Victoria and Albert Museum, the National Portrait Gallery, the British Museum, and Aberdeen Art Gallery were also consulted. I must thank Mark Haworth-Booth, David Wright, Colin Ford and Angela Weight for all their help.

I was fortunate in discovering a grand-daughter of Wilson living in Aberdeen as this brought me my first contact with the family. Mrs Laura Fraser-Low kindly lent me family papers, letters and photographs relating to her grandfather, and her letters and conversations provided another valuable source. It was a great shock to me when she suddenly died in the spring of 1977. Typically, she had instructed her executors to pass much of the material on to me. This was further enriched by material found during the settling of her estate, and I am grateful to her executors, Mr P. M. Mitchell and Miss Davis, both of Aberdeen, for their care and consideration of my research interests at this time.

Even more family material came to me from another grand-daughter, Miss Anne Cumming-Smith, who lives in Honolulu, Hawaii. Through her kindness I happily find myself responsible for the Wilson family archive.

Other people have shown me great kindness in allowing me to use their private collections of Wilson material. Howard Ricketts and Bernard Haworth Loomes are foremost amongst these, and I thank them sincerely. I must also thank Graham Ovenden for his gift of a splendid set of Wilson prints. Similarly, I must record my gratitude for the various help I received from André Jammes, Mike Hiley, Hugh and Alistair McIntyre, Beryl Vosburgh, Chris Pearce, George Murray, Andrew Cluer, Archie Strath-Maxwell, Richard Morton, and Frances Milne.

During the course of my researches I was fortunate enough to be accepted for the Victorian Studies Course at Leicester University, where I had my mind and eyes opened to the whole social and cultural significance of the Victorian period. The staff teaching the course are eminent in their own particular fields of Victorian history and under their influence and guidance this book has assumed its present form. I am, therefore, especially grateful to them all and to the excellent library staff of the University.

I have also to thank the following institutions and people for their help: The British Library, The Guildhall Library, The National Library of Scotland, The London Library, The Public Record Office, The Scottish Record Office, The Lord Chamberlain's Office, George Eastman House, The Royal Scottish Academy, Brenda Cluer, Dr A. Marchbank, Marcus Milne, Fenton Wyness, Harry Wills, and Paul Wing.

To transform a manuscript into a book is no easy matter and requires the cooperation and enthusiasm of many people. In particular I want to thank two people who have done a great deal to bring this book to fruition by giving freely of their skills and time. They are Colin MacLean, of Aberdeen University Press, who carefully guided the book through all its production stages, and Professor Peter L. Payne who suggested many useful alterations.

On a more personal note, I would like to record my gratitude for the hospitality and kindness shown to me by Tony and Anne Hedley during my frequent visits to Aberdeen. I would also like to thank Avril Williams for so diligently reading and correcting my text and Sue Armitage for her careful attention to detail when typing it. And to the anonymous driver of a Ford Cortina with a 'GWW' registration plate, my thanks for driving past me every day for five years and so reminding me of all the things I had still to do.

Finally, I would like to dedicate this book to my wife Chris and the children for the patient and persevering way in which they have put up with my absences from family life during its research and writing. It is to them that this book is given.

Early Life

When George Washington Wilson invited a number of his closest friends to Christmas dinner in 1872 he planned that it should be a splendid affair. Whilst the meal was primarily a celebration of Christmas it also served to celebrate the affluence that twenty years as a photographer had brought to Wilson and his family. No expense was spared. The Prince of Wales' own cook was engaged to plan and prepare the numerous dishes that made up the twenty-two-course meal. Wine flowed as freely as the conversation. The evening was considered a huge success by all present.

As Wilson made his way up to bed that evening he may well have reflected upon the contrast between his present prosperity and his humble beginnings as a crofter's son. He was an example of the Victorian self-made man: he had risen from rags to riches in one generation.

His attitude to life and personal self-advancement seems to have been passed on from his father, another George, whose early life had been as romantic and colourful as his son's was to be successful. The father's adventures had started in 1793 when, on the death of his father, he was left the family property at Culvie in Banffshire. What should have been a straightforward inheritance was complicated by an objection being raised to the will: the matter was taken to law for a settlement. Because the case was to be heard in Edinburgh the sixteen-year-old George left home and sailed for Edinburgh. When the boat docked at Leith, the port of Edinburgh, it was boarded by men from the Navy who press-ganged all the likely men and youths into active service against the French. George was given the choice of either entering the Navy or joining the Artillery. As a landsman he wisely chose the latter.

During the course of the wars he travelled extensively in Europe, fighting in the Low Countries and in the Peninsular campaigns. His years of service and experience raised him from the ranks to the status of sergeant and whilst in Portugal he was allowed to 'marry on the strength'. Tragically, his wife and three children were drowned in the Bay of Biscay when the ship bringing them home to Scotland capsized and sank.

Peace finally came to Europe in 1815. In 1817, in recognition of his twenty-four years of service, Wilson was given a gratuity of £40 and discharged. During his long absence, the property at Culvie had passed into other hands. With only £40 Wilson was not in a position to re-open the case. He used his capital to rent a small croft on a remote, uncultivated hillside seven miles to the south of Banff. Because the war had raised the price of produce and had increased

the prospect of profitability landowners were encouraging their tenant farmers to reclaim the land.

Undaunted by the loss of his first wife and family, Wilson remarried (Plates 1, 2). His second wife was Elspet Herd, a local girl

Shortly after 1832 the uncle and aunt who had raised Elspet invited the Wilson family to build a house adjoining theirs so that they might live closer to each other. Wilson's elder brother was to remember their home at the Waulkmill of Carnousie (3) as '. . . an

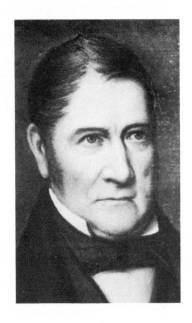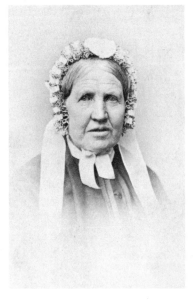

Plate 1. George Wilson, aged 69, painted by G. W. Wilson, c.1846

Plate 2. Elspet Wilson, aged 85, carte-de-visite by G. Wilson, c.1860

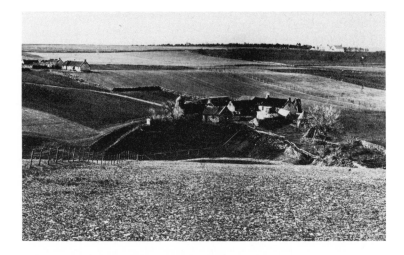

Plate 3. The Croft at the Waulkmill of Carnousie, c.1880

who had been raised by her childless uncle and aunt on an adjoining farm. They had eleven children of whom George Washington was the second son. The precise date of his birth is unknown. An entry in the Alvah parish register reads: '. . . George Washington, Lawful son of George Wilson and Elspet Herd residing at Brownside, was born on or about 7 February 1823. The above entry was omitted to be made at the proper time.'[1] The distinctive second Christian name was presumably chosen as a tribute to the former President of the United States of America: George Wilson had already chosen Benjamin Franklin's surname as a second Christian name for his eldest son Robert.

old-fashioned farmhouse with offices attached, all thatched with straw and ropes, and situated on the south side of a hill . . . and about four hundred yards from its base, and having a morass or bog of like distance to the south. The steading occupied three sides of a square; the dwelling house, barn, and men's "chaumer" all in a line, occupied one side of the square, whilst at right-angles to these at one end stood the byres and at the other the stable and kiln-barn, with a dunghill in the centre.'[2]

Here George Washington Wilson spent his childhood. He was raised on a simple and largely meatless diet. The three meals a day were drab and repetitious, '. . . breakfast consisted of porridge and milk followed by bread and milk, *ad libitum*, which was used to supplement every meal. For dinner there was perhaps kail . . . or potato soup; for supper cabbage or kail and brose, or turnip and brose, with a supply of bread and milk as usual.'[3]

By the time Wilson reached the school age of seven he and his elder brother were expected to contribute their share of digging and trenching to drain the fields. After this task they had their breakfast and set off to walk the two miles across the fields to Forglen school. The elder brother remembered that '. . . everything generally taught in parish schools was taught at this school, and some other subjects besides; but it was usual to teach only such subjects to the bigger pupils as they chose to learn, and these pupils generally preferred to dispense with reading, except in the Old and New Testaments. There were no bound copy-books in those days. The scholars bought a pennyworth of paper (foolscap size), folded it up, and stitched it into a piece of brown paper. Quills were used for writing with, but steel pens began to come into use about 1832 or 1833.'[4]

Scotland enjoyed a reputation of being one of the best educated nations in Europe. For a child from a rural working-class home the opportunities for education in Scotland were impressive in comparison with those in England. In Banffshire they were particularly good. On 24 May 1828 a Mr James Dick died in London leaving the considerable bulk of his fortune 'to the maintainance and assistance of the County Parochial schoolmasters . . .'[5] in his native Elgin, and in the neighbouring counties of Banff and Aberdeen. This gift of £113,000 became known as the Dick Bequest and was carefully administered by the Church, which used it to alleviate hardship and to supplement the £11 annual salary paid to parish schoolmasters. It was never intended, or used, as a charity; instead it was to be allocated as a reward for the educational self-advancement of the schoolmaster and his pupils: payment by results. This distribution of money raised standards and attracted better qualified schoolmasters.

Forglen school was a parish school set in a conveniently central position: it drew its children from the surrounding farms and crofts. Its schoolmaster, the Rev John Webster, a graduate of Aberdeen University, was a hard-working, painstaking man who taught by the intellectual rather than by the rote system, seeking to make his pupils understand what they read. The curriculum he offered in this tiny school was broad. Available to the children were the

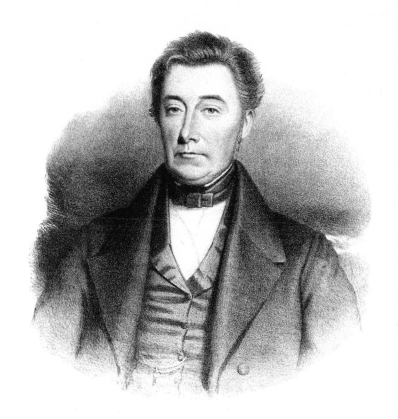

Plate 4. The Reverend John Webster, Lithograph by G. W. Wilson, c.1850

options of English reading, writing and grammar, arithmetic, algebra and mensuration, geography and Latin. The choice and number of options followed by each child depended very much upon the finances of the parents, as each option was chargeable at a

few pence per month. Webster's influence upon the academic attainment of his pupils was well known.

Wilson started school already well prepared by his parents who had somehow found time to teach him to read, write and do basic arithmetic. He was also educated and entertained by his father whose experience and knowledge of foreign lands and languages must have seemed magical to a child whose knowledge of the world extended to just a few miles around his home. Wilson used to tell in later life how his father had used the maps and charts of Europe and of North America adorning the living room walls to explain and illustrate the campaigns and manoeuvres he had taken part in.

With the educational stimulus of the parish school and the interest shown by his parents in his academic progress, Wilson flourished and developed into an intelligent and perceptive young man. Some years later, during the early 1850s, Wilson, now an artist, drew a portrait of John Webster (4), which may have served as his acknowledgement of the start in life he had been given by this remarkable teacher.

Wilson left Forglen school at the age of twelve to become apprenticed to a carpenter and house-builder. It is not known whether his talent for drawing had already developed but as an apprentice to a carpenter and house-builder Wilson had ample opportunity to use his brain, eye and hands in a co-ordinated and purposeful way. That he was allowed to take up such an apprenticeship at all speaks for the encouragement given to him by his parents who were not anxious to tie him to the farm in order that he might support them in their old age. Wilson's other brothers were given similar opportunities, two becoming ministers, another a schoolmaster, whilst others emigrated to Australia and New Zealand.

Almost nothing is known of Wilson's early years after leaving school and starting his apprenticeship. He and his master presumably had to travel about the area to wherever their work took them. It was perhaps on one of these trips that he met Isabella Johnstone, a farmer's daughter, who bore him an illegitimate son, Alexander, in 1842: she refused to marry Wilson.

Initially Alexander (5) was probably cared for by Isabella, but later she handed the responsibility for his care and education over to Wilson. After Wilson married in 1849 he continued to be responsible for his son and later, when Alexander was a teenager, Wilson taught him everything he knew about photography. During the 1860s Alexander moved to Leamington Spa where, with capital from his father, he established himself as a photographer and bookseller.

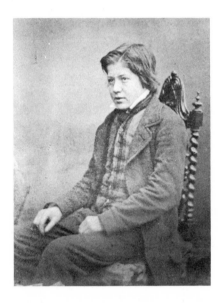

Plate 5. Alexander Johnstone Wilson, aged about 13

In 1846, when Wilson was twenty-three, he finished his apprenticeship, though it is not clear whether he continued to work for the same employer or not. He was, however, still working away from home and reliant, to some extent, on parental support. His father, in one letter explaining the state of the harvest, said that because '. . . I have a good crop of corn I can spare half a dozen of quarters but the potatoes are next to all rotten, we will scarcely save seed'.[6]

What prompted Wilson to become an artist rather than a carpenter is unknown, though it is fairly certain that prior to 1846 he had been painting and drawing for a number of years. The first positive indication of his intentions comes in a letter of introduction

written on Wilson's behalf by a Mr Gibbon of Glassaugh to A. Munro, an advocate in Edinburgh. Who Gibbon and Munro were remains a mystery, but we do know that Glassaugh was a mansion not far from Banff, close to Wilson's home at Carnousie. One has to presume that, with such an estate, Gibbon was a man of wealth and perhaps some influence. It is clear from the tone of the letter that he knew Wilson and his work sufficiently well to recommend him as 'a young and rising artist . . . who is very desirous of following up the further study of his Profession under the greater advantages of Edinburgh'. Gibbon hoped that the advocate would be able to bring Wilson to the notice of 'one or other of your eminent artists in Edinburgh who may be disposed to take him kindly by the hand'.[7]

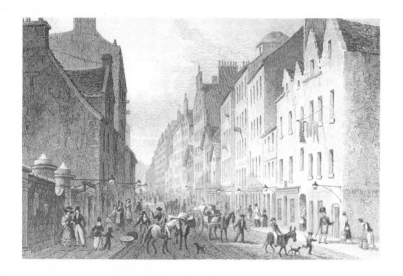

Plate 6. The Canongate, Edinburgh

Edinburgh (6) was a natural choice for Wilson; the Fine Arts had for a number of years been promoted there by the Trustees' Academy and by the Royal Institution for the Promotion of the Fine Arts. These worthy bodies trained artists for the manufac-turing industries, the intention being to raise design standards and combat foreign competition.

In 1830 a group of Scottish artists, dissatisfied with the objectives of these institutions, broke away and formed their own Scottish Academy in Edinburgh. One of the Academy's most important functions was to mount an annual exhibition and its secretary, D. O. Hill, who was responsible for the mounting of the exhibitions, had to rely heavily on artists working in London. The exhibitions mounted during the first two decades of the Academy's existence were therefore largely English in character and it was not until 1846, the year when Wilson probably came to Edinburgh, that an exhibition could be called wholly Scottish. Much of the drive and energy that went into the creation of this 'Scottish School' can be credited to D. O. Hill. He is probably better remembered for his important contributions to photography when he worked with R. Adamson in a short-lived but momentous partnership.

Into this stimulating setting came Wilson, a youth with a recog-nised talent and a letter of introduction. We do not know how Munro was able to help Wilson or whether he managed to intro-duce him to an artist. But there is ample evidence that Wilson received a formal art training. It is possible that he attended either the Trustees' Academy or the College of Art; family legend has it so, but no records survive to substantiate any such claim.

Wilson chose to become a miniaturist. This branch of the arts had the potential of being remunerative if the artist was at all successful, but it was being seriously threatened by the impact of photography, which produced likenesses more cheaply and with greater veracity than before. Certainly, Wilson must, at an early stage, have been aware of photography; it would have been almost impossible for him not to be when there were in the city a number of daguerreo-type and calotype photographers.

Despite the growing influence of photography, Wilson remained an artist and later, when photography won him over during the 1850s, he did not forsake the artistic principles given him at Edin-burgh in favour of a purely lenticular vision, but instead preferred to apply those principles to his photography. He always thought of himself primarily as an artist, then as a photographer; the two

pursuits were inseparably linked. From 1855 to 1888 his professional title was always 'G. W. Wilson, Artist and Photographer'. This continuance of the artist in Wilson long after he had left Edinburgh was a point often noted by others. Thomas Sutton, the influential and invariably caustic editor of *Photographic Notes*, when reviewing Wilson's photographs, believed that 'it is no exaggeration to say that these stereograms by Mr. Wilson, bear the same relation to the works of ordinary photographers that paintings by the old masters bear to those of ordinary artists. Altho' Photography is certainly a mechanical means of representing nature, yet when we compare a really fine photograph with an ordinary mechanical view we are compelled to admit that it exhibits mind, and an appreciation of the beautiful, and a skill in selection and treatment of the subject on the part of the photographer, to a degree which constitutes him an artist in a high sense of the word.'[8]

Wilson firmly believed that an artist was in reality still an artist even if he was using a mechanical means to secure the image. (This was a subject of heated debate between the photographers and artists throughout the nineteenth century.) Wilson expressed his views in a series of letters to the readers of *The British Journal of Photography* in 1864, when he explained most of his working methods and attitudes.

I have some faint recollection that my last contribution left me talking of *composing* a picture. A great many people think that sort of language is all cant and nonsense when applied to photography, because a photographer cannot select and arrange his subjects in a way to suit his ideas of composition in the same way that a painter can, but must take them as they are presented, and in no other way. One photographer is as good as another, they say, and the fraternity as a whole is not very remarkable for intelligence or common sense, not to mention taste or feeling. Now this objection might be very true if there were only one *possible* view of any subject which could be photographed, and that the ugliest and least interesting. But, so far is this from being the case, even supposing one man could use his fingers and chemicals as dexterously as any other man, that there are very few landscapes,

for instance, which cannot be photographed from a great many points and under a great many different aspects of light and shade. The photographer, therefore, has ample room for the display of taste—if he has any—in selecting his point of view, his light, and his foreground: upon the happy selection of these depends, in a great measure, whether his picture is to be merely a 'bit' or a satisfactory whole.[9]

This belief was the result, now somewhat refined, of his training and experience in Edinburgh and it is unlikely that Wilson would have achieved the reputation he did without his understanding of artistic principles.

Wilson was probably called home from Edinburgh during the summer of 1848 to be near his father, now aged seventy-one, who was failing in health and who finally died on 16 August. With the death of his father Wilson must have felt the need to evaluate his own situation and come to a decision about the direction of his career. With twelve years of apprenticeship and art training behind him, here he was at twenty-five just beginning his chosen career, whereas most young men of his age would have been already well established in a steady job.

The first priority was to choose a place to live, and inevitably that choice would be largely influenced by the prospects for employment. There were not many openings for an aspiring young miniaturist and it was a foregone conclusion that Wilson would have to live in a large town or city in order to attract sufficient clients. His choice of Aberdeen was eminently practical and entirely suitable to his immediate needs. It was a city with a long artistic and cultural tradition, adequately supported by a prosperous middle class society. It was perhaps familiar to him through his elder brother, Robert, who had graduated from the University in 1840. Finally, it was close enough to home for him to visit his mother without too much inconvenience.

There is no evidence to show what employment he took when he moved to Aberdeen. His name does not appear on any post office register or lists, which suggests that he was living in lodgings, and perhaps working in the town as an assistant to an artist. It is pos-

Plate 7. *Letter from E. H. Corbould to G. W. Wilson, 1849*

sible, and is suggested by documentary evidence, that he could have been working for J. & J. Hay as an assistant in their framing and restoration workshops. One thing is certain: he did not establish himself as an independent artist, perhaps feeling that he needed still more experience before he could make that decisive step.

His first fully documented appearance is both dramatic and significant. His diary records that on 5 May 1849 he sailed from Aberdeen on board the *Duke of Sutherland* bound for London on a voyage designed to establish himself in the eyes of his future Aberdeen patrons as an artist with experience of London and Paris studios.

On 17 May, he obtained a permit enabling him to copy from his favourite old masters of the Dutch School in the National Gallery. He also attended the open life classes given by the Royal Academy and received lessons from the miniaturist and historical painter, E. H. Corbould,[10] whose work had been bought by Queen Victoria and Prince Albert (7). A note from Corbould to Wilson reads: '. . . come therefore as early as you please so as to have a good spell at it and on my return home I will give a finishing touch to your work—setting (as far as possible in the time) such trifles to right as may strike me as incorrect.'[11]

The four month trip was rounded off with a brief two-day stay in Paris where Wilson visited fellow artists' studios and paid a visit to the Louvre. His return to Aberdeen on 24 August 1849 marks the start of a new phase in his life. The trip to London and Paris had given him the confidence and incentive to establish himself independently as an artist. From this date his appearance in the directories, registers, journals and newspapers became a regular occurrence as his reputation and fame grew from a local to an international level.

CHAPTER TWO

Change of Direction

One Victorian guide book has this to say about Aberdeen: 'The granite city ranks next to Edinburgh and Glasgow in point of general importance. It is an attractive and agreeable place of residence combining the conveniences and enlightenment of a large city, with something of the retirement and economy of a provincial town.'[12]

The town's 'conveniences and enlightenment' were in the hands of two dominant social groups, the merchants and the academics. Of these the merchants were the more important. Their wealth was derived from dealing in the products of agriculture, from the extensive and various manufacturing industries of the city and from the equally lucrative shipping trades. The shopkeepers' wealth and importance lay in providing the rest of the middle classes with all the trappings of gentility that were so necessary to establish respectability in the eyes of Victorian society.

The academic life which so 'enlightened' the town depended entirely upon the existence of the two university colleges of King's and Marischal. These institutions, through their presence, provided the cultural and academic balance to an otherwise mercantile society.

A third group making up this large middle class society consisted of the professional classes, the bankers, advocates, accountants, surveyors and physicians.

The members of these three groups mingled freely in the expanding western suburbs of the town. They also came together in the various societies, clubs and institutions that were a feature of the town—the Hellenistic Society, the Chess Club and, perhaps most notably, the Philosophical Society. This Society, founded in 1840, grew out of the interests of a number of academics in promoting the '. . . subjects of science, literature and philosophy'.[13] Its initial membership was almost exclusively academic, but during the next decade professional men and merchants were allowed to join until they were equal to the academics in number.

The town itself had been growing since the seventeenth century around the natural harbour provided by the estuary of the River Dee. As a protection against flooding, all principal streets and buildings stood on rising ground to the north of the river. The eastern quarter of the town, being the oldest, was made up of a jumbled confusion of small lanes, wynds, courts and alleys. By contrast, the new, western suburbs were well conceived and laid out along broadly curving streets that were inviting to look at and pleasant to live in. Linking these two distinctly different areas was

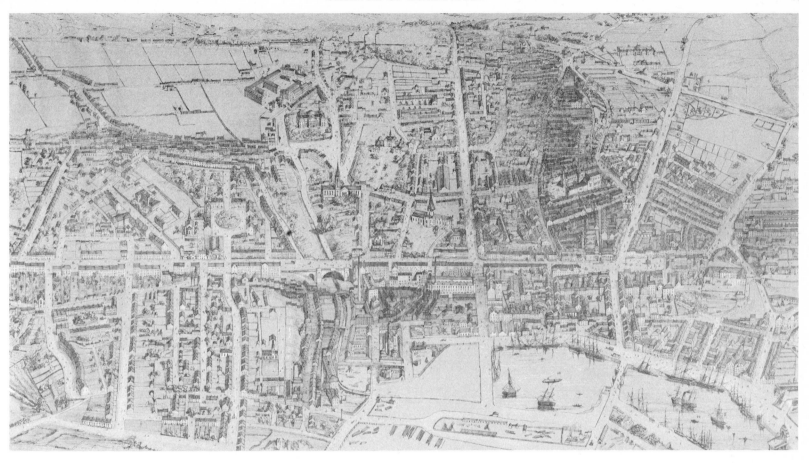

Plate 8. View of Aberdeen, drawn by Wilson during 1850 (see p 11)

Aberdeen's great thoroughfare, Union Street. Most of the town's public and private offices, banks, churches and institutions flanked this mile long ribbon of greyish white granite. It was a prosperous, vigorous and respectable town, populated with commercially and artistically talented people.

Of all the things that Wilson must have considered during his voyage back to Aberdeen one must have been the need to find accommodation that would be suitable both as a studio for his work and as a home for himself and his future wife. His bride was the

her younger brother. As she was soon to be married it was natural that she should inherit the furniture and bring it with her to Aberdeen to set up the new home. The wedding took place on 18 December 1849 in Banff, Wilson having taken his friend John Hay, Junior, along for moral support and to act as his witness (9, 10).

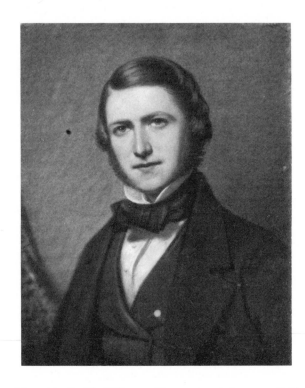

Plate 10. G. W. Wilson, self portrait miniature, c.1849

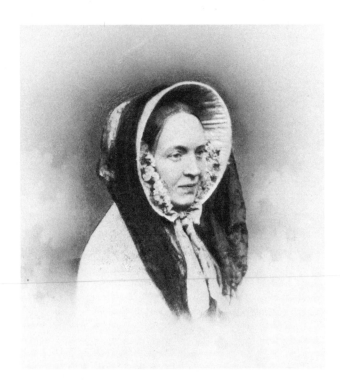

Plate 9. Maria, wife of G. W. Wilson, photograph c.1860s

twenty-two-year-old Maria Cassie who had been orphaned earlier in the year when her father, an innkeeper in Banff, had died. The few belongings that her parents left were divided between herself and

The Wilsons' first lodgings were in Nether Kirkgate, one of those narrow, ill-drained lanes that ran haphazardly through the old part of town. This accommodation may have been only temporary, or it may have proved unsuitable for Wilson's work, which required both a good address and plenty of light. Whatever the reasons, by the year 1851 Wilson had moved to 75 Union Street, an address which gave him the opportunity to offer his talents both as teacher

and artist.[14] This move from the Nether Kirkgate into Union Street was the first stage in the gradual process of bringing Wilson nearer to the rich western suburbs, where he was finally to make his own home in 1865.

A small business card (11) distributed by Wilson whilst he was in Union Street shows that now he was supplementing his income by

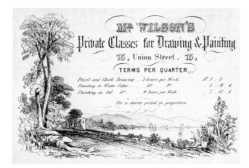

Plate 11. Wilson's Business Card, 1851

offering '. . . private classes for Drawing and Painting'. The charges made for each of the different media were moderate enough but nevertheless indicate the financial status of his prospective pupils; only middle class families could afford even the small luxury of painting lessons.

Sketching and painting, part of those social accomplishments in which the Victorians delighted, ranked with Berlin wool work and crocheting as a method of occupying the leisure hours, but were capable of being much more exciting since the media of pencil or paint offered the opportunity to express—in idealised, romantic landscapes and vignettes—one's inner feelings and emotions. It is doubtful whether any pupils passing through Wilson's hands ever intended becoming artists; to them it was a social grace that marked their respectability as well as their talent.

Wilson's main income was derived, however, from his portrait miniatures which must have occupied a great deal of his time and energy, and were the foundation of his success. Skill in handling

pencil and paint were not the only talents an artist had to display. He also had to show that with equal skill he could handle his sitters by putting them completely at their ease with a flow of small talk designed to compliment and flatter even the most nervous and apprehensive. Wilson's natural charm put him in good favour with his clients and it was not too long before his reputation had spread throughout Aberdeen.

As if to confirm that his business was flourishing and financially secure, Wilson moved his premises during 1852 from Union Street further westward into fashionable Crown Street. Here he had purchased a small block of property at numbers 22 to 24. By moving into Crown Street Wilson at once established himself within the artists' community of Aberdeen, nearly all of whom were living either in or around Crown Street at the time. Crown Street in the 1850s (12) ran a broad sweeping course to the south from Union Street. In the best Aberdeen tradition its houses were solidly built of granite and arranged into unpretentious terraces. They were totally free from any surface decoration, the only relief coming from the decorative railings and gates.

Like the other artists in the area Wilson had his home and studio combined under one roof at number 23, while 22 and 24 on either side (such was the street numbering) were let by Wilson, who was no doubt grateful for the small income they produced at a time when his own finances must have been fully stretched by the expense of moving and setting up home.

The few surviving examples of Wilson's work from this period are those that have been preserved by his family: they are, in consequence, mainly self portraits and unfinished sketches (13, 14). His ability as a draughtsman is clear to see as his style follows the required trend of commercial art, clarity of line and precision of form being preferred to free creativity. Other small unfinished watercolour sketches survive in a scrap book now preserved in Aberdeen Public Library.[15] These show a preoccupation with getting an exact likeness down on paper rather than trying to capture the spirit of his sitter.

One work that stands apart from all Wilson's portraits is his bird's-eye view of Aberdeen (8) drawn in 1850 and published in that

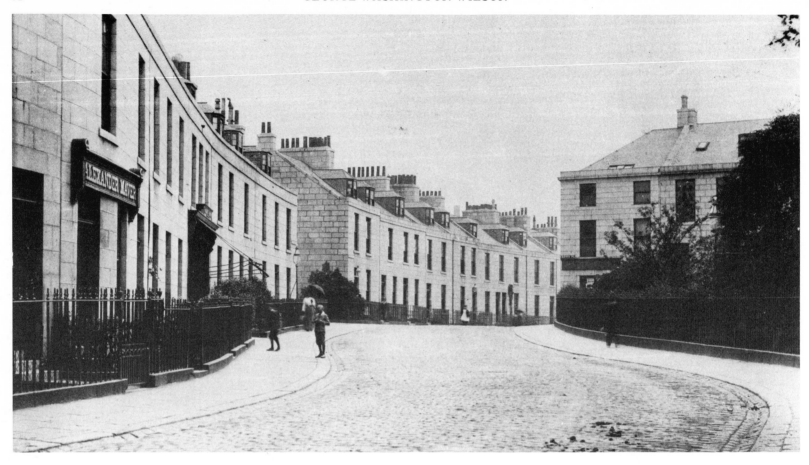

Plate 12. Crown Street, Aberdeen c.1890s

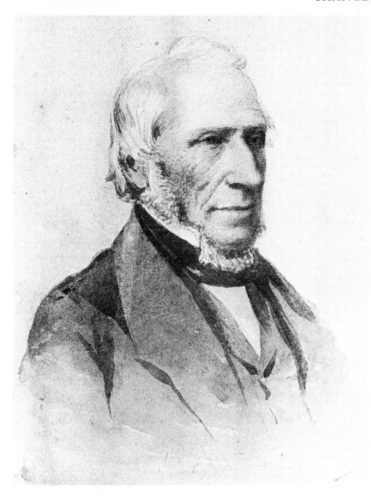

Plate 13. Watercolour sketch by G. W. Wilson

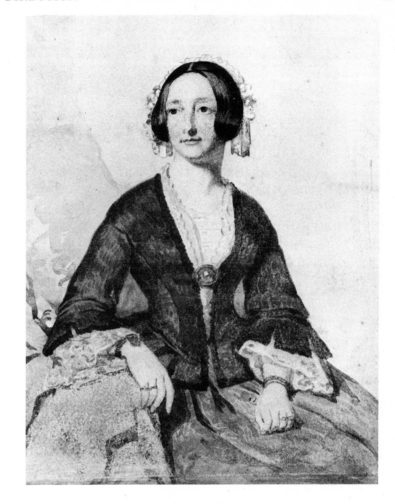

Plate 14. Watercolour sketch by G. W. Wilson

year by J. & J. Hay. It gives an overall view of the city from the south, with the harbour in the right foreground and Union Street running horizontally across the centre. In order to bring together the whole Wilson had to consult maps and make countless sketches, many from high buildings, in order to assemble the whole jigsaw of detail together. Apart from its associations with Wilson it is of interest because of the clear idea it gives of the size and layout of mid-nineteenth century Aberdeen.

While Wilson was steadily increasing his income by hard work and talent, and while his reputation was becoming established, he must have been ever conscious of the threat that photography was posing to the continuing success of his livelihood. Having been in Edinburgh between 1847 and 1848 and in London and Paris during 1849, Wilson cannot have remained unaware of photography. It was simply everywhere: it was discussed in the newspapers and nearly everyone was caught up in the rush of enthusiasm that greeted its introduction. Artists of the day, however, realising its significance, either praised its merits or damned it because of the dangers it presented.

As an artist himself, Wilson took the view that although photography has many advantages over painting, it was best seen as an alternative, rather than a superior method of making portraits. So in 1852, when Wilson moved into Crown Street and opened his new studio there, he began to offer his clients the alternatives either of having their portraits painted or of being photographed. Whilst this date was subsequently claimed by Wilson as the foundation of his photographic business, it is probable that his involvement with the medium, as an amateur, pre-dates 1852. Prior to 1851 Wilson would have had just two processes available to him, the calotype and the daguerreotype, both of which had been freely employed in Scotland since the early 1840s. Probably the daguerreotype's expensive metal plates and complicated processing procedures would have put it beyond Wilson's abilities and means. The calotype process, on the other hand, was much simpler and cheaper to operate and as such would have been more appealing to Wilson.

It is tantalising to speculate on where Wilson might have received his instruction in the calotype process, particularly as he was in Edinburgh during its most flourishing period. One possible source of his information may have been the monthly journal *The Art Union* for June 1846 in which Fox Talbot gives a very detailed and precise account of his process. That Wilson was a reader of *The Art Union* is suggested by a copy he made of a small engraving presented on an earlier page of the journal. The engraving is in itself a translation from a painting by F. Taylor and Wilson's copy is a further translation from this engraving.[16] The calotype's easy manipulation and comparatively low cost were offset by its poor rendering of detail and as Wilson's task as a miniaturist was entirely concerned with detail and reduced scale, perhaps the commercial possibilities of the calotype print would not have appealed to him.

In 1851, however, things were to alter radically for the photographic world with the introduction by F. Scott Archer of the wet-collodion process. This new process, though in many ways more difficult to manipulate than the daguerreotype or calotype, gave an image of better quality. For the first time glass, rather than metal or paper, was used as the support for the light-sensitive emulsion. This technical breakthrough gave the negatives a brilliance and sharpness previously unattainable. The tonal range of the positive image was enhanced by the superior negative emulsion, which, though still only sensitive to the blue end of the spectrum, gave a new richness and depth to the prints. These advantages were immediately apparent. The process was eagerly taken up by photographers, who in their desire for images of superior quality overcame the very considerable problems of manipulation posed by the process.

Wilson's decision to move into photography during 1852 coincides exactly with the point at which the process was brought to perfection. Whereas previously Wilson may have felt that the calotype was too coarse for his commercial use, the wet-collodion process offered him everything he was looking for; it may well have been the final spur that encouraged him to become a photographer.

On 20 August 1842 in *The Aberdeen Herald* an article on photography said: 'The fond parent may, from time to time, and at trifling expense, fix indelibly the expanding features of his child; friends at a distance, who have been longing to see each other, may

now exchange faithful portraits without trenching greatly on scanty incomes; memorials of the old, the peevish, or the weakly, may be obtained without subjecting them to much trouble or inconvenience; and in a hundred ways, the ease and cheapness with which photographic portraits can be obtained, may be made to serve the purposes of reverence, esteem and affection.'[17]

This description of photographic portraiture had been prompted by a visit the reporter had just made to Aberdeen's first daguerreo-

> **Photographic Portrait Gallery,**
> 69, UNION STREET, ABERDEEN,
> NEXT DOOR TO THE ROYAL HOTEL.
>
> MESSRS. WATSON & FANNIN, in introducing the PHOTOGRAPHIC PORTRAITS to the Nobility and Gentry of Aberdeen and its vicinity, beg to announce that their Gallery is now open daily, from 11 till 5; and feel that little is necessary to recommend these wonderful productions, which have been so long patronised by the higher circles in England, to the Nobility and Gentry of Aberdeen and its vicinity. Their process, which embraces all the recent improvements made at so enormous an expense, insures the entire removal of those objections formerly urged against these Portraits, viz., the difficulty of catching the proper light upon them, want of expression, &c.
>
> The following are a few of the paragraphs, upon this subject, which have appeared from time to time in the leading London journals:—
>
> "This art, by which portraiture, in living likeness, is won from the hand of nature herself, and which must rank amongst the most extraordinary discoveries of this era of scientific marvels, may now be looked upon as clearly and satisfactorily reduced into practice."—*Morning Herald.*
>
> "The likenesses are admirable, and closely true to nature."—*Times.*
>
> "The portraits taken by this means are really extraordinary as likenesses: they are true to nature, for nature here is her own delineator. The features are admirably pourtrayed; and the likenesses, at first sight, are so extraordinary that they are really startling."—*Morning Chronicle.*
>
> Single Miniature, in a neat Case or Frame, £1 1s.; two of the same sitter, £1 11s. 6d.; full length Portraits, large size, £2 2s.; Kit cat, £2 2s.
>
> Messrs W. & F. think it necessary to observe, that from the superior and more expensive nature of their process, the above prices are so low, that any future reduction is *utterly impossible.*

Plate 15. Advertisement for Aberdeen's first portrait photographers, 1842

type studio opened in Union Street by Messrs Watson & Fannin in July 1842 (15). He was impressed by the paraphernalia of the studio and by the skill of the photographers, who, he wished to testify, were now capable of taking likenesses '. . . in a better style, and in a shorter time, than they could be taken, only a few months ago, in one of the most celebrated of the London establishments'.[18] Whilst

he thought the qualities of the portraits were high, the method by which they were produced remained a mystery to him; a mystery that was to perplex sitters for decades to come. His description of the daguerreotype process summarises it as '. . . a heating, a cooling, a wetting, a drying, a wiping, a blowing—a hanging over mercury and under spring water—a hot bath, and a blast from the mouth'.[19] This early and auspicious start for photographic portraiture in Aberdeen encouraged others to follow Watson & Fannin's example and set up their own studios.

In the decade that followed, photographers—or so they called themselves, though many had little or no experience—came and went as regularly as the seasons. Competition and poor workmanship forced them out of business. But the photographic portrait had gained a secure and lasting affection with the public, who were incessant in their demands to be photographed.

Photographers offered to the upper and middle classes the pleasure of having their 'likenesses' taken in a novel way. Because of the comparatively low cost of the photographers' services the better-off artisans could afford for the very first time to have portraits made of themselves and their families—thus creating a visual heritage for succeeding generations, a privilege that had previously been the exclusive prerogative of the wealthy.

Foundations of Success

Whatever our lack of information concerning Wilson's early and tentative beginnings in photography, we may be sure that because of his inexperience and the risk involved Wilson must have had misgivings about his future. As a safeguard, he continued to give priority to his painting and teaching, relying on the knowledge that to date he had been successful in these. The diversification into the now fashionable photography was a move that Wilson felt he had to make if he was to have a secure future as a portraitist. One thing was in Wilson's favour; he was already well established as a miniaturist, with his clients from the affluent middle classes of Aberdeen. This gave him a decided advantage over his competitors, who, trying to work up a photographic business from scratch, would not have had so many useful contacts.

One such competitor in Aberdeen was Wilson's friend, John Hay, Junior, whose studio, opened during 1853, was attached to his father's workshops in the Guestrow. With his brother James, John Hay, Senior, ran the old-established and well-respected firm of J. & J. Hay, carvers, gilders, frame-makers and picture restorers. Apart from the workshops, they had in Market Street a shop where they sold a host of mathematical, scientific and optical instruments, as well as prints and artists' materials.[20]

Within this small artistic and scientific enclave, John Hay, Junior, ran his photographic business, where he would have had ample opportunity to tempt his father's customers into his studio to have their portraits made. He managed to persuade some of them to write letters of commendation which he then included in an advertisement for his studio. One of these letters, from John Philip the painter, says that Hay's portraits 'are most faithful—so true to nature, and the treatment admirable as to tasteful arrangement, &c. Indeed, as far as I am able to judge, many of them are equal to Delamotte, and other noted London practitioners of this delightful and most useful art.'[21]

It seems strange that only one week after placing this advertisement in the local paper John Hay, Junior, with all the initial advantages of the social contacts available to him, should have approached Wilson with a view to forming a partnership. Wilson noted in his diary on 15 September 1853 that 'John Hay, Junior, asked me to join him in partnership and after thinking the matter over, [I] have decided to do so'.[22] By the nineteenth of the same month the contract was signed and the partnership of Wilson & Hay came into being. Just what motivated Hay to approach Wilson is unclear. Wilson was already well known to the Hays and it could

have been that the proposal was made in the hope of combining Wilson's talents and clientele with their own commercial enterprise. The partnership had many potential strengths. Wilson's name was given primacy in the title of the partnership. He took the opportunity to move his practice out of Crown Street and into the Guestrow. This suggests that it was Wilson rather than Hay who was the leading photographer, and that Hay, with a more secure financial background, was able to offer better studio and darkroom facilities. The skills of the two men were complementary: Wilson's abilities with the collodion process were matched by Hay's with the calotype.

Their main business, as one might expect, was portraiture, which they advertised as being '. . . taken daily, in the highest style of which the art is capable—Coloured, if desired, to equal fine miniatures'.[23] Here is evidence that even in photography, Wilson found an outlet for his skills as a colourist. It was the fashion of the day to hand-colour photographs, usually printed lighter to accept the colour better, and to make them look as little like photographs as possible. For this service Wilson & Hay charged an additional 12s. 6d. for their smallest prints while the largest cost a guinea extra.[24]

Three months after the partnership was formed, Aberdeen mounted its first photographic exhibition at the Mechanics' Institute. This was in essence the same exhibition, though now in reduced form, that had been organised the previous year by the Society of Arts for its soiree on 22 December 1852, where, predictably, it had been a huge success. The collection of prints assembled for Aberdeen, from the original eight hundred shown in London, was reduced to the more manageable size of eighty-three. This still gave a representative cross-section of work from some of the best photographers then practising. For example Cundall, Delamotte, Fenton, Le Gray, and Fox Talbot were among those exhibited.

A special feature of the Aberdeen exhibition was the inclusion of a competition section for work by Scottish photographers who could enter either landscape or portrait photographs. Wilson & Hay, recognising the opportunity for publicity, submitted twenty-two portraits and two landscapes to this competition. The judges gave the highest award, a silver medal, to Rodgers of St. Andrews for his portraits; the bronze medal they awarded to Messrs Wilson & Hay for their portrait of Provost Blaikie's family. In addition, the judges were so impressed by the overall display entered by Wilson & Hay that they awarded them an extra silver medal for '. . . the general excellence and evidence of progress displayed in their Collodio-Calotype Portraits'.[25] This success was immediately put to good use in an advertisement carried by a local paper. Whether by good fortune or persuasion, the advertisement was sited next to the report of the exhibition where it could hardly be overlooked.[26]

The only portrait taken during the partnership to have survived is a collodio-calotype portrait of Professor Anderson—'Wizard of the

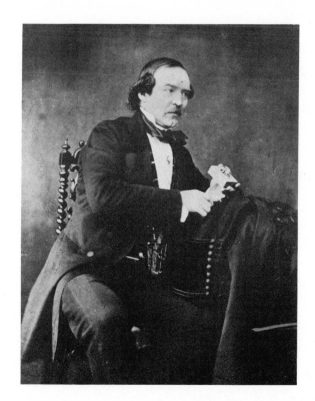

Plate 16. Professor Anderson, Wizard of the North, 1854

North'—Aberdonian and magician extraordinary (16). He is seated, rather awkwardly, at a small table which is hidden beneath a heavy black cloth that was perhaps a part of the act. In one hand he holds a small box that is clearly one of his properties, and his other hand hovers expectantly, waiting to begin the trick. The photograph is not first class and can be criticised for its inadequate focus and poor lighting, which do little to describe the features. It is unfair to judge this sole survivor as a representative of Wilson & Hay's total output, and despite the fact that we know Anderson was well pleased with the photograph, we have to keep an open mind about the competence achieved in their portraits.[27]

The collodio-calotype process used for these early portraits was a practical solution that overcame the difficulties of both of the processes while retaining the advantages of both. The negative was made by the collodion process, which gave shorter exposures and better graduated negatives than the calotype process. Normally this negative was printed on to albumen paper, but during the early 1850s manufacture of this was still at an early stage and it could not be relied upon to produce consistent results with a wide tonal range. Alternatively, the collodion negative could be printed on calotype paper which was certainly more reliable. Wilson's knowledge of the collodion process and Hay's of the calotype made them ideal partners.

In September 1853, the month in which Wilson and Hay became partners, an event took place some fifty miles from Aberdeen that, unknown to Wilson, was to have a profound effect on his social life and business prosperity. On 23 September Queen Victoria, aided by Prince Albert and watched by her family, gently tapped into freshly laid mortar the foundation stone of their new highland home, Balmoral Castle.

This remote and beautiful estate, with its old castle, originally belonged to the Earl of Fife. It was rented in 1821 to Sir Robert Gordon who greatly enlarged the castle, adding turrets and wings piecemeal over the years (17). On his death the lease passed to his brother, Lord Aberdeen, who suggested to the Queen that it might be suitable for her and her family as a Scottish home and sporting retreat. The Queen's first impression of the old castle and its

grounds came from the watercolours prepared, at the suggestion of Lord Aberdeen, by James Giles, an Aberdeen artist. These so pleased the Queen that she dispensed with the usual formality of an inspection. Having sought the advice of her physician, who recommended the climate for its dryness, she took on the remaining twenty-seven years of the lease.

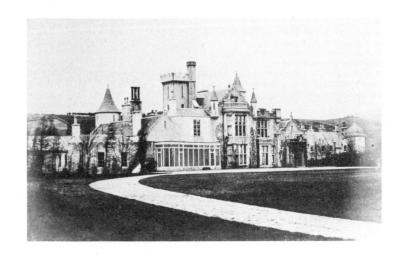

Plate 17. Old Balmoral Castle, c.1854

Her first visit in September 1848 reinforced her first impressions. During that visit she wrote to her uncle, the King of the Belgians, '. . . This house is small but pretty, and though the hills seen from the windows are not *so* fine, the scenery all around is the finest almost I have seen anywhere. It is very wild and solitary, and yet cheerful and *beautifully wooded*, with the river Dee running between the two sides of the hills. Loch Nagar is the highest hill in the immediate vicinity, and belongs to us.

'Then the soil is the driest and best known almost anywhere and all the hills are as sound and as hard as the road. The climate is also very dry, and in general not very cold, though we had one or two very cold days. There is a deer forest—many roe deer, and on the opposite hill (which does not belong to us) grouse. There is also

black cock and ptarmigan. Albert has, however, no luck this year, and has in vain been after the deer, though they are continually seen, and often quite close by the house.'[28]

This appraisal overlooked the inconveniences of the haphazard and badly laid-out castle which so outraged Prince Albert's love of organisation and order that, as soon as possible after the purchase of the estate had been negotiated, he set about planning a new castle to replace the old. It was to be built of granite in a Scottish baronial style, from designs by William Smith of Aberdeen, at a cost of about £100,000.

Once the work was under way, Prince Albert commissioned Wilson & Hay to make photographs at regular intervals of the building's progress. What prompted Prince Albert to select Wilson & Hay is unknown. It could have been on the basis of a recommendation from the Aberdeen architect who was perhaps familiar with their work. Their first visit during March 1854 found the building already well advanced, with one part of the structure roofed in. In the weak spring sunshine they set up their whole-plate camera and using the collodio-calotype combination made a series of five views. They were to return to the castle again during July and October.

Nearly all of the photographs made during the three visits are straightforward shots of a building site, which is what they were intended to be. Only one photograph (18) of the site transcends the others: it shows the new castle, bleak and unfinished, its great black sockets of windows contrasting sharply with the light grey granite. All about is confusion; builders' materials lie everywhere in seeming disorder. What sets the picture apart is the decision by the photographer to include, right across the foreground, a simple wooden fence. This was not an unconscious action; the careful alignment, both vertically and horizontally, shows a sensitivity to the value of including the fence within the frame. The fence forms a natural base for the castle and the builders' materials. On the extreme right, spars of timber create a diagonal force that runs out of the picture and is echoed again and again within the frame.

By October the new castle was structurally almost complete; nearly all that had to be done was detail work. With the completion of the new castle, the life of the old castle was nearing its end. It was soon to be demolished and reduced to a commemorative plaque. Before this happened Queen Victoria asked Wilson & Hay to photograph the interior of the castle so that she might have a permanent record of her first home at Balmoral (19). These interior views were later handed to James Giles for colouring, a task he performed with infinite patience, though the patterned wallpaper and carpets nearly drove him to despair.

Wilson & Hay's visit during the early part of October coincided with the annual visit of the Royal Family. Between 4 and 7 October, Prince Albert accompanied by his keepers, jagers and ghillies, went stalking deer with more success than in 1848. The trophies were triumphantly and proudly borne back to the castle and the photographers were called upon to make a record of the event (20, 21). All the studies show a stag lying at the foot of a small tree, accompanied by the appropriate keeper. In those photographs where the lighting is direct sunshine, the stag has been carefully placed and arranged for maximum modelling of its features. For the eight days they were in attendance Wilson & Hay charged the Queen £25. 4s. 0d., which was based upon a charge of three guineas per day. The eighty-two prints ordered from the negatives cost a further two shillings each.[29]

These first photographs of Balmoral, taken in 1854, proved Wilson and Hay competent photographers and marked the beginning for Wilson of a long business association with the Queen. In addition, Wilson and Hay used the occasion to raise their own status in Aberdeen by advertising in the local press (22) that they were now 'Under the Immediate Patronage of Her Majesty'.[30]

Robert Wilson, on hearing of his younger brother's visits to Balmoral wrote: 'I was quite delighted to hear that you had been mixing in society of the first water since I last saw you—a great honour certainly—no wonder though you should be puffed up, almost to bursting. I am afraid it will be the means of ruining you by turning your head and making you neglect your business, or by being saucy to your customers and treating them rather cavalierly.'[31]

The opposite seems to have been the case. Wilson and Hay recognised that they were at the threshold of a new phase in their business lives. Success, they believed, came in part from keeping

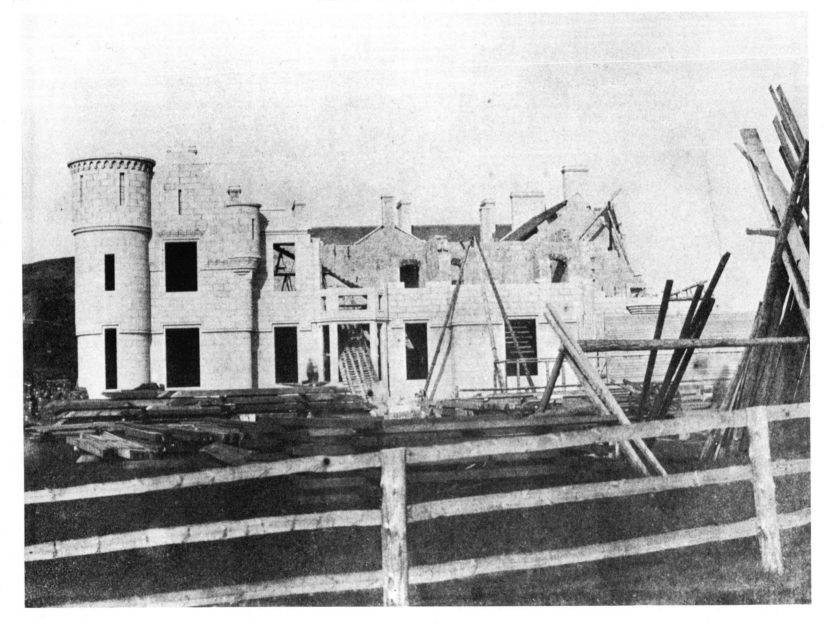

Plate 18. The new Balmoral Castle under construction, Spring 1854

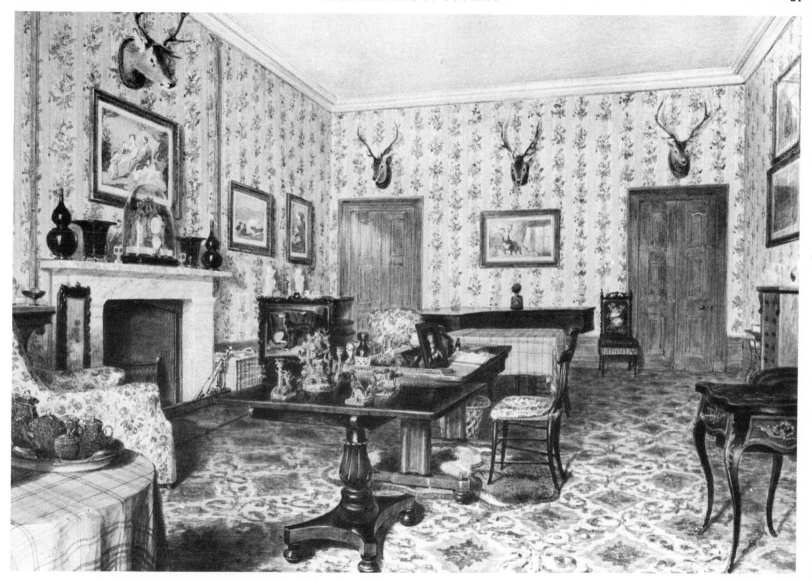

Plate 19. Queen Victoria's sitting room in the old house, Balmoral, 1854

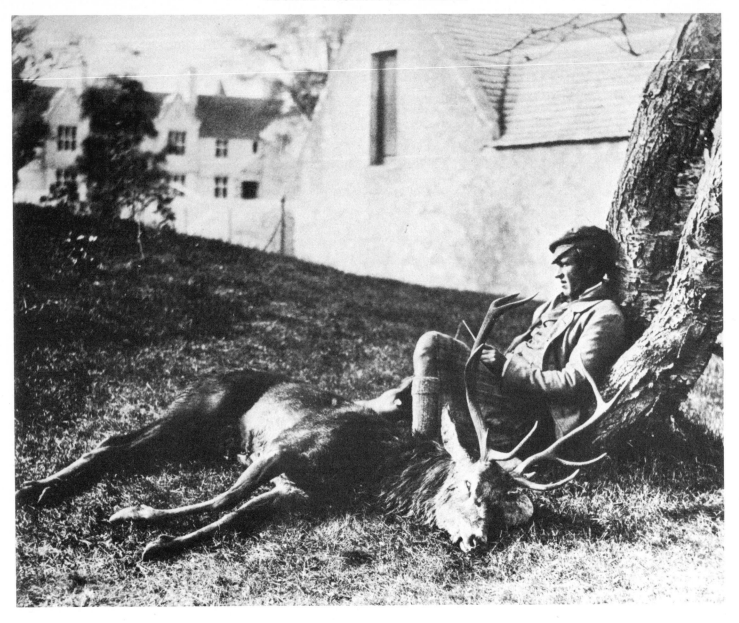

Plate 20. Stag shot by the Prince, 4 October, on Corrie-na-Poitch and Donald Stewart, one of the foresters, Balmoral 5 October, 1854

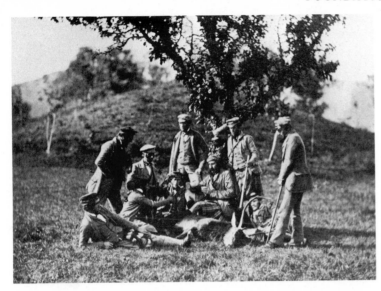

Plate 21. Stag shot by the Prince Consort, 5 October, 1854, in Corrie Buie

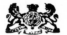

Under the Immediate Patronage

OF HER MAJESTY.

Messrs WILSON & JOHN HAY,

IN returning thanks for the Liberal Patronage bestowed on them within the last twelve months, take the opportunity of stating that, in order to keep pace with the rapid advancement the Art of PHOTOGRAPHY is making on the Continent, where it is untrammelled by Patents, their Mr WILSON has visited Paris, whence he has just returned fully instructed in all the various Systems and New Improvements, as practised by the most eminent Artists.

They have also procured larger and finer Instruments, and are now prepared to execute PORTRAITS, Coloured and Plain, equal in Style and Artistic Treatment to any in the Kingdom.

Landscapes and Views of Gentlemen's Seats

TAKEN ON MODERATE TERMS.

A large Assortment of Stereoscopic Subjects on Glass and Paper.

Amateurs supplied with CHEMICALS and INSTRUMENTS of the Best Quality, and Instructions given in the COLLODION PROCESS in all its details.

19, Guestrow, 1st September, 1854.

Plate 22. Advertisement for Messrs Wilson & Hay, 1854

abreast of the latest developments in photography. To that end 'their Mr. Wilson has visited Paris, whence he has just returned fully instructed in all the various Systems and New Improvements, as practised by the most eminent Artists'.[32]

This raises an interesting point about the authorship of the photographs taken during the partnership. It is not positively known whether Wilson or Hay took the leading role as photographer, or whether they both took an equal part—being, as it were, interchangeable. The press announcement suggests that Wilson was the photographer, which reinforces the idea that, from the formation of the partnership, he took the leading role.

Whatever hopes they may have held about the future prosperity of their business, these were soon to be shattered. Wilson's diary notes on 11 December 1854: 'The Hays are in difficulties and are contemplating bankruptcy, in which case John and I shall have to dissolve [the] partnership. James Hay has mismanaged the business and brought it from a flourishing condition to this pass.'[33] By January 1855 the bankruptcy was a reality with ten shillings in the £

being offered to the creditors. So close was the financial association between J. & J. Hay and Wilson & Hay that John Hay, Junior, felt he must withdraw from the partnership and offer Wilson his half of the equipment and stock.

Thus ended a promising partnership, and Wilson found himself independent once more, but now with a thriving photography business to run. Wilson was fortunate in being able to continue his tenancy at the Guestrow studio during 1855 while he made necessary and extensive alterations to his own property in Crown Street. When Wilson had transferred his photography from Crown Street in September 1853 he had left behind a studio that shared premises with his home. By 1855 this studio space had become clearly inadequate for the needs of a business that had grown and which promised future expansion. To create a large studio with sensitizing and printing rooms Wilson had first to ask his tenant at number 22 to leave and then alter the premises to suit his own requirements. These conversions were completed in 1856 and Wilson moved in. A later visitor to Wilson's studio noted its 'temporary

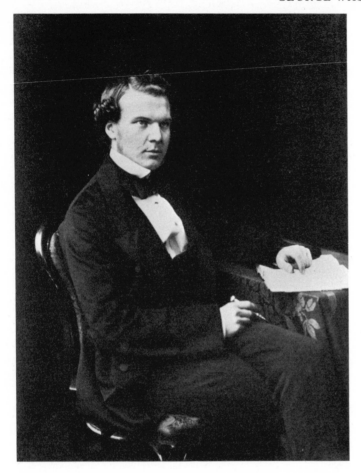

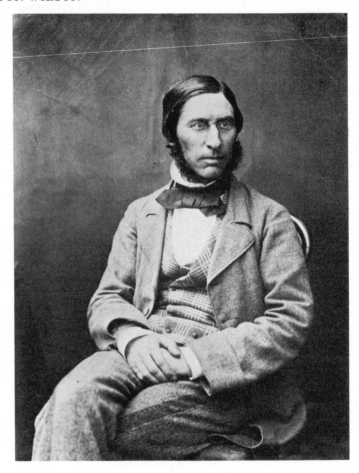

Plate 23. Mr. McKenzie, Architect, c.1855

Plate 24. Mr. Matthews, Architect, c.1855

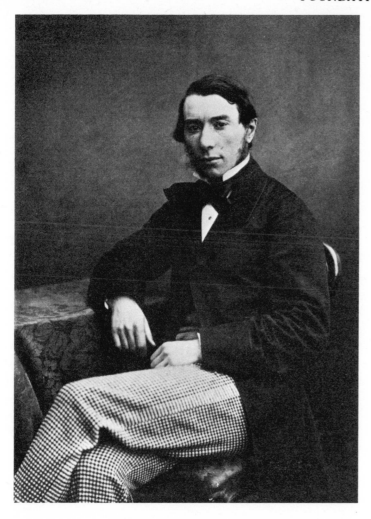

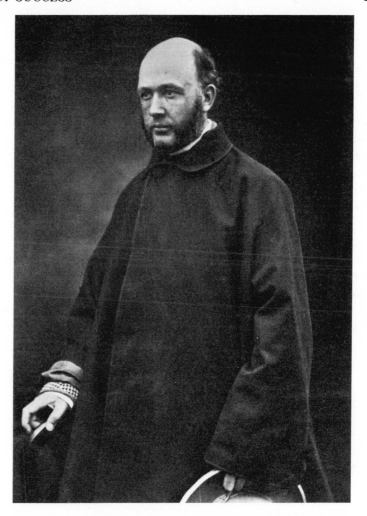

Plate 25. *J. F. White, Miller, collector and photographer, c.1855*

Plate 26. *John Phillip, R.A., c.1855*

character' and 'wooden front' which allowed constant rearrangements to suit the needs of a growing business, but gave it 'a somewhat straggling appearance'.[34]

Between the failure of the partnership and his move back to Crown Street, Wilson had found time to write *A practical guide to the collodion process in photography* which was published simultaneously in London, Edinburgh and Aberdeen in 1855. Its publication in Aberdeen prompted a paragraph in the press, where Wilson was described as 'well-known as a most successful professional cultivator of the art' and in the booklet he 'made . . . a full and unreserved revelation of his secrets—only retaining what could not be communicated—the eye of the artist and the hand of the cunning workman'.[35] (see Appendix Three).

His description is clear and concise and not only covers the manipulative processes of coating, exciting and developing the plate but also gives advice and recommendations, based upon experience, about cameras, chemicals and lenses. From its pages we can glean some ideas about the methods of working preferred by Wilson. On chemicals, he advised 'It is of great consequence that the chemicals be pure. The only way to insure this is to purchase them from a respectable dealer, and pay a sufficient price for them. Economy in this matter tends only to create disgust with the art; for where impure chemicals are used none but inferior pictures can be produced. . . . The collodion prepared by Mr. Thomas, Pall Mall, is, undoubtedly, the best for negatives that has yet been manufactured in this country.'[36]

In the matter of lenses 'Those manufactured by Mr. Ross of London, judging from the eminence of the maker, and the high price he charges for them, appear to take the lead. But . . . if in taking a half-length portrait with one of Ross's whole plate lenses, on a moderately clear day, you bring the eyes, nostrils, and mouth of the sitter in focus on the ground glass of the camera, you will find that the ear is slightly out of focus, and the hair at the back of the ear entirely so, the field being, as it were, only an inch or two in depth. Performing the same experiment with a lens of the same diameter by Lerebours and Secretan of Paris, the whole head is in focus and other parts of the figure are less distorted.'[37]

The ever-present difficulties of depth of field were to occupy photographers for most of the early decades of photography, particularly in portraiture where the need for short exposures, often in poor light, exaggerated the problem. The poses adopted in front of the camera were often determined by the stringencies of depth of field, the photographer taking great care to arrange the sitter so that nearly every part fell within the one plane.

Looking at the few surviving studio portraits from those made by Wilson during the 1850s and 1860s, one is aware of how conscious he was of the technical difficulties imposed by the process, when poor, inadequate lighting, slow emulsions and lenses all conspired against the photographer to make his task difficult. In most cases (23, 24, 25) Wilson's subject was seated beside a small, draped table, on which a few objects or books indicated his interests, talents or aspirations. This gave the sitter something firm to sit in and pose against: books or pencils were available to still a restless hand during exposure. The backgrounds were plain and dark with no suggestion of drapes to distract the eye.

Much of Wilson's approach to portraiture was drawn from his own training and experience as a painter, and it is not surprising that when he adopted photography he should retain the visual language of painting and translate it into his photographs. He also believed in the writings of John Burnet, a prolific and popular writer on matters of art. Burnet's beliefs were based upon the numerous examples to be found in the works of Old Masters whose compositions he used in his discourses on composition, light and shade, and portrait painting.[38] In the first few lines of his *Practical hints on composition in Painting*, Burnet comes straight to the point: 'To secure a good general form in composition, it is necessary that it should be as simple as possible. A confused complicated form may hide the art, but can never invite the attention.'[39] This pronouncement fits in exactly with Wilson's own beliefs as illustrated through his portraits, and it is more than likely that he was directly and positively influenced by Burnet himself. Burnet advises that 'in a single head we often have but one light; it is therefore necessary to set it to harmonize with the shadow, either in the background or upon the dress. Rembrandt, accordingly, frequently painted the

light of the dress the same colour as the shadow side of the face, thereby keeping up a union and simplicity.'[39] Wilson takes careful note and applies the advice to his portrait of John Philip, R.A. (26).

During 1854 Wilson became acquainted with George Walker (27), a young man just a few years older than himself. Walker's family were comfortably off and he had received a thorough education at the Trades schools and Aberdeen Grammar School. At the time when Wilson first knew him he was a junior partner in the firm of A. Brown & Company whose bookselling, stationery and fine art business was well known to Aberdonians. In his later life Walker wrote about his experiences of Aberdeen and its society in a lengthy, seventeen-volume manuscript journal.[40]

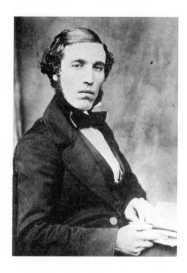

Plate 27. George Walker

By 1857 Wilson was firmly established as the leading portrait photographer of Aberdeen and at that time he would have had on file several hundred negatives of his sitters. It was Walker who suggested to Wilson that he should make a selection of these and arrange them into a group under the title 'Aberdeen Portraits'. (28) The selection and careful arrangement of the heads within the oval format were jointly made by Wilson and Walker: they represent a good cross-section of middle class society in and around Aberdeen. The choice was dictated not only by those who had been to Wilson's studio but also and more importantly by the choice of two men who used the opportunity to grade and position society within the montage. The size and placing of the heads take on a particular significance, and it comes as no surprise that the largest and centrally placed head belongs to the only titled person, Sir Thomas Blaikie. Around him are ranged the advocates, artists, bankers, professors, reverends and surgeons, until at the very perimeter there appear those people whose status deserved an inclusion but who nevertheless did not warrant a larger space or more central position. There was no false modesty from Wilson and Walker, whose own portraits appear large and centrally, a positive statement about their view of their own position in society.

When the arrangement was complete and the subject rephotographed, the first print was placed in the window of Walker's bookshop in the hope of getting orders for the photograph. The response was immediate. Walker tells us that 'I had numerous enquiries as to when & where all these people had been collected & photographed for though groups had appeared nothing like this one had been seen, & the grouping of the separate pictures was never suspected'.[41]

This response to the world's first recorded use of photomontage is understandable when one considers the lack of visual awareness and naivety of the public who had a touching faith in the truth of photography and were puzzled when it tricked them. Once understood, the portrait was a success and despite its comparatively high price of six shillings it enjoyed large sales and Wilson was hardpressed to meet the demand for prints. Its popularity was such that Wilson and Walker were encouraged the following year, 1858, to publish another group portrait similarly arranged.[42] Wilson's ability as a publicist is illustrated by these two montages which simultaneously drew attention to himself and to his clients and their status. Other people would feel impelled to pay a visit to Wilson's studio in the hope that at some future date they too might be included in such a prestigious group.

WILSON'S ABERDEEN PORTRAITS

GROUP No. 1

1. Mr. John Manson, of Kilblean.
2. Mr. John Duthie, Shipbuilder.
3. Mr. Duguid.
4. Mr. James Brebner, Advocate.
5. Mr. George Keith, Morningfield.
6. Prof. James S. Brazier (Chemistry).
7. Mr. Beauchamp Urquhart, of Meldrum.
8. Mr. Francis Craigmyle, Writing Master.
9. Mr. Francis J. Cochrane, of Balfour.
10. Mr. William Chisholm, County Rooms.
11. Mr. Arbuthnot, Peterhead.
12. Mr. George Abernethy, Engineer.
13. Mr. W. Chalmers, Northern Assurance Co.
14. Dr. Walker.
15. Sheriff Watson.
16. Captain Ramsay, of Straloch.
17. Mr. Andrew Murray, Senr., Advocate.
18. Mr. James Fordyce, Brucklay Castle.
19. Mr. William Fordyce, Brucklay Castle.
20. Mr. Gustavus V. Brooke, Tragedian.
21. Rev. J. Sharp, Blairs College.
22. Dr. Keith.
23. Mr. Wm. Brown, Inland Revenue Office.
24. Mr. Gavin Hadden, Lord Provost.
25. Mr. Gray Chalmers.
26. Major Craigie, H.E.I.C.S.
27. Captain Rennie.
28. Lieut. Cotton, H.E.I.C.S.
29. Mr. William Gibson, of Kinmundy.
30. Mr. John Blaikie, of Craigiebuckler.
31. Mr. John Farley Leith, M.P., London.
32. Mr. Thomas Todd, of Maryculter.
33. Dr. Robert Dyce.
34. Mr. William Allardyce, Wine Merchant.
35. Mr. Hay Macdowal Grant, of Arndilly.
36. Mr. Penketh, Railway Contractor.
37. Mr. John Jamieson, N. Agric. Co.
38. Mr. Alexander Pirie, of Waterton.
39. Colonel Sykes, East India Coy., M.P. for Aberdeen.
40. Mr. Robert Grant, of Monymusk, Convener of County.
41. Mr. John Ramsay, late of Aberdeen Journal.
42. Mr. James Allardyce, H.E.I.C.S.
43. Mr. Edmond.
44. Rev. Gilbert Rorison, Peterhead.
45. Mr. John Hay, Carver and Gilder.
46. Mr. David Chalmers, Printer, Aberdeen Journal.
47. Sheriff Davidson.
48. Dr. Kilgour.
49. Mr. John Philip, R.A.
50. Mr. William Dyce, R.A.

Published 1856

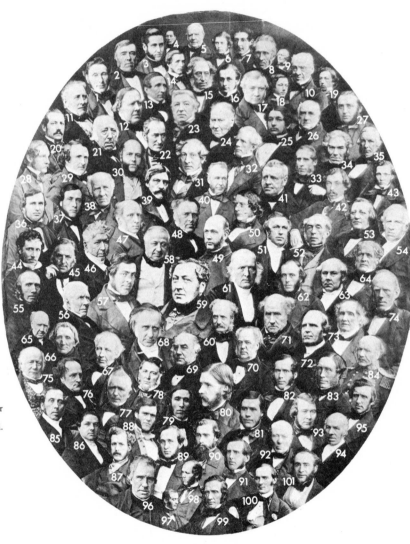

WILSON'S ABERDEEN PORTRAITS

GROUP No. 1

51. Dr. Maclure, Prof. of Humanity, M.C.
52. Dr. Robertson, of Indego.
53. Mr. Isaac Machray, Royal Hotel.
54. Dr. R. J. Brown, Prof. of Greek, M.C.
55. Mr. Alex. Thom, General Merchant.
56. Mr. William Leslie, of Warthill.
57. Mr. James Abernethy, Engineer.
58. Mr. J. Duguid Milne, senr., Advocate.
59. Sir Thomas Blaikie.
60. Colonel Fraser.
61. Rev. Henry Angus.
62. Mr. Robert Abernethy, Engineer.
63. Rev. Dr. Paul, Banchory Devenick.
64. Mr. William Leith, of Freefield.
65. Mr. Alexander Webster, Advocate.
66. Mr. Thom.
67. Mr. Macdonald.
68. Rev. Dr. Thomas Guthrie, Edinburgh.
69. Colonel Lumsden, of Belhelvie.
70. Mr. Laybourne, W.S., Edinburgh.
71. Mr. William Lumsden, of Balmedie.
72. Prof. Fairbairn, F. College, Glasgow, late of E. College, Aberdeen.
73. Captain Ramsay, of Banchory Lodge.
74. Dr. John Cruickshank, Prof. of Mathematics, M.C.
75. Mr. Charles Cumming, Allanaquoich, Braemar.
76. Baillie Williamson, Druggist.
77. Captain Rennie.
78. Mr. William Williamson, Seafield.
79. Mr. George Walker, Bookseller, A. Brown & Co.
80. Mr. Geo. W. Wilson, Photographer.
81. Mr. Robert Wilson, Old Deer.
82. Mr. W. L. Thomson, Wine Merchant.
83. Mr. Wm. Hogarth, Provision Curer.
84. General Turner, of Mennie.
85. Rev. D. Henry, Free Church, Marnoch.
86. Rev. Wm. Chalmers, late of Edinburgh.
87. Mr. Pratt.
88. Mr. Alexander Simpson, Advocate.
89. Mr. Charles Warrack, Record Office.
90. Captain Lumsden, H.E.I.C.S.
91. Dr. Fraser, Schoolhill.
92. Mr. John Macdonald, Book Agent.
93. Mr. Fraser L. Johnstone, Merchant.
94. Mr. William Clark, late Ironmonger.
95. Mr. John Duthie, Jun., Shipbuilder.
96. Bishop Kyle.
97. Dr. Henry Dewar, Surgeon-Dentist.
98. Mr. Robert Smith, of Glenmillan.
99. Mr. Alexander B. Whyte, Merchant.
100. Mr. Edward Lindsay.
101. Mr. John T. Rennie, Shipping Agent.

Present Re-issue, 1907.

Plate 28. Aberdeen Portraits No. 1 1857

From the beginning of Wilson's photography in 1852 there were other Aberdeen photographers in competition, though how many at that date is unknown. It was only in 1856 that the Post Office directory started to list Photographer as a separate trade or profession and thereby to provide some idea of the rise of portrait photographers in Aberdeen. These figures have more relevance when compared with the 1861 Census returns which show that in Aberdeen (town) photography employed sixty-two people who represented every aspect of the trade from the photographer to the humblest retoucher. In the whole of Scotland in 1861 there were six hundred and forty-four people similarly employed, making Aberdeen responsible for approximately one-tenth of all those employed in photography in Scotland.

Number of Photographers Working in Aberdeen 1856–1866

1856	5	1860	13	1864	18
1857	7	1861	14	1865	18
1858	10	1862	17	1866	19
1859	10	1863	18		

The increase in the number of photographic studios in Aberdeen, indeed throughout Britain, can be largely attributed to the introduction of a new size of portrait, the 2¼ × 3½ in. (57 × 89 mm) *carte-de-visite*. The popularity of the *carte* lay in its cheapness. Previously one 10 × 8 in. plate was prepared for each exposure. With the new system, the camera, with six suitably mounted lenses placed the exposures simultaneously or consecutively beside each other on the same 10 × 8 in. plate. These six smaller images brought the cost per exposure to one-sixth of the price of the larger portrait. This substantial saving was not passed on to the customer when the portrait was taken: the photographer was wary of the customer who only ordered one print—which barely covered the photographer's expenses. The real saving came with any subsequent order when each print would cost only a few pence each. In Wilson's case the cost for taking and having one print was five shillings but if you ordered six prints during the sitting then the all-inclusive price was eight shillings, which meant that the additional five copies had cost the sitter only 7½d. each.[43]

The *carte-de-visite* had been introduced to England in 1857 by A. Marion & Co., a French firm of photographic dealers and publishers, who had seen its invention in France three years earlier. It did not find favour immediately and it was not until 1860 that it became widely popular. Its cheapness made it available to a wider cross-section of the public than ever before and the possibilities of multiple prints at such low cost meant that families were soon exchanging photographs, gradually assembling the whole hierarchy of a generation within an album. As well as exchanging *cartes*, families also collected others of Royalty and of any Victorian who had even the slightest claim to distinction. This branch of photographic publishing became both widespread and lucrative and it was not unusual for even the most provincial photographer to approach his own local celebrities and persuade them to sit for their portraits with a view to subsequent publication. This close involvement by the public led to an increased demand for portraits, and photographers everywhere soon found themselves caught up in the whirl of 'cartomania'.

Wilson's own response to the *carte-de-visite* appears in 1860, coincident with their sudden popularity. At that date he began alterations to his property once more, this time rationalising everything into two units, his house at 23 and his studio and darkrooms at 24. During the next three years further alterations were to take place so that by March 1864 Wilson could announce 'that in order to enable him to execute his orders for Portrait in the most advantageous manner possible, and as promptly as is consistent with good workmanship, he has added a SECOND GLASSHOUSE to his premises in Crown Street, thus securing additional accommodation for sitters, and a steady light at all hours of the day. In consequence of this increased facility of production, he has pleasure in being able to announce that, in future, a considerable reduction will be made in the price of *Cartes-de-visite*.'[44]

Just what the scale of this reduction was is not known, but even his revised lowest charge of five shillings for a sitting and one print, was twice the price charged by his closest competitor, John Lamb of 28½ Crown Street. Wilson relied upon his reputation for high quality rather than upon low prices to attract his customers. And

the customers came in sufficient numbers to make Wilson a handsome profit. In 1864/5 the year in which the second glasshouse came into operation and the only year for which we have any figures, the studios made 3762 negatives which gave Wilson total sales in that department alone of £4625. 16s. 11d.[45]

The majority of the sitters on these 3762 negatives would have belonged to the middle classes although some may have been affluent artisans. Wilson never set out, unlike some of his competitors, to appeal to the working classes. By keeping his prices high he effectively confined his market to the middle income groups. Even among these groups, who were often well-educated, there was ignorance and many popular misconceptions about the rigours of being photographed. In order to overcome some of these fears and to explain how simple it really was, Wilson published (29) a small pamphlet called *A Dialogue on Photography or Hints to Intending Sitters*. In the preface he explains his motives for writing the dialogue: 'A portrait photographer in successful practice must devote a considerable part of his time to mixing and keeping in order the chemicals which he employs, and to preparing and developing the plates of every portrait which he takes, the delicate manipulation of which ought to be superintended with care and without interruption. In the midst of these labours, however, he is often called upon to attend his patrons, for the purpose of answering such questions as are usually asked by those who wish to sit for their portraits. In order to provide, as much as possible, against this distracting of his attention, MR. WILSON begs respectfully to submit the following imaginary colloquy to the attention of those who propose honouring his studio with a visit.'[46] (30-33) Significantly he chooses a lady for the dialogue as presumably she would be the least informed and the most ignorant about photography. The dialogue reveals much about Wilson's working methods and ideas of taste, and illustrates how our view of the Victorians as sombre dressers has been caused by a technical limitation of the process. (see Appendix Four).

LADY—I want my portrait photographed and wish to consult you as to what sort of dress I ought to put on?

PHOTOGRAPHER—The material is of little consequence; but ought to be of a dark colour. Black, brown and green are most suitable. Blue, pink, white and lilac or light purple, should be avoided, principally because in the photograph they look almost white, and cause the face to appear dark by contrast. A little white about the throat and wrists is an improvement, to prevent the picture from having a sombre look, but it ought to be as little as possible.

Plate 29. Title Page 'A Dialogue on Photography . . .' c.1862

A little later the dialogue tells us how long the exposure times were and what endurance was required in just keeping still.

LADY—How long does a sitting usually occupy?
PHOTOGRAPHER—The arranging of the sitter requires some time, but the actual taking of the portrait occupies only a few seconds, varying from one to thirty or forty according to the light and the season of the year. In spring and summer, the average time required for taking a small portrait is about four seconds, and in winter about fifteen.

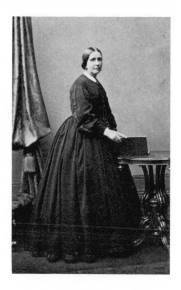

Plate 30. Carte-de-visite from
the Crown Street studio, 1860s

Plate 31. Carte-de-visite from
the Crown Street studio, 1860s

Plate 32. Carte-de-visite from
the Crown Street studio, 1860s

Plate 33. Carte-de-visite from
the Crown Street studio, 1860s

He tactfully avoids mentioning that for the more unsteady sitter there was the ever-present head and body clamp which restrained the sitter into semi-immobility, a device not loved because of the unnatural way in which it posed their bodies, but there was no real alternative.

LADY—And in what position ought I to stand?
PHOTOGRAPHER—It is better to leave that to the photographer, who, if he has good taste and some knowledge of pictorial composition, ought to be able to arrange the position in a few minutes, while the plate is being prepared on which the portrait is to be taken.
LADY—But I should like to see that I am in a nice position before I am taken.
PHOTOGRAPHER—It is impossible to show you this, even by means of a mirror, which would have to occupy the exact spot where the camera stands; and the slightest change of position, or even inclination of the head, may make all the difference between a graceful portrait and vulgar caricature.

The dialogue continues with a detailed description of the photographic processes which lead up to the finished print. The lady, much impressed by the explanation of chemical and manipulative skills, must have felt that the higher prices were well justified and a lengthy wait for the results worthwhile. She finished completely in sympathy with the photographer's difficulties and delays, saying: 'Well, I shall be more careful of photographs in future, and don't hurry mine please. I would rather wait a month for them and have them properly done, for I understand now how they gain nothing by being hurried.'

This polite and persuasive publicity was typical of Wilson's business sense: he understood the potential benefit of explaining carefully the photographer's position while putting the customer at ease before a sitting.

With the introduction of the *carte* came a new stylistic approach to portraiture. The three-quarter length study in which everything was simple and restrained gave way to a much more exuberant,

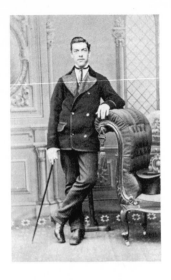

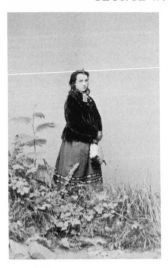

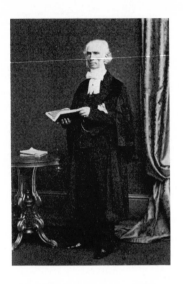

Plate 34. Carte-de-visite by
Sanderson, Preston, 1860s

Plate 35. Carte-de-visite by
Thomas Edge, Preston, 1860s

Plate 38. Carte-de-visite from
the Crown Street studio, 1860s

Plate 39. Carte-de-visite from
the Crown Street studio, 1860s

Plate 36. Carte-de-visite by
Negretti & Zambra, Crystal
Palace, 1860s

Plate 37. Carte-de-visite by
F. Spalding, Chelmsford, 1860s

Plate 40. Carte-de-visite from
the Crown Street studio, 1860s

Plate 41. Carte-de-visite from
the Crown Street studio, 1860s

showy, full-length pose, against a decorative set. These settings were often masterpieces of bad taste and incongruity. The most obvious anomalies of rivers flowing towards carpeted floors, rustic settings that finished sharply where the backcloth met the floor, did not seem to worry the Victorians. With elaborate flights of fancy, the city dweller was back among ferns by the riverside, the uneducated were splendid in libraries, and even the dissolute could be saintly in an ecclesiastical setting (34–37).

Although Wilson had to make stylistic concessions to conform with current fashion, he never allowed his settings to be excessive riots of decoration. Instead, he preferred to create the impression of solid respectability with mahogany tables, well-upholstered chairs and the occasional plant. The tone of the domestic setting perhaps struck a harmonious chord with the sitters, who never look out of place in it (38–42). In fact, many of these portraits may not have been taken by Wilson himself. By the early 1860s his growing commitment to landscape photography meant that frequently he had to leave the day-to-day running of his studio in the hands of a series of managers who came and went with depressing regularity. They saw their opportunities only too well, for after a period as manager during which they learnt the secrets of his operation and success, they left and set up their own studios in the town, advertising themselves as being 'Late with G. W. Wilson'. During the 1880s when Wilson had personally given up portraiture and when three of his sons were associated with the family business, the portrait studio was managed by one of them. By coincidence, of his six sons it was John Hay Wilson who managed the portrait business.

It would be wrong to claim that Wilson had any significance as a portraitist: he was clearly just a competent, first-class photographer who enjoyed a considerable local reputation, a reputation greatly enhanced by his associations with Balmoral. But it was a combination of all these factors that gave him the financial independence that allowed him to develop into other areas of photography, notably landscape photography. Who can say how Wilson's career might have developed without the success of his portraiture? He made long, expensive trips in search of suitable landscape subjects, and he invested in extra equipment and stock. He used the profits

from his portraits to establish a landscape-photography publishing business. This business was on a sufficiently large scale to enable him to supply his productions to bookshops, stationers and railway stalls all over Scotland and later all over Britain. It was from the security of his portraiture that Wilson was able to develop into landscape photography.

Plate 42. Reverse of carte-de-visite 1860s

CHAPTER FOUR

'Photographer to the Queen'

On 7 September 1855, Queen Victoria wrote in her journal: 'At a quarter-past seven o' clock we arrived at dear *Balmoral*. Strange, very strange, it seemed to me to drive past, indeed *through*, the old house; the connecting part between it and the offices being broken through. The new house looks beautiful . . . the rooms delightful; the furniture, papers, everything perfection.'[47] This delight and enthusiasm for the new castle mark the beginning of a long association that Queen Victoria was to have with Balmoral and one that over the years became ever more affectionate—not least because of Prince Albert's part in the planning of the castle and its grounds. 'All has become my dear Albert's *own* creation, own work, own building, own laying out, as at *Osborne*; and his great taste, and the impress of his dear hand, have been stamped everywhere.'[48]

The countryside which had so delighted her in 1848 revealed itself in even greater beauty as she and Prince Albert explored it together on their ponies. After ascending Ben Muich Dui in 1859 the Queen believed she would 'never . . . forget this day, or the impression this very grand scene made upon me; truly sublime and impressive; such solitude.'[49] Queen Victoria visited 'the poor people' who lived around the estate: she took a positive delight in paying them social calls, dispensing small gifts of warm petticoats and handkerchiefs. In her own way she felt close to what she termed 'these good people, who are so hearty and so happy'.[50] From the start she took an interest in the welfare of all her estate workers and their families.

Part of Wilson's role as a photographer at Balmoral was to record and translate these enthusiasms of the Queen into images, and much of his success can be attributed to the skilful way in which he interpreted his commissions so that they fitted closely with the Queen's own idea of what was appropriate for each subject. Wilson, then, was expected to be a photographic jack-of-all-trades.

The circumstances under which Wilson had to take his photographs affected his attitude and approach. In September 1855, when he took his first photographs of the Queen, Prince Albert and other members of the Royal Family, Wilson must have felt overwhelmed by the occasion: he kept himself and his camera at a respectful distance (43). Little of the usual attention seems to have been paid to composition, lighting and background.

The occasion was equally important to the Queen and Prince Albert who, as proud parents, wanted photographs to celebrate the engagement of their eldest daughter, Princess Victoria to Prince Frederick William of Prussia. Prince Frederick William arrived at

Balmoral on 14 September: six days later, immediately after break-fast, he spoke to the Queen and Prince Albert of his wish to marry Vicky, whom he found so 'aller liebst'. Queen Victoria and Prince Albert called the proposal 'most gratifying and satisfactory' but it had wide diplomatic implications and strict secrecy was urged during the nine days that it took to settle these.

On 29 September the engagement was announced and Wilson was on hand to record the event. Just when he arrived at Balmoral is not clear. His invoice reveals that he was in attendance for thirteen days and yet his photographs bear the date of the engagement. Perhaps he had been called to the castle early to be ready when family and diplomatic discussions allowed the engagement to be announced.

quently he achieved a much happier camera-to-subject relationship (44). The young Prince is seated against the dark foliage of the garden with his arm locked over the back of the chair: his hat, with what looks like a sprig of heather in the band, is tucked in the crook of his arm and his stick is firmly planted between his legs. All these details of posture combine to make the Prince look natural and at ease.

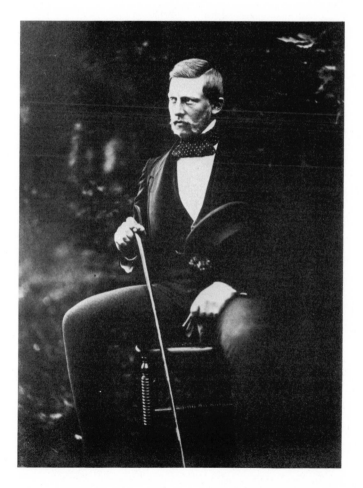

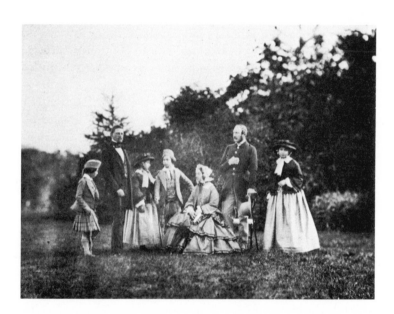

Plate 43. Engagement photograph at Balmoral, 29 September 1855

In addition to the group engagement photographs, Wilson made two studies of Prince Frederick. In these he seems to have overcome the awe he had experienced when photographing the Queen: conse-

Plate 44. Prince Frederick William of Prussia, 29 September 1855

This was the first time that Wilson had been to Balmoral since his separation from Hay. He took every opportunity to capitalise upon his Royal associations. Whereas Wilson & Hay had claimed that they were 'Under Royal Patronage', Wilson now proclaimed (45) that he was 'Photographer to the Queen'.[51] This self-assumed title,

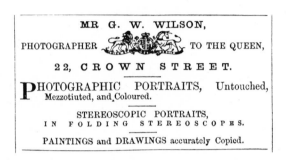

Plate 45. Advertisement for G. W. Wilson, February 1856

which also included the Royal coat of arms for good measure, had no official recognition or approval; it was simply a device to attract custom and prestige. Many tradesmen during the nineteenth century adopted a variety of titles, all of which associated them, more or less, with the Royal Family or aristocracy. Often these claims were entirely spurious. The only official system by which a tradesman could claim a business association with the Royal Family was controlled by the Lord Chamberlain, who was empowered to issue warrants which entitled traders to claim that they were 'By appointment to Her Majesty'. Abuses of the system continued virtually unchecked until 1880 when the Merchandise Marks Act gave the Lord Chamberlain a measure of control and legal redress.

As well as taking portraits which celebrated particular occasions, Wilson was expected to provide landscape views and this he did from the very beginning of his association with Balmoral. Queen Victoria's admiration for the countryside was influenced by a romantically inclined nature and her understanding of the picturesque: she appreciated the various elements that combined to make a 'lovely' or 'magnificent spot'. In one description of a river her analysis has the precision and wealth of detail one expects of a Victorian guide-book. 'The rapid river is overhung by rocks, with trees, birch and fir; the hills, as you advance, rise very steeply on both sides, with rich rocks and corries, and occasional streamlets falling from very high—while the path winds along, rising gradually higher and higher. It is quite magnificent.'[52] Wilson's own visual judgement when photographing the landscape conformed closely to the Queen's. The views he submitted to her in 1857 must have given her pleasure: the following year she requested Wilson to submit a further selection of both large (10×8 in.) and stereoscopic views to choose from (46–49).[53]

After the first of her 'Great Expeditions' with Prince Albert to Glen Feshie and Grantown in September 1860, the Queen, excited by what she had seen, wrote asking Wilson to remember that: 'when he intends making his next photographic tour in the Highlands, Glen Fishie [sic] etc. . . . there are several points of interest to which Her Majesty would like to draw Mr. Wilson's attention.'[54] When the Queen commissioned Wilson to photograph specific scenes her instructions were always clear as to the location, but she left him to choose the point of view. Though the copyright of these commissioned photographs rested with the Queen she invariably gave Wilson permission to use them for commercial publication. It is therefore impossible to say how many of these comissions Wilson undertook, as the origin of the negatives was lost once they entered a catalogue.

The portraits Wilson made were a different matter: they were entirely personal and not meant for publication. In 1861 when the Queen asked for a series of portraits to be made of her Balmoral keepers, wives and children, she insisted that the 'portraits must remain private property'.[55] Her other instructions about the portraits on that occasion were equally clear, stating that the portraits must be 'taken in *groups*, the figures 3 or 4 inches in height . . .'. Wilson carefully complied (50, 51, 52).[56] Other photographers besides Wilson contributed to the Queen's photograph albums of Balmoral life, notably Pierce whose landscapes and portraits show him to have been a talented worker.

By 1863 Wilson's status as a landscape photographer was internationally acclaimed and to keep abreast with the public's demand

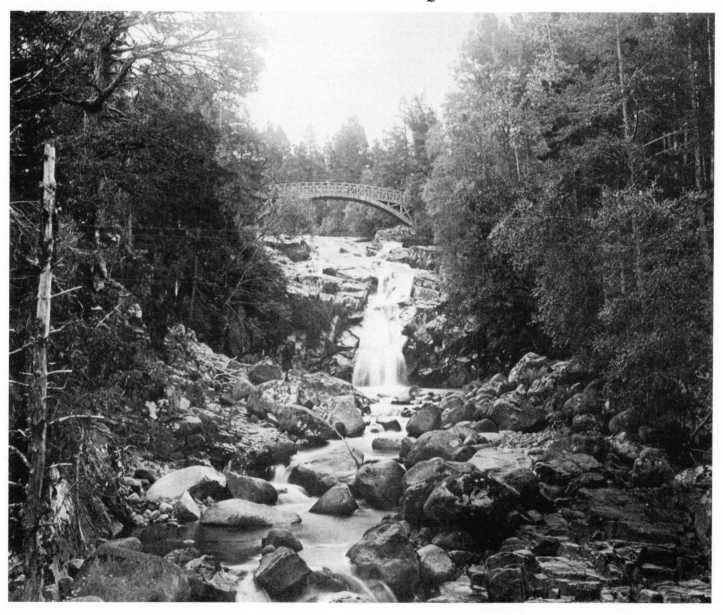

Plate 46. Bridge over the Falls of Garbhalt, September 1857

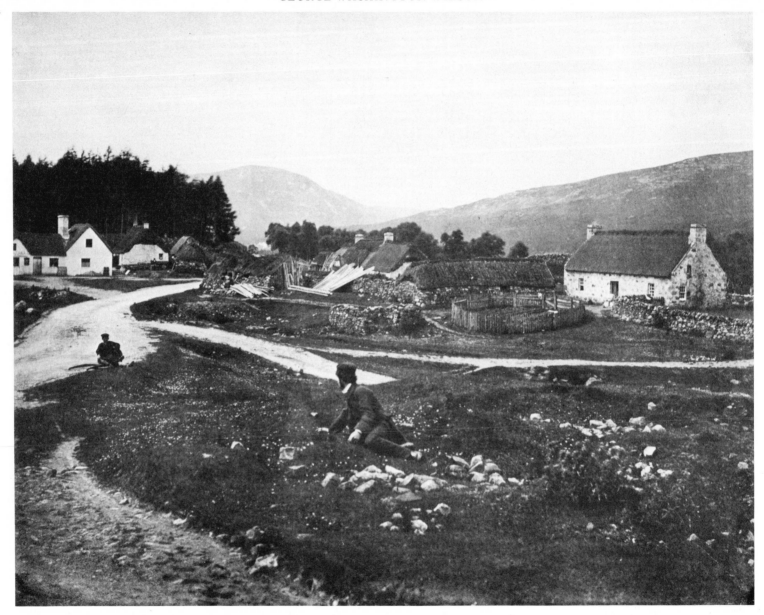

Plate 47. Castleton of Braemar, 1857

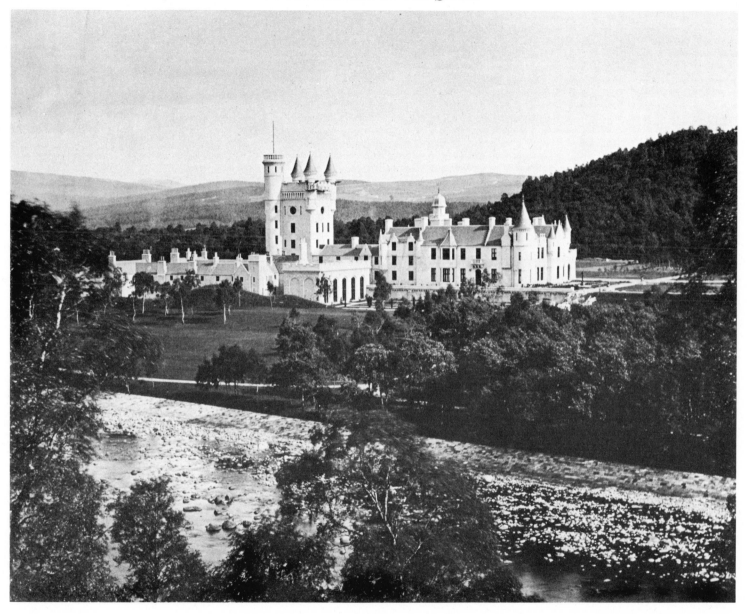

Plate 48. Balmoral Castle, from the opposite side of the Dee, September 1857

Plate 49. Birkhall, c.1857

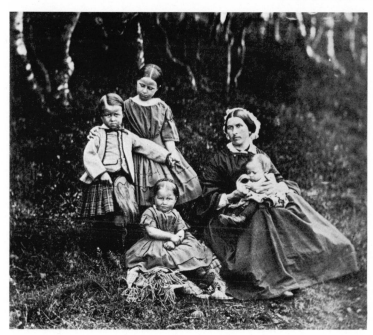

Plate 50. Mrs. Donald Stewart with her children, Mary, Charlie, Lizzie and Albert, 1861

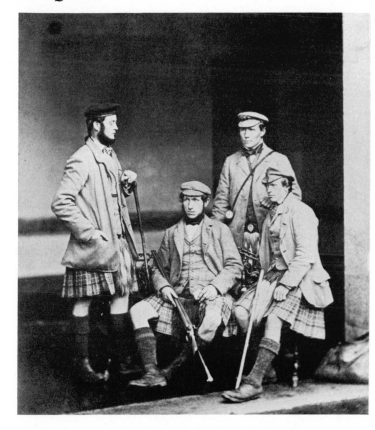

Plate 51. James Smith, W. Kennedy, P. Robertson and Sandy Grant, 1860

for new views he was forced to make extensive photographic tours. At these times his commercial interests could conflict with his duty to the Queen. October 1863 found Wilson on the west coast of Scotland where the mist and rain had made his life a misery and his photography impossible. After several damp, depressing days he reached Gairloch where he met a man who had driven the considerable distance from Beauly to deliver an urgent telegram from Wilson's wife in Aberdeen, who two days previously had received a letter from Balmoral requesting Wilson's presence there. Wilson left early next morning. After a day and a half of travel he arrived home where he smartened his appearance and made ready his plates and chemicals.[57] Wilson knew from the letter that he was to take several portrait groups, but he must have wondered what form these were to take as circumstances had greatly changed at Balmoral since 1861.

The death of Prince Albert of 14 December 1861 caused the Queen immeasurable grief. She went into deep reclusive mourning and her life was now one of introspective widowhood. The former enthusiasm for Balmoral had given way to sad recollection of earlier days when she and Prince Albert had been so happy together in their highland home. So it is not surprising that some of Wilson's photographs were arranged as tributes to Prince Albert. The first (53), taken in the sitting-room of the castle, shows the disconsolate Queen with two of her family in front of a portrait of Albert. The arrangement of the various elements within the photograph is care-

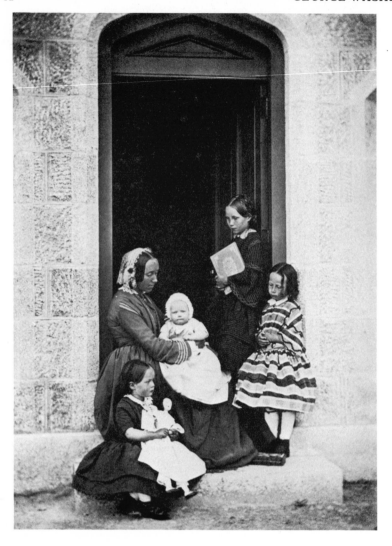

Plate 52. Mrs Duncan and her children, Jessie, Jane, Mary and Alice, 1861

fully contrived: the widowed Queen is dressed all in black, accompanied by two young girls in white—a poignant image. The other photographic tribute (54) is less obvious: it shows the Queen upon her pony Fyvie, flanked by two of her keepers, John Brown and John Grant. The significance of the photograph for the Queen was that it was taken on the second anniversary of her last 'Great Expedition' into the mountains with her husband when she had ridden Fyvie and had been accompanied by Brown and Grant. Permission was granted for its commercial publication: Wilson issued it as a *carte-de-visite* of 'The Queen, Balmoral, 1863' (55) The format, of necessity, had been altered to vertical, with the loss of John Grant. Its context was also altered: now the tribute was to the Queen rather than Prince Albert, and the public, unaware of its original message, bought the portrait because of their sympathy for the widowed Queen. In the first year of its publication, 1864, Wilson sold just short of 13,000 copies of this and a few other portraits made on the same occasion.[58] Of all the portraits that Wilson made of the Royal Family this one, showing the Queen on her pony, enjoyed the widest popularity.

The sales of *cartes-de-visite* of personalities were phenomenal and the large annual production was handled, in the main, by two London firms, A. Marion & Co. and the London Stereoscopic Co. Marions were not photographers but publishers who bought their negatives from those photographers who had been fortunate enough to have sittings from any Victorian with a claim to distinction. J. E. Mayall, of Regent Street, who was renowned for his *carte-de-visite* portraits of the Royal Family, was 'paid upwards of £35,000' by Marions for the publication rights of his negatives.[59] We do not know what Wilson managed to negotiate from Marions for the publication of his 1863 portraits of the Queen. Although it was likely to have been a substantial sum it probably did not approach Mayall's grand figure.

At the hands of Marions the portrait underwent its final metamorphosis: it appeared as the only published photograph showing the Queen with her personal attendant John Brown, about whom there was a good deal of gossip and rumour. It was suggested variously that Brown was either the Queen's morganatic husband or a spiritualist who used his special powers to recall Prince Albert from the dead during seances. It is curious that a photograph originally intended as a widow's tribute should come to be viewed as evidence of indiscretion.

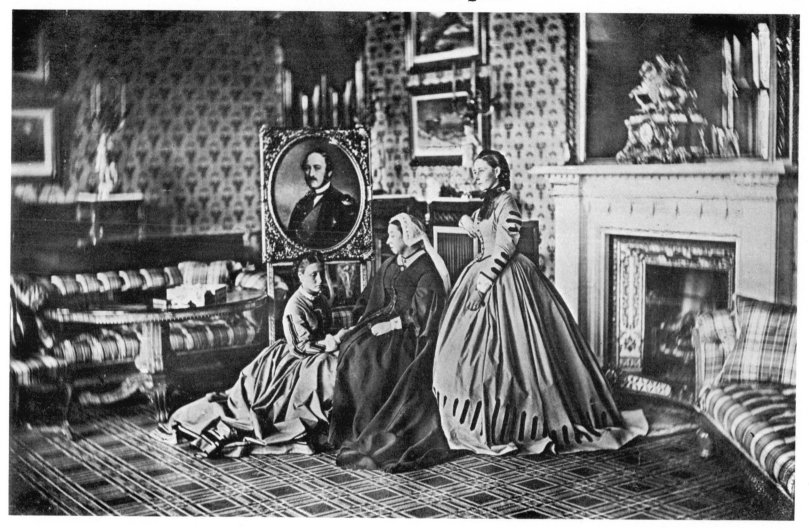

Plate 53. Queen Victoria with Princess Alice and Princess Louise, Balmoral, October, 1863

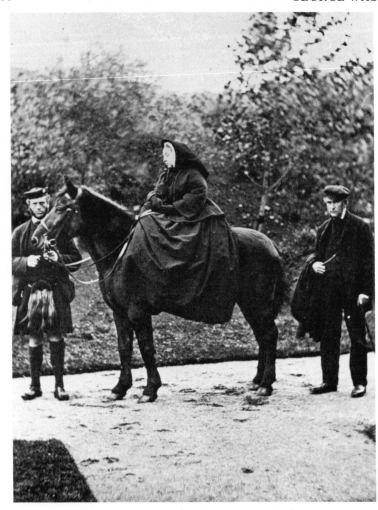

Plate 54. The Queen on 'Fyvie' with John Brown and John Grant, 20 October 1863

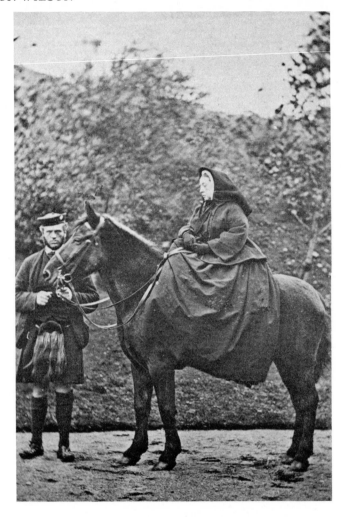

Plate 55. The Queen, Balmoral, 1863

The other photographs taken on the same occasion, October 1863, were informal portraits intended for family albums (56, 57). Prince Frederick William, now Crown Prince of Prussia, and his family were visiting Balmoral—they were staying at nearby Abergeldie—and the Queen, pleased to see her eldest daughter and the grandchildren, asked Wilson to photograph them in their highland dress in the gardens of the castle. These were the last informal portraits that Wilson was to take of the Queen and the Royal Family.

In subsequent years a curious hybrid style emerged that was neither studio nor outdoor in its context but was a curious mixture

of both. Impromptu studios were set up within the castle where the light was good but the background inconspicuous; sometimes a grey screen was used. The first group of portraits showing this change of style were made in June 1865 of Prince Arthur who is shown (58) in front of plain pine boarding with just a table for support. Wilson was recalled to Balmoral for this commission from the south coast of England where he was photographing in the excellent light of early summer. The Royal summons to Balmoral prompted the *British Journal of Photography* to remark 'We trust that this inimitable artist will still be able, before the conclusion of the season, to resume again his nomadic wanderings southward, and accomplish even yet much of the artistic work left unfinished when Her Majesty commanded his presence at her Highland residence.'[60] Clearly, the editor of the *Journal* thought that Wilson would have been better employed taking landscapes than portraits of the Royal Family. Wilson's thoughts on the matter went unrecorded. Such time-consuming journeys, no matter how important, must have been uneconomical: in the same time, he could have made landscape photographs that would have produced many

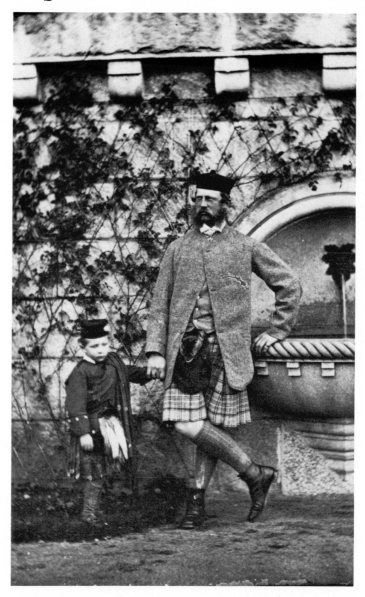

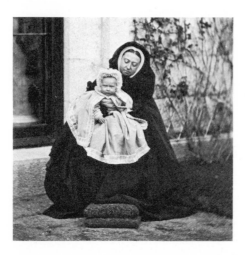

Plate 56. Queen Victoria and her granddaughter Princess Victoria, Balmoral, 1863

Plate 57. The Crown Prince of Prussia and his son Prince William, Balmoral, October 1863

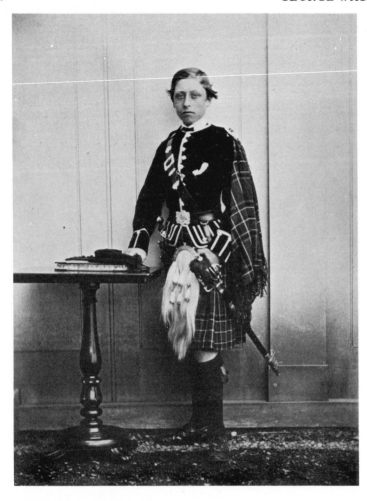

Wilson's work. Evidence for this claim comes in part from a small album from Balmoral inscribed 'All the photographs in this volume were collected and arranged by His Royal Highness The Prince Consort, 1860-61'. This slim but significant album contains sixty-one of Wilson's best views, mounted, one to a page, and carefully annotated by hand.[61] It reveals that Prince Albert was a perceptive admirer not only of photography but of Wilson's productions in particular: no other photographer had his work similarly compiled.

In 1868 the Queen's autobiographical account of her life in Scotland entitled *Leaves from the Journal of our Life in the Highlands* was published. In this many of the line illustrations, especially in the lavish quarto edition, were made directly from Wilson's photographs. Two examples will serve to illustrate the

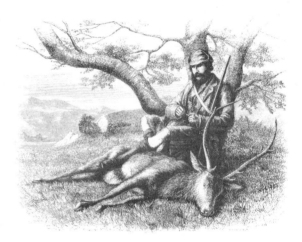

Plate 58. Prince Arthur, Balmoral, June 1865

Plate 59. J. Macdonald, the Prince Consort's Jager, with stag. Wood engraving

times the fee he charged the Queen. We must assume that the Queen thought Wilson's abilities as a photographer sufficient justification for her requiring him to travel several hundred miles when it would have been easier for her to call upon other photographers who were closer to hand and with whom she was equally familiar.

There is no doubt that Prince Albert too had thought highly of

point. On page 61 is a drawing of Macdonald with a dead stag at his feet (59) and this was based upon the photograph taken by Wilson & Hay on 7 October 1854. Apart from some artistic licence with the tree and gun, which were elements borrowed from other photographs of the same date, it comes through almost unaltered. Wilson's landscapes also appear; on page 65 the illustration of 'Falls

on the Garbhalt' [sic] is based upon a Wilson photograph of 1857 (60).

The choice of Wilson's photographs to illustrate a work that was so personal to the Queen, when views by other photographers were also available in her albums, illustrates the high regard in which he was held. Also there must have been an association in the Queen's

Plate 60. Falls of the Garbhalt. Wood engraving

Plate 61. Title page of folio of photographs to illustrate the Queen's Book, 1868

mind between Balmoral and Wilson that made him a natural choice. It was almost a foregone conclusion that *Leaves from the Journal of our Life in the Highlands* would be an immediate best-seller with the public who had never before been given access to the thoughts and emotions of their monarch. Wilson published in the same year, 1868, a folio of forty-two photographs to illustrate the *Queen's Book* (61).[62] These small landscape views—there are no portraits—follow the text so closely that one must conclude that Wilson either had extensive negative files to select from or they were specially taken for the publication. Each 3×4 in. (76×102 mm) view is mounted within a slightly larger printed border and captioned. The folio was sold separately from the text with the intention that they be bound together by the purchaser and Wilson published instructions to the binder with each issue. The retailing and distribution of the folio was later taken over by Marions who sold it for 25s. 0d.

During the late 1860s Wilson's dominance as the photographer at Balmoral began to be eroded as other photographers visited the castle and did work that once would have been Wilson's prerogative. In part this was due to there being greater numbers of professional photographers with large businesses who were prepared to compete vigorously for the patronage of the Royal Family. The Queen's attitude towards photographers and photographs had also changed since the early days when she had expected a photograph to fulfil a personal family need and allowed the photographers to be present at informal gatherings to make a record of the event. By the 1870s photographers had to content themselves with formally arranged groupings. This is particularly evident in a photograph by Wilson (62) where the formality of each person's posture bears no relationship to the occasion—and draws our attention away from the carelessly arranged carpet and grey screen.

Wilson was at this time altering the status of his landscape photography business. The change required a great deal of capital and prestige to make it successful. It was at this critical juncture that Wilson decided to ratify his self-assumed title as Photographer to the Queen by applying to the Lord Chamberlain's office for a warrant appointing him to the Royal Household as one of the Queen's tradesmen. On 17 July 1873 the warrant appointing him to

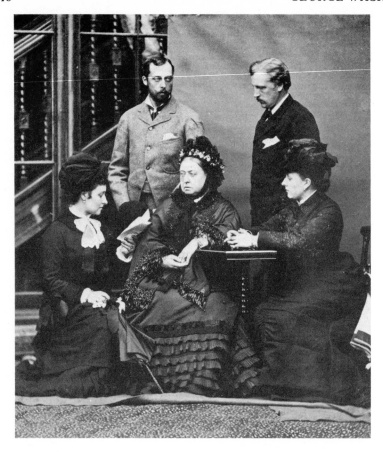

Plate 62. *Queen Victoria, Princess Louise, Prince Leopold, Marquis of Lorne and Princess Beatrice, Balmoral, September 1878*

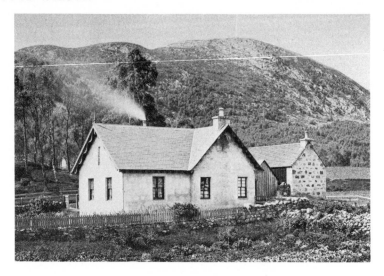

Plate 63. *Monaltrie Cottage, exterior*

Plate 64. *Monaltrie Cottage, interior*

The Place and Quality of Photographer to Her Majesty in Scotland was issued.[63] (This warrant lapsed with Wilson's retirement from photography in 1887, but in 1886 his youngest son, Charles, by then photographer at Balmoral, had made a successful application to the Lord Chamberlain for a warrant which appointed him to his father's position.[64])

Wilson's personal relationship with the Queen is, after so long a time and in the absence of clear evidence, difficult to determine.

Numerous anecdotes were told within the family but over the years these were probably greatly embroidered. He was undoubtedly

helped by his friendship with John Brown whose influence with the Queen was out of proportion to his status as personal attendant. Whenever Wilson wished to be excused from attending Balmoral, or when he sought permission to photograph the State Apartments at Windsor in 1876, it was Brown who successfully laid his request before the Queen. Frequently Wilson received his orders from the Queen through Brown. The orders gained much in the translation: no longer are the instructions precise and clear as in earlier letters, they are now stamped with Brown's individual literary style. 'I am desired by the Queen to send this order for Her at once. Please let me have it at once or as soon as you can to be the same as the others of the same sort which you sent before for the Queen as she wants this the same and send them all together and likewise return the order so as she may see all is done. Both on your part and mine.'[65]

One can only speculate on the degree of influence Brown may have had in what was perhaps the most personal gesture the Queen made towards Wilson when she allowed him and his family the use of one of the Balmoral estate cottages at Monaltrie (63, 64) as their summer holiday home. The Wilsons would move each summer from their comfortable surroundings in Aberdeen to endure the difficulties of living in what was, by comparison with home, a sparsely furnished and entirely rustic dwelling, though it was not entirely without its charms.

The family benefited in other ways from Wilson's association with the Queen. His relationship was unlike those of most other Aberdeen tradesmen who supplied their goods and services to an unseen monarch. As a portrait photographer he was brought into direct social contact with the Queen and the Royal Family: this would not have been lost on his friends and clients. His status in Aberdeen society was advanced by the work he undertook at Balmoral.

Tourism and Photography

Before one can begin to understand Wilson's career as a photographer one has to examine the wider context in which it was set. His landscape photographs were made in response to the demands of tourists who readily bought them as souvenirs. In this respect he was like countless other photographers; but what set Wilson apart was his understanding of the tourists. They journeyed to Scotland in search of a romanticised and picturesque landscape: consequently his photographs were iconic representations of those places most revered in the tourist literature where literary and historical associations reinforced the appeal.

By the mid-nineteenth century tourism was widely established within Scotland. Observers noted that the annual migration from England was like a great wave that engulfed all before it. One Scottish writer in the 1860s noted that 'the summer tide of tourists has receded from our straths and glens townwards to the last drop'[66] leaving behind a silence and a stillness that was more characteristic of the eighteenth century when pleasure-seeking visitors had been a rarity.

Daniel Defoe began a 'tour' of Scotland in 1706 and was resident in Scotland for long periods up to 1710. His enthusiasm was clear and uncomplicated. 'Those who fancy there (are) but wild men and ragged mountains, storms, snows, poverty, and barrenness, are much mistaken: it being a noble country, of a fruitful soil and healthy air, well seated for trade, full of manufacturers by land, and a treasure great as the Indies at their door by sea.'[67] His observations on the scenery were less favourable: he drew attention to the desolation and waste which often surrounded him. In part this view was influenced by the rigours and dangers of travelling through such an inhospitable landscape. It also arose from the English belief that Scotland was full of barren and terrifying landscape.

Following the Jacobite uprising of 1745 the relationship between Scotland and England suffered a setback. The view of the English soldiers garrisoned in Scotland following the rebellion was one of despondency and dread, heightened by isolation and their preconception of Scotland. 'It is a rarity to see the sun', wrote one officer, 'constantly black and misty looking mountains, attended with wintry rains and cutting winds, with violent streams of water rolling down from every part of the mountains.'[68] Another officer went so far as to think 'if an inhabitant of the south of England were to be brought blindfold into some narrow rocky hollow, enclosed with these horrid prospects, and then to have his bandage taken off, he would be ready to die with fear.'[69]

Samuel Johnson, in the company of James Boswell, made an extensive tour of the Highlands and Hebrides in 1773. He had formed his opinion of Scotland before he left London and seems to have chosen a route which best fitted his view that the country was a treeless land 'naked of all vegetable decoration'[70] and where 'a tree might be a show . . . as a horse in Venice'.[71]

tops of the vast mountains soaring above: some of these were naked, but in general covered with wood, except on the mere precipices, or where the grey rocks denied vegetation, or where the heath, now glowing with purple blossoms, covered the surface.[73]

Plate 66. A resemblance of the picturesque Bridge at Hawick, 1776

Plate 65. View from Beinn na caillach in Skie 1772

Thomas Pennant made two tours in 1769 and 1772: When he and Johnson describe the same area it is as if they were in different countries. Johnson dismissed the landscape around Loch Ness as being generally barren and 'towering in horrid nakedness'.[72] Pennant approached the area with more feeling.

After a ride of about six miles reached *Loch-Ness*, and enjoyed along its banks a most romantic and beautiful scenery, generally in woods of birch, or hazel, mixed with a few holly, whitethorn, aspin (*sic*), ash and oak, but open enough in all parts to admit a sight of the water. . . . In many parts we were immersed in woods; in others they opened and gave a view of the sides and

Pennant describes the whole scene as 'picturesque', a term which in the late-eighteenth century had a more particular meaning than it has today. 'Picturesque' was then specifically applied to landscape and was used when scenery was being viewed as a series of pictures. The picturesque code was formulated by the Reverend William Gilpin, MA, (1724-1804). He helped to transfer the word from the realm of art criticism, where it had been used to describe a particular kind of painting, into the real world of nature, where it was used in the examining, analysing and recording of landscape. The ideal scene, for Gilpin, had to include the qualities of light and shade, roughness of texture, irregularity, variety and the power to stimulate imagination. By themselves these aesthetic features were not picturesque but had to work in combinations of two or more to produce the desired effect.

Gilpin wrote several books, published between 1768 and 1808: these had a considerable influence on English taste for many decades. He rejected the traditional appreciation of symmetry and smoothness. His ideas were sufficiently radical to create a controversy over taste. The leading critics of Gilpin, Richard Payne Knight and Sir Uvedale Price, said his ideas were often illogical and that the confusion in his mind between art and nature led to inevitable contradictions. They published treatises in an attempt to

Plate 67. View of a castle on Lake Dochart, 1776

clarify Gilpin's original concepts. In their hands the picturesque involved the man of taste and education in an active relationship with landscape. No longer was it sufficient for him to be a passive wayfarer whose only intent lay in getting from A to B. Instead, it was expected that he would be a sensitive observer of nature and a seeker out of new horizons. Inquiry and curiosity were integral parts of the picturesque ideal, and travel in search of the picturesque became an important motive behind much tourism.

In 1789 in his essay 'Picturesque Travel' Gilpin wrote:

The primary source of amusement to the picturesque traveller is the pursuit of his object, when novelty meets him at every step, and every distant horizon promises a fresh gratification. After the *pursuit* we *attain* the object: we now examine the scenes we have discovered, we examine them as a *whole*, the composition, colouring and light under one comprehensive view. . . . But our supreme delight arises, where a grand scene opens to the eye and arrests every faculty of the soul, when we rather feel, than survey it.[74]

Here Gilpin brings emotion into play, as did the Victorians in their appreciation of landscape. Emotion was an important item in the Victorians' portmanteau of sensibilities and was evident in their literature, music and fine arts. For them, emotions in relation to landscape were measurable and were categorised into the beautiful, picturesque and sublime. Each was at a different plane of response, the lowest of which was the beautiful. It evoked, said Sir Uvedale Price, a feeling of 'love and complacency: it acts by relaxing the fibres somewhat below their natural tone and thus is accompanied by an inward sense of melting and languor'.[75] At the opposite end of the scale was the breathtaking emotion of sublimity. This could, according to a *Handbook of Literature and the Fine Arts* be experienced by observing 'vastness either of form or of power; as in the violent dashing of a cataract, in the roar of the ocean, in the violence of the storm, . . . mere intensity is sufficient to produce the sublime'.[76] In the central and therefore neutral position was the picturesque, which neither stretched nor calmed the nerves, but only aroused curiosity in the viewer, and in nature it was the only category that was surrounded with rules for its better appreciation. To the Victorians the picturesque was a means whereby the visually uneducated could fashion his concepts of natural scenery to a commonly held ideal.

However, in the eighteenth century even Gilpin had found little picturesqueness in Scotland. His impression of the country was traditional and he came upon vast tracts of land entirely 'in a state of nature'.[77] In his opinion the only way to make nature conform to an ideal state was for man discreetly to assist by gardening and 'improving' the scenery. The wild and neglected state of much of Scotland was therefore a barrier to its widespread acceptance and it

lagged far behind the Lake District, the Wye Valley and the West Country in popularity.

One person who effectively realigned English taste and made the natural state of Scotland acceptable was Sir Walter Scott. The deeds and exploits of his historical characters came alive before the lovingly described backgrounds of Scottish scenery. After the publication of *The Lay of the Last Minstrel* in 1805 and *Marmion* in 1808 came the influential and popular *Lady of the Lake* which made its appearance in 1810 and sold 20,300 copies in that year alone.[78]

writing. Two years later Scott acted as master of ceremonies for the first visit by a British monarch to Scotland: the occasion of George IV's visit was surrounded by great splendour. After Scott's death in 1832 many statues and monuments were erected in his memory: the most eloquent of these is the Gothic-inspired Scott monument in Princes Street, Edinburgh (69).

Plate 68. Loch Katrine

Plate 69. The Scott Monument

Scott used the little-known area of the Trossachs and Loch Katrine (68) for the poem's setting. Visitors began to flock there, anxious to see for themselves the scenes so beautifully described. A guide book to the area told in later years how 'there are still some alive today who are able to remember when the first rush of visitors was made by the publication of the "Lady of the Lake", and when the farmer, who had a cottage in the neighbourhood, being somewhat astonished but not displeased that the fashionable world should all at once take possession of his dwelling, converted it into a public house, and from that into an inn'.[79]

In 1820, George IV made Scott a baronet in recognition of his

When the copyright on Scott's novels lapsed during the 1850s there was a renewed spate of publishing which brought edition after edition at ever more competitive prices.[80] It is impossible to calculate how many of these later editions were sold; the early sales (1813, *Rokeby*, 10,000 in three months; 1813, *Rob Roy*, 10,000 in fourteen days[81]) had been considerable. The effect Scott had on tourism was widely recognised and it was through his writings that 'crowds hastened to the north to behold the scenes so admirably delineated by his magic pencil'.[82] Some of the places mentioned in his works were remarkable for their beauty and were already well established as tourist centres, but he also 'conferred on many a spot,

formerly unknown to fame, a reputation as enduring as the annals of history itself'.[83]

Scott's writing helped to form Queen Victoria's expectations of the Scottish landscape before her first visit to Scotland in 1842. Her preconceptions were very different from those of Johnson some seventy years before. Instead of regarding the view with varying degrees of horror and distaste she felt as if the landscape 'did her good'. It was during this first visit that she and her party were being rowed up Loch Tay with pipers playing in the bows and later, after reading the *Lady of the Lake*, one passage reminded her of the voyage:

> See the proud pipers on the bow,
> And mark the gaudy steamers flow
> From their loud chanters down, and sweep
> The furrow'd bosom of the deep,
> As, rushing the lake amain
> They plied the ancient Highland strain.[84]

The Queen's attachment to the country deepened with subsequent visits and played a significant part in her decision to build a summer home at Balmoral. In turn she bestowed a new respectability upon Scotland. Following her example, the aristocracy and newly-rich industrialists also sought residences there. Estates and grouse moors were either bought or leased, and following Prince Albert's example a rash of turreted castles and mansions in the Scottish baronial style of Balmoral soon dotted the countryside. Then the middle classes, anxious to emulate their betters, began travelling North. Only much later in the century, when social change and statutory holidays had affected the patterns of life for the working classes, was it possible for them to visit Scotland in any number.

There is no one clearly identifiable factor which brought about the discovery of Scotland during the first half of the nineteenth century. A number of closely interlinked yet different attractions combined to persuade the English that Scotland had a great deal to offer. Once the trend had been established it accelerated at a phenomenal pace. The influences of the picturesque, Sir Walter Scott and Queen Victoria have all been mentioned: each affected the other in a chronological chain of events. Less apparent is the role played by industrialisation. Between 1813 and 1880 the percentage of the country's population living in towns rose from 20 per cent to 70 per cent. This huge shift in the population created problems of housing and sanitation within the towns and cities. Dwellings were built with scant attention to the need for adequate ventilation, fresh water or sewage systems. These problems were most acutely felt in the new manufacturing centres. The very density of the population, confined in such insanitary conditions, made them vulnerable to the frequent epidemics of cholera, typhus, smallpox and scarlet fever.

Plate 70. 'A court for King Cholera', cartoon from Punch, 1852

The realisation that towns were unhealthy, even dangerous, places to live in convinced the upper and middle classes that periodic escape to the purer air of the countryside was desirable. A new motive for travel was initiated. The effect upon health of climate, change of air and the location of the resort became a matter of importance to the Victorians. The Queen's physician noted how

much 'the influence of climate in the prevention and cure of disease, is, for many reasons, a subject of peculiar interest to the inhabitants of this country'. In particular he was aware of 'the marked improvement of general health, effected by a change from a great city to the country, even for a short period';[85] In the 1850s the discovery of the health-giving properties of ozone, found abundantly in the mountains and at the seaside, added further to the popularity of travel.

To enable a more informed choice to be made, small guide books were published which outlined the major attractions of each resort and, under the heading of climate, gave the mortality rate, com-

Plate 71. Title page 'Where Shall We Go' 1869

paring it with the national average (71). So, for instance, the resort of North Berwick boasted only sixteen deaths per thousand per annum, a rate which was 'a lower proportion than is reached by even the healthiest districts of England'.[86]

The travel guides and handbooks offering such useful advice did not originate in the Victorian period but grew out of publications that dated back to the eighteenth century. At that time road books and itineraries had been published as indexes to the mail and stage coach routes which intersected Britain. In briefest detail they described the routes, turnpikes and coaching inns, but within a few editions this had been enriched with information about country houses, parliamentary returns, natural curiosities and other landmarks, with which knowledge the traveller was able to entertain himself on an otherwise tedious journey.

Equally important to the final form of the guide book were the small books and pamphlets sold in many cities and towns which set out to describe the history of the place and draw attention to the most noteworthy buildings and features. They were often limited in scope, having been written by a local worthy. But they created a precedent of form that was to be taken up by the guide books.

By the 1830s the guide book had blended these two earlier elements and created a new hybrid form of its own. In Scotland its development was furthered by the increasing numbers of tourists who came to rely upon its pages for advice, information and

Plate 72. Title page 'The Scottish Tourist' 1834

Plate 73. Map showing the Third Tour from Edinburgh to the Western Isles 1834

edification (72). This advice, presented in a number of ways, usually took the form of suggesting several 'tours' or 'excursions' which took the tourists 'through the most romantic regions of Scotland, and in each of them give a concise account of as many places and objects as possible, including the picturesque and magnificent scenery both of the Highlands and Lowlands'.[87] These tours became such a feature of travel in Scotland that it was possible to predict with reasonable accuracy where a tourist would visit once he had embarked on a particular itinerary (73).

Further emphasis was given to the notion of 'tours' when organised excursions were offered by travel, railway and steamship companies during the latter half of the nineteenth century. They too sent their excursionists along the established tour routes. Others, with more leisure and money, viewed the scurrying tourists and excursionists with critical superiority before stepping aside to let them pass. One such person was the satirist Cuthbert Bede, who made particular note of one party as they passed him by: 'These tourists left Edinburgh shortly after six this morning, they came by rail to Callender, stopping at Callender for breakfast. They coached through the Trossachs, sailed up Loch Katrine, crossed Rob Roy country, dined at Inversnaid and are now sailing down Loch Lomond. They will reach Glasgow this evening.'[88]

The guide book directed the tourist's attention and suggested the response he should expect of any prospect. Thus in Loch Earn the tourist is told: 'There is nothing trifling or small in the details—nothing to diminish its grandeur of style, and tell us we are contemplating a reduced copy. On the contrary, there is a perpetual contest between our impressions and our reasonings: we know that a few short rules comprehend the whole, and yet we feel as if it was a landscape of many rules . . . a lake to be ranked among those of the first order and dimensions.'[89]

In describing other locations the authors fictionalised the scene. For instance, in wild and rocky places the tourist was expected to imagine the 'most fantastic forms; some like pointed spires, others suggesting the idea of vast architectural ruins or impregnable battlements', or, 'The tourist might be tempted to suppose that here the *Titans* had contended with the gods, and that the hills and hillocks

are the fragments of mountains torn from their deep rooted foundations, to be hurled at their celestial adversaries.'[90] (74) Other publishers relied extensively on 'Traditionary Historical and Literary illustrations, by which a recollection of the scenery will be more permanently fixed in the memory of the tourists, than by any original description of its features which the author could himself have given'.[91] This was particularly true of A. & C. Black, Edinburgh, who, as copyright holders of Scott's works, drew heavily on his descriptions of history and landscape for their own guide books.

Plate 74. The Quiraing, Skye

Whereas landscape excited one kind of attraction for the tourist, equally strong was the interest in buildings, especially if they had Gothic tendencies. Very often these castles, cathedrals, abbeys, and such like, were in a state of ruin, in which case they could be viewed as a monument rich in historic associations, and as picturesque ornaments. For example, the ruined abbey at Arbroath (75) was said to be of 'the most picturesque description, consisting of towers, columns, Gothic windows, cloisters, staircases, &c. all exhibiting the effects of time and the ravages of religious zeal'.[92] In the cities and towns the tourist could place himself with equal confidence in

the hands of the guide books whose street maps were marked out with 'walks' in lines of differing colours. The routes of these were chosen in the belief that 'the most convenient way of imparting

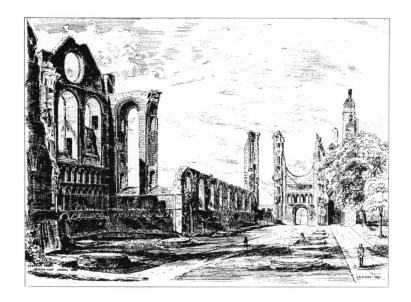

Plate 75. Arbroath Abbey

information to strangers is to select a particular district of the city to be perambulated, describing the objects of interest on the way'.[93] In Edinburgh four separate walks were indicated; in Glasgow, three. In both cities the tourist assiduously following the routes would have been brought to every notable building, park and monument in turn.

The guide books offered little practical advice about the climate and the proper dress for walking. Nor did they give any warnings about the varying standards of accommodation, which in out of the way places could sometimes be exceptionally poor. Brief mention of the scale of charges in hotels and for conveyances was sometimes included, together with warnings about the monopolies and extortions employed by the Scots to prise money from the unwitting.

These guide books were most influential in determining the

pattern of tourism, not only in Scotland but in the rest of Britain. Another factor that, in a very practical way, determined the route taken by tourists was the provision of adequate transport. From the very outset the success of tourism depended upon transport. In the nineteenth century the tourists' choice of conveyance changed with the decade in which they were travelling. At the turn of the century there were only two alternatives to be considered, the stage coach and the sailing packet, neither of which offered much by way of comfort or speed. By the 1830s many of the major roads had been made good, allowing some coaches to achieve an average speed of nine miles per hour. But the stage coach was expensive, with gratuities expected on every occasion. The monopolies held by coaching inns kept the price of accommodation and food disproportionately high (76).

THE MAIL TRAIN.

SWELL. "*Haw!—He—ar! What's-your-Name! What Time do we Arrive at Aberdeen!*"
GUARD (snappishly). "7.10."
SWELL (making himself quite at home). "*7.10! Haw!—Well then, let me have my Boots, and Call Me at—Haw—6.45.*"

Plate 76. Cartoon from Punch, 1861

The shipping companies operating the coastal routes around Britain offered the would-be tourist a cheaper and less arduous

alternative. The accommodation was more spacious and if the weather held fine a sea voyage could be most enjoyable. On the east and west coasts of Britain there were numerous ports of embarkation, though in Scotland it was usual to dock at Glasgow, Leith or Aberdeen. With the introduction of steamships in the 1830s both comfort and speed were increased and there was considerable movement of passengers along the coast.

During the 1840s railway companies began to lay a network of lines throughout Britain: over the next two decades this became a comprehensive transport system that ousted the stage coach and seriously challenged the steamship companies. Geography and financial caution at first confined railway building in Scotland to the heavily populated Central Lowlands between the Forth and the Clyde where its use was local and small-scale. The natural barriers of gradient and a deeply indented coastline made expansion difficult. It was not until 1848 that the Caledonian Railway Company opened their West Coast route. Two years later the North British Railway Company opened their own, faster, more direct East Coast Line: this had been made possible by the bridging of the Tweed at Berwick. Both companies, by laying down their

tracks over difficult terrain at great expense, had made it possible for a passenger to make a journey from London to Scotland without a break. This initiative on the part of the railway companies made possible the tourist invasion of Scotland. Despite the lower prices offered by the steamship companies, tourists turned in their thousands to the railways (77).

Linked with these developments was the introduction of organised tours and excursions, when a company took care of all the

CALEDONIAN RAILWAY.

ROYAL MAIL ROUTE
BETWEEN
ENGLAND AND SCOTLAND.

DIRECT TRAINS run to and from LONDON (Euston), BIRMINGHAM, LIVERPOOL, MANCHESTER, LEEDS, BRADFORD, &c., with DUMFRIES, PEEBLES, EDINBURGH, GLASGOW, PAISLEY, GREENOCK, and the WEST; also, STIRLING, PERTH, DUNDEE, ABERDEEN, INVERNESS, and the NORTH.

A Sleeping Saloon is run Nightly between London and Glasgow.

To the Firth of Clyde and the West Highlands of Scotland.

The Company's Trains run Daily from Edinburgh, Glasgow, &c., to Greenock, in connection with the Steamer "Iona," for Dunoon, Innellan, Rothesay, Kyles of Bute, Tarbert, Oban, Iona, Staffa, Ballachulish, Glencoe, Fort-William, Caledonian Canal, Falls of Foyers, Inverness, Isle of Skye, &c.

Also, in connection with other Steamers on the Clyde, for Loch-Long, Loch-Goil, Inveraray, Kilmun, Blairmore, Arran, &c.

To Stirling, Perth, Aberdeen, Inverness, and the North Highlands of Scotland.

Trains run from Carlisle, Edinburgh, Glasgow, &c., to the North, in connection with Coaches from Callander for Trossachs, Loch-Katrine, and Loch-Lomond; from Crieff and Lochearnhead for Circular Tour via St. Fillans and Loch-Earn; from Killin and Aberfeldy for Circular Tour via Loch-Tay and Taymouth Castle; also, Tours via Dunkeld, Pitlochry, Pass of Killiecrankie, Blair-Athole, Inverness, Aberdeen, Isle of Skye, &c.; and from Tyndrum for Loch-Awe, Dalmally, Inveraray, Taynuilt, Oban, Iona, Staffa, Glenorchy, Blackmount Deer Forest, Glencoe, and Fort-William.

Tourists from England may break their journey at Beattock for Moffat, and at Lanark for Falls of Clyde, either in going or returning.

For particulars, see the Company's Time Table and Programme of Tours.

CALEDONIAN RAILWAY COMPANY'S OFFICES, JAMES SMITHELLS,
GLASGOW, 1874. *General Manager.*

Plate 78. Advertisement for the Caledonian Railway, 1874

MR. BRIGGS, FEELING THAT HIS HEART IS IN THE HIGHLANDS A-CHASING THE DEER, STARTS FOR THE NORTH.

Plate 77. Cartoon from Punch, 1861

travel arrangements and accommodation in return for a fee. This novel idea was initiated by Thomas Cook in 1836. His first excursion booked a party of teetotallers on a special train for the short journey between Leicester and Loughborough: till then railway passengers had not been booked *en masse*. Then Cook began to

organise more elaborate excursions and tours. One was to take a party of 350 from Leicester to Scotland in 1846 before the West Coast railway line had been laid down. This necessitated an overnight voyage from Fleetwood to Ardrossan where they took a train to Glasgow. On arriving at the station they were greeted by a band who accompanied the party to the Town Hall where the civic authorities greeted them with a warmth that recognised the importance of this pioneering group of excursionists.[94] Cook was soon providing some 5000 holidays annually and by 1861 the whole system of tourist tickets for Scotland was in his hands with the railway, shipping and coaching companies giving him special concessions. However in 1863 these companies decided to arrange their own excursion tickets (78).

By 1873 Murray's guide book could report that 'railways have intersected pretty well nigh all the lowland and coastal districts and are now penetrating into the recesses of the Highlands wherever there is the remotest chance of traffic, present or future'.[95] As the railway companies were extending their networks, so the steamship companies were consolidating their routes to provide a comprehensive system that made the remote islands and fishing villages of the West Coast accessible to tourists.

The increased passenger traffic stimulated by the efforts of the railway and steamship companies, far from bringing coaches and other transport into decline, created new opportunities for their local use. This secondary system of transport was much more haphazard and ill-defined, but it was the coaches, carriages, gigs and traps that allowed the tourist to escape from the busy confines of the termini into the surrounding countryside.

With equal vigour local businessmen and entrepreneurs invested in refurbishing, extending and building hotels and shops. There followed a building boom that produced a frenzy of activity throughout all the towns and popular districts of Scotland as contractors hastened to finish the work ready for the new season.

The planning of these developments was largely uncaring and took little account of the aesthetic qualities of the countryside. Hotels were erected where they could command the finest vista, or could offer the only accommodation in the district, and in so doing

often irrevocably changed the original nature of the view they were built to exploit (79). This seemed to matter little as the comforts offered by these hotels helped the tourists turn a blind eye to the way in which the landscape was disfigured. In the cities and larger towns the changes were less apparent and the new buildings less in-

Plate 79. The 'Locheil Arms' Banavie, on the Caledonian Canal, c.1862

trusive, but the expansion of the number of hotels was none the less dramatic. During the twenty-five year period from 1852 to 1876 the number of hotels advertising in the Black's guides for those years doubled in number. In addition, there must have been numerous unadvertised, smaller private commercial and temperance hotels as well as guest houses that opened seasonally. The trade of these smaller establishments was entirely dependent upon tourism.

All tourists seem to want souvenirs of their travels. The Scottish souvenir manufacturers provided a dazzling array of tartans that represented every known and unknown clan. The tartan motif became the height of fashion and even Parisian couture houses were obliged to design costumes that made use of it. Tartan was also used to decorate everyday objects such as inkstands, envelope cases and work boxes (80).

Souvenirs were thought to be most successful when they related

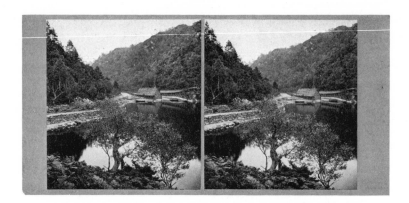

Plate 80. Advertisement for souvenirs, 1862

Plate 81. Stereoscopic Card, Loch Katrine, The Boat House No. 20

in some way to the place of their origin, for then the owner could reflect nostalgically on his or her experiences. No souvenir was more capable of ensuring this than the stereoscopic view that was finding its way on to the market during the 1850s. Stereoscopic photographs, like human vision, relies for perception of space and depth upon the brain receiving information from twin images set slightly apart: These merge into a single three-dimensional, spatially correct image (81).

Sir Charles Wheatstone invented a device in 1832 which artificially introduced depth into two specially drawn pictures. Wheatstone's rather cumbersome instrument was used for viewing photographs but was never really popular. In 1849 Sir David Brewster designed a much neater and more compact instrument that could easily be held in the hand. His viewer was a small wooden box (82) with lenses at one end, and the other was a slot for the card on which the photographs had been mounted side by side. In the top of

the viewer was a small mirror glued to a flap which, when angled correctly, reflected the light onto the photographs. This arrangement of viewing stereograms remained, with slight modifications, improvements and variations, the basic principle of stereoscopes for many years. The popularity of the stereoscope was so great that no home was thought to be complete without one and the enthusiasm with which it was received amounted, by the late 1850s, to near

Plate 82. Brewster stereoscope

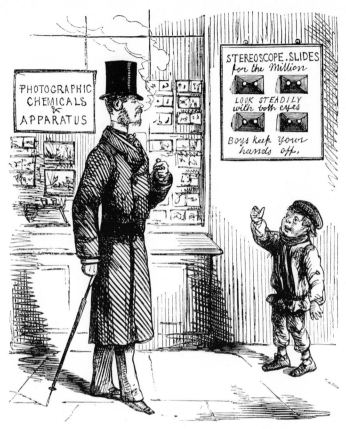

PHOTOGRAPHIC
CHEMICALS
&
APPARATUS

STEREOSCOPE SLIDES
for the Million

LOOK STEADILY
with both eyes

Boys keep your
hands off.

Boy. "I SAY, SIR—HEAVE US UP TO HAVE A LOOK AT THEM PICTURES!"

Plate 83. Cartoon from Punch, 1856

mania (83). The role of the stereoscope as an instrument of education and persuasion was equally valuable.

Many fireside travellers learnt to enjoy the delights of Scotland and elsewhere without stirring from their chairs: others were no doubt inspired by the scenes they bought to make the journey to see the reality for themselves.

The impetus given to Scottish tourism by the direct rail link to England came at a time when photography was receiving its

greatest stimulus with the introduction of the wet-collodion process in 1851. Only with this process could photography respond to the commercial opportunity that presented itself with tourism. Whereas earlier photographic processes had been successful in their own particular ways they all had severe limitations that effectively restricted their commercial application. The wet-collodion process overcame many of the disadvantages and combined most of the advantages of the earlier processes. It was eagerly taken up by photographers and once it was perfected by circa 1852 it allowed them the opportunity to develop the scope of their business. It was found to be well suited to landscape photography, which in turn allowed the public demand for stereoscopic views to be fully exploited.

The development of Wilson's career as a photographer has to be seen in the context of these developments in photography as well as in the context of tourism and the prevailing aesthetic attitudes. When he decided to include photography in his repertoire in 1852 it is more than likely that he was responding to the introduction of the wet-collodion process. Similarly, when he began making commercial landscape views they were taken for the stereoscope which was then beginning to gain widespread popularity. These responses suggest the commercial awareness and sharp judgement that were to give his company a dominance over competitors.

It has been noted in an earlier chapter that Wilson considered himself an artist *and* photographer, making no distinction between the two roles. In this he epitomised many of the first generation of photographers whose success was more often than not attributable to their artistic backgrounds. Because artist and photographer are so closely interwoven in Wilson's his various photographic tours must have been as rewarding to him as painting trips were to an artist. The discovery of Scotland through his photographic tours was, much of the time, as novel an experience for him as for tourists. The combination of artistic concern and novelty of experience gave Wilson's photographs a vigour that became his hallmark. *The Art Journal* was impressed by his 'astonishing industry; an amount of zeal and activity we imagine entirely unsurpassed. Obviously he is an enthusiast in his art, to whom its

NOW WE DARE SAY YOU WONDER WHAT THE DEUCE THIS MEANS. THE FACT IS, THAT SMITH
AND TOMKINS HAVE GOT A PLACE IN SCOTLAND THIS YEAR, AND THEY ARE DOING ALL THEY
POSSIBLY CAN TO ACCUSTOM THEMSELVES TO DIZZY MOUNTAIN HEIGHTS, AND TO GET THEIR
FACES AND LEGS THE PROPER TONE FOR THE NORTH.

Plate 84. Cartoon from Punch, 1861

results are its rewards.' Further to distinguish him from others they point out that he had 'not been stimulated solely, or even chiefly, by commercial enterprise'.[96]

To begin with, he was careful in his choice of subject matter, concentrating his efforts on the most popular scenes in the most frequented areas of Scotland. But this changed with the growing financial security of his business. He ventured into the remoter, unexplored regions of Scotland where tourist and photographer alike were unknown. In so doing Wilson had his own effect upon tourism for through his photographs he encouraged others to undertake the journey in search of the beauty and grandeur he had revealed to them.

CHAPTER SIX

The Early Landscape Photographs

Wilson is often dismissed as being just another photographer who exploited the mass market. In this respect he was certainly his own worst enemy, for by the year 1880 he had established a company that was one of the largest, if not the largest, publisher of topographic views in Britain. Annually hundreds of thousands of prints were distributed to all parts of the civilised world and it is the flotsam and jetsam of this that we are left with today—prints from numerous collections and countless albums in which he appears alongside his competitors, Bedford, Frith and Valentine. It is not easy to approach so incoherent a body of work and make chronological or aesthetic sense of it.

Wilson's career as a photographer divides itself neatly into two phases, each approximately twenty years long, with the year 1873 as the mid-point. The difference between the two phases is marked by the change in Wilson's attitude to photography. Initially, the novelty of the experience and the vigour of his enthusiasm created a close bond with the medium which prompted him to experiment and innovate with it. By 1873, when his reputation was made and his company well-established, he was moving into a new relationship with the medium: he was now more concerned with innovations in communication. There is a remoteness about this later period, and little is revealed about Wilson other than his involvement with company affairs. The transition had taken place from artist and photographer to photographer and businessman.

Plate 85. Advertisement for G. W. Wilson, 1855

This chapter covers the period between 1854 and 1864. In 1854, when Wilson & Hay were running their portrait studio in the Guestrow, they were prepared to venture out of the studio to undertake commissions, photographing 'Landscapes and Gentlemen's seats'[97] which of course included the important commission for Prince Albert at Balmoral. The following year, after the partnership

with Hay had been dissolved, Wilson advertised in the Aberdeen press (85) that he was able to supply the public with 'Views of Castle Street, Bridge of Don, Ballater, Elgin cathedral &c., 3s. 6d. each'.[98] The subjects listed are local and would have appealed to both Aberdonians and tourists. For the first time there is an indication that Wilson was making landscape views on a speculative rather than commissioned basis. One photograph from this early period shows Ballater (86) nestling under a pine-covered slope with

Plate 86. Ballater, 1855

the wooden bridge coming in from the right. The handling of the subject reveals none of the care and consideration for lighting and foregrounds that were to become so much a part of his style. The only device is the alternate horizontal banding of light and dark that divides the picture into thirds.

1856 saw Wilson's real entry into commercial landscape photography with the publication of his first list of stereoscopic views. This new departure shows that he considered this form of pub-

lishing to be a useful, secondary source of revenue that would supplement his main income derived from portraiture. It was a new departure in another sense in that the format of the photographs had now been scaled down for the stereoscope. On Wilson's list (87) were 44 views taken in sixteen locations in and around Aberdeen, the most distant subjects being Braemar and Elgin.[99] What is revealed by the list is the conscious way in which Wilson used his camera with the interests of mid-nineteenth century tourists in mind and photographed the most popular tourist haunts in the area. There was a rich variety of subject matter in what he chose, ranging from castles and cathedrals to bridges and waterfalls (88, 89).

George Walker, stationer, bookseller, and friend of Wilson tells us that in 1855 'stereoscopic views began to appear at this time, & Wilson experimented. I went with him one day, & took a view of the Old Mill at Cults, which though a poor subject, turned out a tolerable stereoscopic view, & on seeing it finished, I astonished him by a large order for them; & as they were then sold at 2/- each, he continued to experiment upon them.[100] The friendship between the two men was cemented by commercial interest; Walker's shop became the major retailer of Wilson's photographs in Aberdeen. Others were sold in Edinburgh by James Wood whose stationery and general photographic depot was on the main tourist thoroughfare of Princes Street.[101] Even in 1856, with only two years' experience of landscape photography, Wilson had already determined the course that his work was to follow. Primarily, he was going to appeal to tourists and take every opportunity to place his work before them by establishing a network of retail agencies throughout Scotland in stationery, book, and fancy-goods shops. These agencies were also to be found in hotels, on steamships and on railway bookstalls. Within a few years this network had spread— with Wilson's fame—beyond Scotland so that by the 1860s his photographs could be bought throughout Britain.

At this time Wilson was also successfully promoting his portraiture, and the work produced by both branches of his photography were dealt with at his home, studio and workrooms in Crown Street, where the strain upon the limited facilities must have been severe. The landscape photography was largely dependent

STEREOSCOPIC VIEWS,

By G. W. WILSON.

r in my kesenion r.t

1.—CASTLE STREET & UNION STREET,
Aberdeen.

2.—KING STREET,
Aberdeen.

3.—MARISCHAL COLLEGE,
Aberdeen.

4.—EAST CHURCH.
Aberdeen.

5.—UNION BRIDGE,
Aberdeen.

6.—GORDON'S HOSPITAL,
Aberdeen.

7.—FREE CHURCHES and DENBURN,
Aberdeen.

8.—COUNTY BUILDINGS,
Aberdeen.

9.—CATHEDRAL, OLD ABERDEEN,
From the South-East.

10.—CATHEDRAL, OLD ABERDEEN,
South View.

11.—CATHEDRAL, OLD ABERDEEN,
Entrance, with Trees.

12.—CATHEDRAL, OLD ABERDEEN,
West Towers.

13.—KING'S COLLEGE,
Old Aberdeen.

14.
THE BRIG O' BALGOWNIE, on the DON,
Near Aberdeen.
FIRST VIEW.

15.
THE BRIG O' BALGOWNIE, on the DON,
Near Aberdeen.
SECOND VIEW.

16.
THE BRIG O' BALGOWNIE, on the DON,
Near Aberdeen.
THIRD VIEW.

17.
THE BRIG O' BALGOWNIE, on the DON,
Near Aberdeen.
FOURTH VIEW.

18.—THE LINN OF DEE,
Aberdeenshire.
FIRST VIEW.

19.—THE LINN OF DEE,
Aberdeenshire.
SECOND VIEW.

20.—FALLS OF CORIEMULZIE,
Aberdeenshire.

21.—FALLS OF THE QUOICH,
Aberdeenshire.

22.—FALLS OF THE GARR-VALT,
Balloch-bowie Forest, Aberdeenshire.

23.—FALLS OF THE GARR-VALT,
Balloch-bowie Forest, Aberdeenshire,
FROM THE FOG-HOUSE.

24.
MAR LODGE & CORIEMULZIE COTTAGE,
Aberdeenshire.

25.—MILL ON THE CLUNY,
Castletown of Braemar, Aberdeenshire.

26.—BRIDGE ON THE CLUNY,
Castletown of Braemar, Aberdeenshire.
BEN-AVON IN THE DISTANCE.

27.—BRIDGE ON THE CLUNY,
Castletown of Braemar, Aberdeenshire.

28.—MILLS ON THE CLUNY,
Castletown of Braemar, Aberdeenshire.

29.—BRAEMAR CASTLE,
Aberdeenshire.

30.—ON THE GARR-VALT,
From the Bridge above the Falls.

31.—ON THE GARR-VALT,
From the Bridge above the Falls.

32.—ON THE CLUNY,
Castletown of Braemar, Aberdeenshire.

33.—CASTLETOWN OF BRAEMAR,
From Craig-Coynach.

34.—FIRS IN BALLOCH-BOWIE FOREST,
Aberdeenshire.

35.—BALMORAL CASTLE,
South-West View.

36.—BALMORAL CASTLE,
North-West View.

37.—ABERGELDIE CASTLE,
Aberdeenshire.

38.—BALLATER, ON THE DEE,
Aberdeenshire.

39.—ELGIN CATHEDRAL,
Choir.

40.—ELGIN CATHEDRAL,
Chapter-House.

41.—ELGIN CATHEDRAL,
Transept and West Towers.

42.—ELGIN CATHEDRAL,
St. Mary's Aisle.

43.—ELGIN CATHEDRAL,
West Doorway.

44.—ELGIN CATHEDRAL,
West Towers from Choir.

SOLD BY A. BROWN & CO., 77, UNION STREET, ABERDEEN.

*Plate 88. The Brig o' Balgownie, on the Don
near Aberdeen, c.1856*

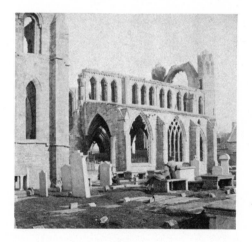

*Plate 89. Elgin Cathedral, St. Mary's Aisle,
c.1856*

Plate 87. List of Stereoscopic Views, c.1856

upon the portraiture: the steady income derived from portraiture enabled Wilson to meet the expenses of his landscape work, and one of the heaviest of his expenses would have been the speculative production of prints against future sales. In portraiture there was rarely any money tied up in stock awaiting purchase. Each stage of the transaction, from the making of the negatives and supplying proofs to the ordering of the final prints, would normally have been paid for separately. With stereoscopic views the situation was entirely different: orders could not be executed on demand. Instead, Wilson had to estimate the future sales of each view he listed, and then print and mount sufficient numbers to meet a predicted demand.

To appreciate the pressures that the publishing of stereoscopic views imposed upon Wilson's printing facilities, suppose he printed only one hundred copies—and this would have been a conservative number—from each of the negatives he listed in 1856. He would therefore have been involved in making nearly four thousand five hundred prints. If each print required ten separate and labour-intensive stages to get it to completion, with only 44 negatives there were approximately 45,000 operations necessary to prepare them for sale.

Wilson must have soon realised that if he were to be economical in the use of his capital, he would have to expand to a stage where he could employ staff as sensitizers, printers and retouchers, for beyond a certain point the effort required at each of the ten stages of print production did not increase in direct proportion to the number of negatives being printed. The answer lay in having even more views for sale. Conscious of this need Wilson, in search of picturesque Scottish scenery, made extensive tours in the following years to regions frequented by tourists.

In order to encourage sales, Wilson began a campaign that used exhibitions and photographic journals as platforms for promotion. These two platforms appealed to different audiences: the exhibitions were concerned with seeking recognition from his peers while the reviews of the work he submitted to the photographic journals for criticism were directed towards the commercial market.

The recently formed Photographic Society of Scotland held its first annual exhibition in Edinburgh during December 1856 and Wilson had several works accepted, though none of them was particularly memorable, judging by the reports. The following year he was fortunate in having his work accepted for the Manchester Art Treasures Exhibition which was opened by Prince Albert on 5 May. At this colossal assembly of the fine arts where no fewer than three thousand paintings were on display, photography claimed its place as a relative newcomer. As this was the first important national exhibition since 1851 to which photographers had submitted work, those finally chosen represented the leading workers of the period. Wilson's appearance among such eminent photographers indicates his ascendancy, but the pleasure of being exhibited was probably marred by the adverse comments on his work made by critics in the photographic press. One journal, reviewing his 'Rubislaw Quarry', wished that his prints had been larger and more in keeping with the subject; it also noted that his printing was inconsistent and poor.[102]

Compared with Roger Fenton's Scottish subjects, taken during 1856, and exhibited both at Edinburgh and Manchester, Wilson's photographs must have seemed somewhat feeble. Fenton's photographs were usually large in size (approximately 23×28 cm) and grand in their manner, everything about them being faultlessly executed. One can only speculate about the extent of Fenton's influence upon Wilson, but it is easy to imagine how the photographically immature Wilson would have been impressed by the fine studies of places he knew so well and had photographed himself for the stereoscope. Certainly, during 1857 there was a noticeable change in his work that reveals itself in the views he made during September for Queen Victoria of the same subjects exhibited earlier by Fenton (90, 91). Examining these photographs one senses an affinity with Fenton. Superficially they are linked by the large size (19.6×24.7 cm) and by the competent handling of the prints' tonal range. At a deeper level there is something more: both men responded to light in an intuitive way that declared their artistic training, and compositional devices used by Fenton which involved carefully organised foregrounds and balanced forms were closely mirrored in Wilson's photographs. The attitudes of both men to photography, and the ways in which they both approached their

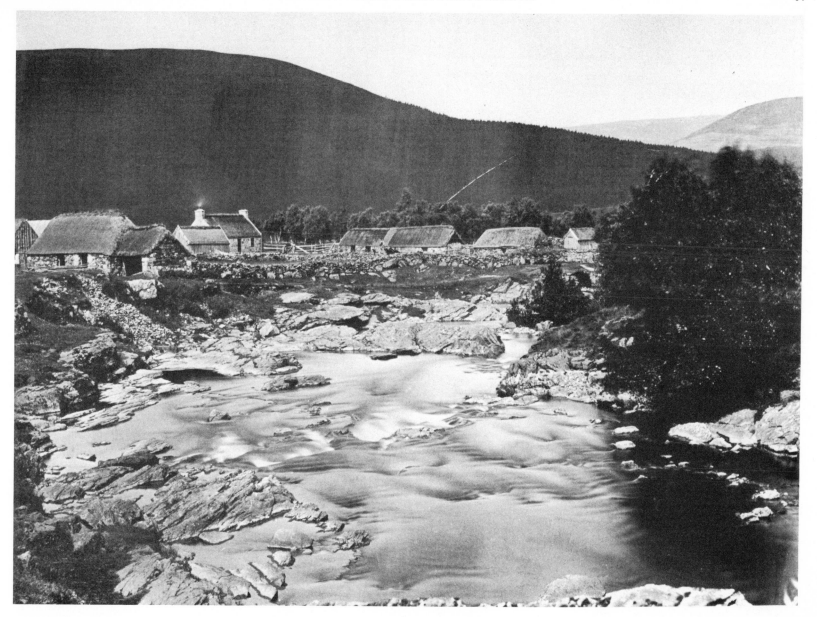

Plate 90. A view near Castleton of Braemar, 1857

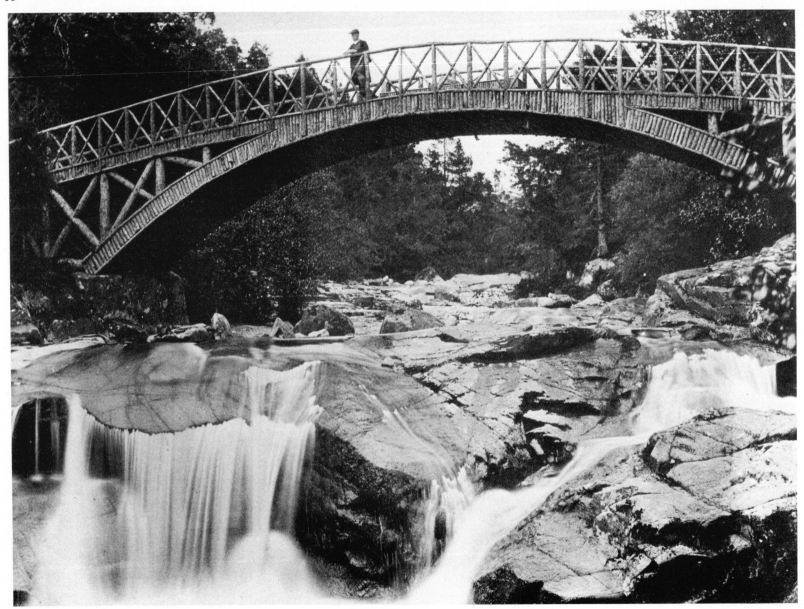

Plate 91. Bridge over the Falls of the Garbhalt, Balloch Buie, 1857

subjects, architectural and landscape, are similar. So similar did they become that in 1861 one reviewer declared that Fenton's photographs were 'somewhat in the style of Mr. Wilson's'.[103]

Another photographer who also exhibited at Edinburgh and Manchester and who greatly influenced Wilson was Gustav Le Gray. Coincidentally Le Gray and Fenton started their artistic lives together as students in Delaroche's Paris studio. Le Gray's style was, however, altogether different from Fenton's and the photographs that caused so much wonder and excitement were his sea and sky studies (92) which first appeared in 1856. These photo-

Plate 92. Seascape with sailing vessel by Gustav Le Gray

graphs showed a dark but sparkling sea under a sky billowing heavily with clouds that were illuminated by the sun from behind. This magical effect had never been attempted before and one critic declared the prints to be 'the most successful seizure of water and cloud yet attempted'.[104]

Such bold and dramatic photographs, said *Photographic Notes*

about the Photographic Society exhibition, were bound to 'do immense good by stimulating photographers to aim at a higher class of subjects than field gates, stiff trees, and stuck up country mansions. The sentiment of landscape scenery lies in the sky and distances, and in atmospheric effects. Those who doubt this may work for another season at the old class of subjects, but they will find, unless we are mistaken, that the public will have read Ruskin and studied Turner to advantage and that subjects which include natural sky and distances will be most appreciated. . . . Fame is to be earned, and money too, by following up the hint given to us by Le Gray.'[105] Wilson took this advice and followed Le Gray's example, never blindly imitating, but preferring to use the simple idea of photographing the sea and sky against the light as a starting point for his own experiments. As Le Gray's working methods were not published in Britain at that time, Wilson would have had to work from his own experience and knowledge.

He had been taught the collodion process by the Edinburgh portraitist, J. G. Tunny, in 1852/3. It was Tunny's normal procedure to develop his negatives in a solution of photosulphate of iron rather than in the widely used pyrogallic acid which was the preferred developer of the period. Using iron developer had the combined advantages of increasing the negative's sensitivity whilst enhancing the shadow and highlight detail. Early reviews suggested that Wilson used the iron developer exclusively, a misconception he corrected in a letter to the editor of *Photographic Notes*: 'When my subject is well lighted, I prefer pyro-gallic acid as a developer, but when there is great contrast in the picture, and an undue portion of deep shadow, then iron is much to be preferred.'[106]

Making a photographic tour in search of the picturesque during the summer of 1858, Wilson was in Oban during a period of fine weather and splendid sunsets. Here he made his first attempts at a number of sea and sky studies intended for publication. In one of these views he was confident enough to point 'his camera directly at the sun's disc. The sun [was] just about to dissappear behind a heavy bank of clouds . . . and the foreground [was] a broad sheet of water covered with ripples. On this water, immediately beneath the sun, [was] a bar of dancing light, not snowy, but just one shade

lighter than the rest of the water.'[107] This effect 'has not been done by any trick in the printing, nor have the negatives been retouched; the result is due to legitimate photography'.[108] So widespread was the belief that clouds belonged only in a photographic sky when they had been artificially introduced that when Wilson achieved this with a single exposure he made a significant breakthrough for British photography, as only the previous year it had been commonly believed that 'English photographers have been thoroughly beaten by the French'.[109]

Wilson had realised that the actinic value of light reflected off the sea was very close to that of a cloud laden sky, which in theory at least meant it was possible to have both areas properly exposed on one plate. Under different conditions, when taking an average landscape for example, the over-sensitivity of the collodion emulsion to the blue end of the spectrum gave the sky a heavy and detail-obscuring density in the negative. The only way to redress the balance, it seemed, was to point the camera towards the sun which should be partially or wholly obscured by clouds and have its light reflected off water.

Even this apparent solution was not without its difficulties. Le Gray's seascapes were criticised for being 'comparatively dim, and dark, and indefinite'[110] in the foregrounds. Wilson overcame this by using the iron developer which gave him fine detail and no 'black unmeaning patches of shadow'.[111] He also discovered that brass bound lenses, when pointed into the sun, gave so much specular reflection that it diffused the image. As a remedy, he lined the barrel of his lens with black velvet and darkened the shiny edges with black paint. As an extra precaution he used a home-made lens hood, also lined with black velvet.[112]

Whether these photographs can claim a significant place in the history of photography is a matter of conjecture. It is not known whether Le Gray's studies of 1856 were made from a single negative or from a combination of two. Wilson's were certainly made on a single plate, but it is not at all certain how Le Gray achieved his results, though the evidence from his prints at the Victoria & Albert Museum suggests that he did in fact use two negatives, one for the sky and one for the sea.[113] Because of the intensity and brilliance of

the light and the use of an iron developer, both Wilson's and Le Gray's photographs were said to have been taken instantaneously. This is of course a comparative term, but at a time when an average exposure was several seconds in duration, an exposure of a quarter of a second was thought to be instantaneous. The term was not absolutely defined, but it was generally accepted that any subject where motion had been arrested, even partially so, was instantaneous. The search for instantaneity, like the search for natural colour in photography, preoccupied early photographers a great deal and there were many dubious claims about exposure times. How these extremely short exposure times were measured, let alone achieved, at a time when shutters were almost unknown, is never mentioned.

Wilson's own interest in instantaneous photography extended beyond his back-lit scenes; he wanted to freeze motion in a normally lit scene, which was inordinately difficult to achieve. His first attempt in 1858, entitled a 'Summer Morning on the Sands' (93),

Plate 93. Summer morning on the Sands, 1858

was only a moderate success and had been achieved through keeping the subjects at a distance where any movement they might make would be less apparent. Such a view later became known as quasi-instantaneous.

Encouraged by the favourable reviews of his year's work, Wilson set out the following summer full of confidence, enthusiasm, and the hope that he could achieve something better. His family took their holidays in a gamekeeper's cottage close to the village of Park which is just a few miles from Aberdeen. Near to the cottage is the small Loch of Park, and here, on a fine summer's evening, Wilson took his camera down to the water's edge to take a series of photographs of various members of his family being rowed by Sandy, the boatman. He managed to take six photographs before the setting sun disappeared behind the hill (94, 95). As images these photo-

kept the subject at a distance, Wilson now moved in close with his camera and established a much more direct relationship with his subject. The composition of each photograph is simple, and relies on the crucial positioning of the rowing boat in the reflected pool of light, where it acts as a focal point and device to interrupt the dominant vertical band of light, thus maintaining the balance within the picture.

Plate 95. Loch of Park, 1859

Plate 94. Loch of Park, 1859

graphs are a logical development and real improvement on those taken the previous year. Whereas for technical reasons, those had

Later in the year, when these photographs were submitted to the photographic journals for review, they caused great excitement and admiration. George Shadbolt, the editor of *The Photographic Journal* (which became *The British Journal of Photography* the following year) departed from his usual review procedure and instead honoured Wilson's achievement by entitling his piece 'Photographic Contributions to Art'. Shadbolt knew from experience that these photographs were important and recognised their indebtedness to Le Gray, but said 'while Le Gray's picture was

admitted by all to be most beautiful, it gave the idea of *moonlight*, albeit taken at high noon-day; but here we have sunshine—glorious, liquid golden sunshine!'[114] This comparison between moonlight and sunshine is an important factor separating Wilson's work from Le Gray's. The technical knowledge applied by Wilson gave his pictures a more natural effect; much closer to reality than Le Gray's moonlight scenes which were produced by under-exposure and heavy printing.

Wilson had also broken one of the sacred rules of photography. 'It has generally been regarded as perfectly futile to attempt to take a photograph of any subject whatever with the sun looking directly into the camera. As a rule the proposition holds good, because all objects seen—*except those in a horizontal position*, as for instance water—must appear in deep shadow and consequently without detail; but, unlike other rules, this one is not without an exception, as Mr. Wilson has proved.'[115] The experiments with a lens hood, black velvet, and a few dabs of paint were now paying dividends. *The Photographic News* thought them to be 'some of the most remarkable stereograms ever presented to us for review . . . it would be difficult to say which we admire most—the wonderful beauty of the pictures themselves, or the skill of the photographer to whom we are indebted for them'.[116] The consensus of opinion acknowledged that Wilson had achieved something that formerly was regarded as impossible in photography, and that the technical achievement in overcoming the problems of pointing a camera at the sun had been surpassed by his artistic interpretation of a most difficult subject.

It was the Loch of Park series that brought Wilson's name, almost overnight, to the forefront of photography and firmly established his professional reputation. In addition to these photographs Wilson also published the results of his summer's work which amounted to about another thirty views. While these were made with the tourist in mind there are two subjects among them that reveal Wilson's other concern in instantaneous photography. The first was entitled 'The Breaking Wave' and shows two urchins dabbling at the shallow water's edge, whilst a third stands further out, intent upon the photographer and unaware of the wave that

threatens (96). The casual, almost non-existent, composition is more reminiscent of a Kodak snapshot than a formally made picture, set up to demonstrate the instantaneous process. Much of the appeal of this picture—an appeal which kept the picture alive in the catalogues for many years—came from the way it showed so naturally the innocent curiosity of childhood.

Plate 96. The Breaking Wave, 1859

It has often been noticed in history that new ideas and developments occur simultaneously yet independently of each other. Unfortunately, this was the case with Wilson's Princes Street photographs which coincided with those published by Edward Anthony of New York. Anthony's views of Broadway were sent to *Photographic Notes* with an accompanying letter explaining how they were taken, and asking 'if you have any specimens of similar results obtained in Europe we should be pleased to hear how they compare'.[117] The letter was dated 29 August 1859. The reviewer praised the photographs for the wealth of natural movement and

detail that had successfully been caught by the camera and closed his notice with a warning to British photographers 'we old-world stick-in-the mud fellows must take care or the Yankees will go a-head of us'.[118] Unknown to Anthony, Wilson had taken a similar photograph of Princes Street, Edinburgh, that summer which was released at about the same time to Anthony's. It was taken from the upper balcony of a building next to the Sun Fire and Life Offices looking towards the Calton Hill (97). One reviewer noted with

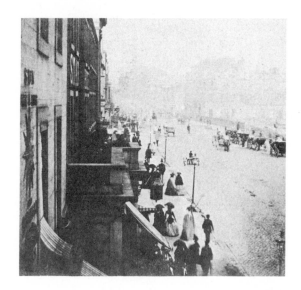

Plate 97. Princes Street, Edinburgh, 1859

delight that 'it is high noon-day, the pavement is thronged with pedestrians, and the roadway with vehicles in motion'.[119] It was not without fault, however: 'there is a slight blur visible in the nearest figures owing to their being in rapid motion'[120] and the large half-inch aperture on his six-inch Aplanatic lenses gave rise to a 'distortion of the houses on the left'.[121] But whatever its faults, the reviewer recognised that it was infinitely superior to 'those cities of the dead'[122] that the Victorians had been accustomed to looking at in their stereoscopic viewers.

Copies of this first photograph are rare and its scarcity can be attributed to its brief existence in Wilson's negative files. The following year, 1860, he revisited Edinburgh and made a whole new series of instantaneous views of Princes Street from the same position which were of a much higher standard, and these immediately superseded the original view. Wilson took yet another series of views between 1863 and 1864 from the identical position of those made in 1860. This has since led to an inevitable confusion about the dating and identification of these views, and those published today and credited as being from 1859 are usually from 1860 or 1863/4. To differentiate between the photographs made in 1860 and those made in 1863/4 one should look at the name of the hotel on the extreme left of the picture (98). In 1860 this was the 'Star Hotel', but between 1861 and 1862 it was modernised, extended and refurnished, re-opening in 1863 under the new name of the 'Edinburgh Hotel' (99).

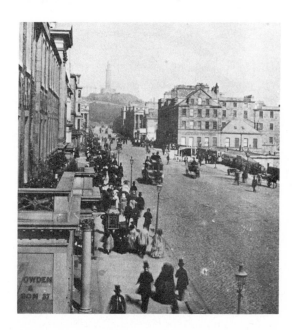

Plate 98. Princes Street, Edinburgh, looking East, 1860

Plate 99. Princes Street, Edinburgh, c.1863

Just before 1859, Anthony, perhaps encouraged by the earlier reviews, submitted further stereoscopic views of Broadway to Thomas Sutton for his comments. Sutton in turn passed the views on to Wilson for his opinion. Wilson particularly admired the speed at which they had been exposed, remarking that 'Anthony's pictures are much quicker taken than mine, and I must get some sort of shutter to open and shut quickly'.[123] Shutters, of almost any sort, were as unusual as they were unnecessary because, at a time when exposures were several seconds long, the simple procedure of uncapping and recapping the lens was considered adequate. Wilson's own variation of this technique was to use his dark blue glengarry bonnet instead of the more conventional lenscap. With this, and a dexterous flick of his wrist, he was able to achieve his instantaneous exposures.[124]

Anthony and Wilson were not the first to be intrigued by the possibilities of instantaneous photography: this was and continued to be one of the most persistent challenges offered to photographers during the early history of the medium. The earlier successful attempts were limited to seascapes with breaking waves and they appear never to have been repeated or improved upon by the amateur photographers who made them; they stand as isolated examples that were not widely acknowledged or acclaimed. Anthony's and Wilson's results received both attention and acclaim because the subject matter of their photographs was significantly different and because they were also widely distributed through the commercial outlets established by both photographers.

This chapter has covered the period between 1854 and 1859 when Wilson was transferring his allegiances from portraiture to landscape photography. The publication in 1856 of his list of stereoscopic views marks the first serious statement of his future intent, and much of the effort that he put into his photography between 1856 and 1859 was directed towards creating the best foundation for his business. Clearly, he believed that to gain attention and reputation he had to innovate: he aspired to and attained higher aesthetic and technical standards. He replaced negatives with superior ones as soon as they became available. This constant updating and improvement of his basic stock-in-trade required a special effort on Wilson's part; it took him even further from his portraiture, which he was forced to leave in the care of a manager and assistants.

Domestically, matters were following the accepted Victorian pattern with children arriving at regular intervals to create the usual large family. By 1860 there were two daughters, Jean and Ann, and three sons, George, John and William, with another child expected soon (100). To help Mrs Wilson with the domestic chores and the children a servant and a nurse were employed.[125] The domestic pressures created by a growing family, combined with the business pressures of an expanding photographic market, prompted Wilson to rationalise his studio, workroom, and living accommodation from a general hotch-potch occupying three premises, into two distinct units. By 1861 the alterations were complete. They gave him a larger house with ten main rooms and a separate studio with workrooms adjoining. This left the way clear for the next phase of development.[126]

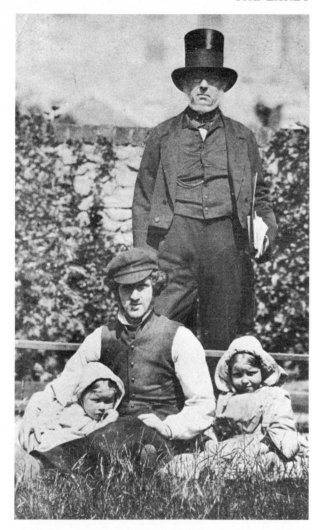

Plate 100. *William Gellie with Anne and Jean Wilson; William Brown stands to the rear, c.1854*

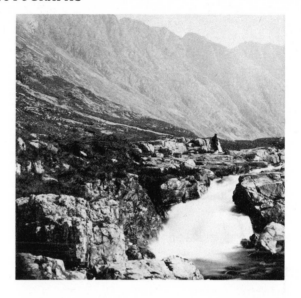

Plate 101. *Waterfall in Glencoe, c.1859*

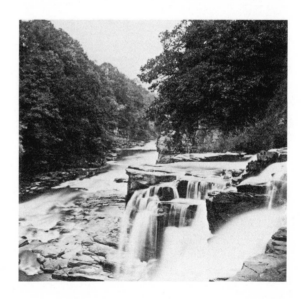

Plate 102. *Bonnington Falls on the Clyde, Lanarkshire, c.1858*

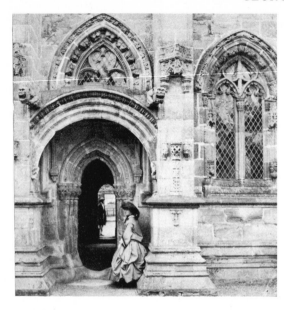

Plate 103. Roslin Chapel—South Door, 1859

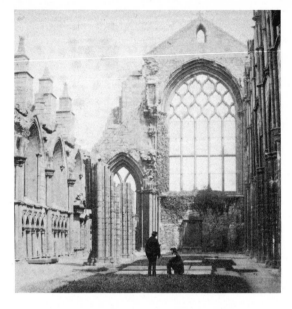

Plate 104. Holyrood Chapel, 1859

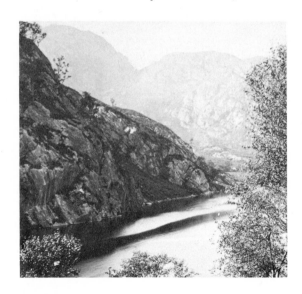

Plate 105. Pass of Bealachnambo, 1859

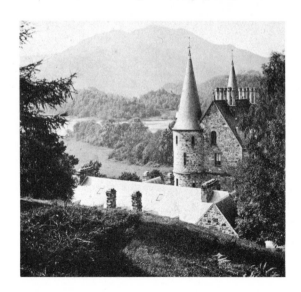

Plate 106. Ben Venue, from above the Trossachs Inn, 1859

Plate 107. Upper Falls of Moness, 1859

Plate 108. Middle Falls of Moness, 1859

Plate 109. Lower Falls of Moness, 1859

CHAPTER SEVEN

International Recognition

From the 1850s onwards countless photographers turned their attention and cameras to their own regions and produced 'studies' that they hoped would catch the eye of passing tourists. Some were successful because they understood that mere representation in photography was artistically inadequate: others failed because they were unable to raise their work above mere representation. Local photographers were able to make adequate livings by their topographic work, but very few had the energy, foresight and entrepreneurial spirit necessary to give them national status.

Wilson's response to the possibilities of photographic publishing, which it must be remembered was still a comparatively new concept, showed him to possess all these qualities, plus an artistic understanding that interpreted, rather than represented, the subject before his camera. We have already seen that in 1859 he was intent on establishing his reputation by pioneering new approaches in photography and was undoubtedly successful in drawing attention to himself by doing so. However, the Loch of Park and Princes Street photographs represent only a small part of his total output for that year. The remaining photographs were all topographical studies of Scottish subjects intended exclusively for the tourist market and to 'carry a gleam of sunshine into many a home'.[127]

Balmoral was now completed and regularly occupied by Queen Victoria and her family. The grounds were laid out with wide

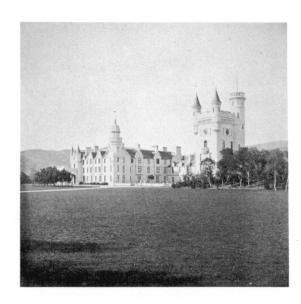

Plate 110. Balmoral Castle from the Southeast

expanses of lawn and newly planted trees. Time had not yet softened the harshness of the freshly dressed granite, so the building stood out stark and white against the softer background of the hills (110). Because of his associations with Balmoral, Wilson was able to gain permission to make a series of views within the grounds which he expected would find a ready sale with the flocks of tourists making the pilgrimage to see their monarch's new Scottish home. At least one of the studies however was criticised; 'in consequence of its inferiority as regards the picturesque, the edifice being too trim and in too good condition to render it a desirable object for an artist'.[128]

On the opposite side of Scotland, on the Isle of Staffa, lay the natural architecture of Fingal's Cave (111), universally recognised

Plate 111. Fingal's Cave, Staffa

as an entirely suitable subject for artist and tourist alike. Wilson's stereogram apparently caught the grandeur and spirit of the place. As one reviewer remarked, 'the celebrity of this picturesque cavern

would alone insure a large demand for a good illustration of it; but even if it were altogether unknown, such a one as we have before us would, of itself, be enough to render it celebrated henceforth'.[129]

The guidebooks recommended the Falls of Foyers, Inverness-shire, as 'the most magnificent cataract, out of all sight and hearing,

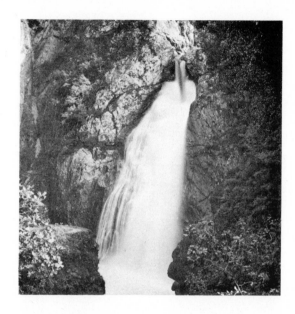

Plate 112. Fall of Foyers, Inverness

in Britain'.[130] Wilson's viewpoint (112) coincided exactly with that recommended by the guide books. It was below the second of the two falls looking up, where 'you are so blinded by the sharp spray smoke, and so deafened by the dashing, and clashing, and tumbling and rumbling thunder, that your condition is far from enviable'.[131]

These three examples, taken from Wilson's work of 1859 illustrate the geographic range of his activities and the diversity of his subject matter. Heartened by the enthusiastic reception of the photographic press which stated that his work as a whole represented 'some of the most remarkable stereograms ever presented to us for criticism',[132] he laid plans for the following year that would

augment his existing work in Scotland and extend his activities into England.

To invade the English market was a bold move that speaks of Wilson's growing self-assurance and enterprising spirit. It was one thing for him to take stereograms of Scottish scenery for English tourists; it was quite a different matter for him to travel to London and the South Coast in 1860 and there make a series of views that challenged the prerogatives of local photographers. The choice of London is easily understood. The metropolis exerted a powerful influence over provincial minds and Wilson's previous visits in 1849 and 1854 would have made him familiar with the city. Less clear is his choice of the South Coast of England. The only obvious attraction that might have influenced his choice was Brunel's leviathan among ships 'The Great Eastern', which was at anchor in Southampton Water that summer. Whether this was the true objective of his journey must remain conjecture, but the great public interest in the ship would have created a good commercial incentive to photograph her.

In London, Wilson confined the majority of his photographs to interior views of St. Paul's and Westminster (113, 114). The problem of exposure in spacious and dark interiors had not been tackled by Wilson before. It was largely a matter of balancing the interior to the exterior light coming in through the windows to avoid losing too much of the highlight detail. This calculation would have been informed by Wilson's experience as an artist which recognised that the main component of light in shadow areas is blue, to which the collodion process is particularly sensitive. Optical deficiencies in the lenses became readily apparent when the low light levels caused them to be used at wide apertures. An interior view of St. Paul's shows a halo around the upper window (115) that was produced by interior reflections within the lens.[133]

Having had some success the previous year with his single instantaneous view of Princes Street, Wilson decided to make two similar views of Regent Street in London. In these photographs, though his viewpoint is lower than before, he keeps the traffic and pedestrians at a similar distance to minimise the risk of movement. In the first

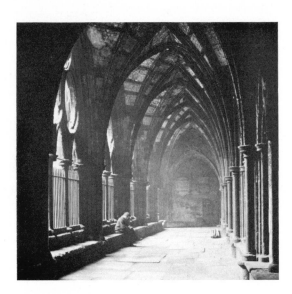

Plate 113. Westminster Abbey—The Cloisters

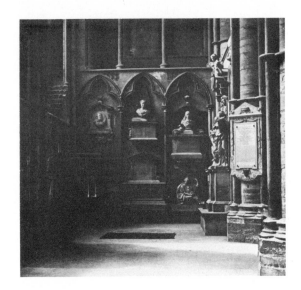

Plate 114. Westminster Abbey—Poets' Corner

photograph one-half of the street is in deep shadow, which must have caused considerable exposure problems in balancing up the extremes of contrast. The prints show all the signs of having been heavily intensified to adjust the shadow detail. The second view of 'The Quadrant' (116) is more successful, both technically and in composition: the great sweep of the buildings carries the eye naturally and easily towards a hidden vanishing point.

On his way to Southampton and *The Great Eastern*, Wilson took the opportunity of photographing Stonehenge and Salisbury Cathedral (117) which were only a short distance out of his way. Stonehenge had always attracted the attention of the curious, and during the Victorian period there was much scholarly debate and heated argument about its origins and purpose. Wilson knew it would find a ready market. His general view from the east (118)

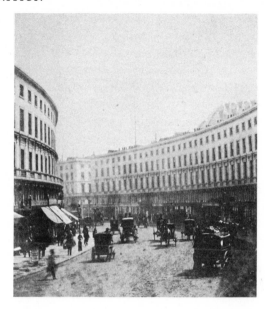

Plate 116. Regent Street, London—The Quadrant

Plate 115. Interior of St. Paul's Cathedral, London

Plate 117. Salisbury Cathedral—Entrance to the Chapter House

places the circle of stones as a band across the centre of the picture: the low viewpoint and tight framing give an even greater sense of mass. Also he placed a figure centrally and a carriage to the right, both against uprights, where they act as further indicators of scale. None of this is particularly novel for the period; what sets this picture apart from its contemporaries is the inclusion of sheep grazing in the foreground and the large and beautiful cloud which dominates the sky. In their differing ways these devices animate areas that would otherwise have been visually dull.

When he reached Southampton Water to photograph *The Great Eastern* the ship was anchored a good distance from the shore in deep water, and there was no way that she could be photographed except from the beach (119). Once again Wilson brings life to the foreground of his pictures: he used his knowledge of instantaneous photography to capture the motion of a wave breaking diagonally across the base of the frame. The relationship between Stonehenge and *The Great Eastern* is perhaps not immediately apparent but on reflection it becomes clear that the Victorian interest in the sublime forms of mass and human achievement closely link the two subjects. The series of *The Great Eastern* also marks the start of a long sequence of 'maritime views' that had a patriotic appeal and for which Wilson became well-known. On his return to Scotland he had the opportunity to photograph the Channel Fleet as it lay at anchor in the Firth of Forth.[134] Wilson overcame the problems of photographing the Fleet as well as individual ships by gaining permission to use the deck of HMS *Trafalgar* as a mobile but stable base for his camera.[135] The resulting photographs (120, 121) are for the most part aesthetically undistinguished and are noteworthy only because they are among the earliest, if not *the* earliest, to be taken of shipping from another vessel whilst at sea.

This excursion to England during May and June was the first of two photographic tours he made in the summer of 1860. It was his experience that during May and June the light from the sun was so clear and intense that he could make better instantaneous photographs than at any other time of the year.[136] Later in that year, during September and October, when again there was a clarity in the air after the summer, Wilson set forth on his second tour, this

Plate 118. Stonehenge—general view from East

Plate 119. The Great Eastern in Southampton Water

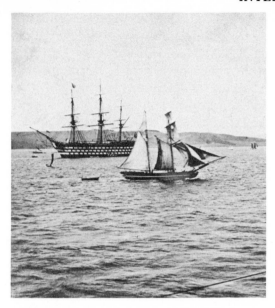

Plate 120. HMS Royal Albert in the Firth of Forth

time concentrating all his attention on Scotland and on subjects more familiar to tourists than shipping. He revisited the Loch of Park to remake, in the light of experience and technical improvements, his earlier successes. These new stereograms (see Appendices One and Two, catalogue numbers 278–92) are often mistakenly thought to have come from the original series, but only two of these had survived (catalogue numbers 124, 125) and they continued to appear in the catalogues for a number of years (122, 123). The most striking image in these new photographs was 'Wild Duck Shooting' where the explosion of the gun, with its puff of black powder smoke, creates an instantaneous dynamism that was lacking in the earlier photographs. As a whole the set was well received and provoked the comment that 'to remain without these subjects is to continue to grope in the dark, and not know what photography is really capable of'.[137]

The instantaneous process opened up other possibilities in photography. Wilson quickly realised that he could use his own special

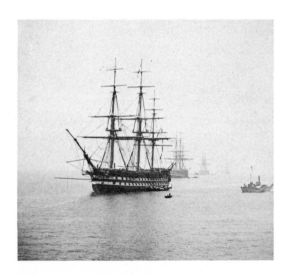

Plate 121. Channel Fleet in the Forth—HMS Donegal

Plate 122. Loch of Park, Aberdeenshire, Wild Duck Shooting

Plate 123. *Loch of Park, Aberdeenshire*

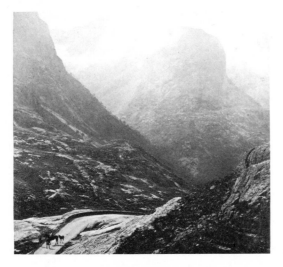

Plate 124. *Pass of Glencoe, looking down*

knowledge to advantage. At a very simple level it meant that now Wilson could take photographs under conditions and in situations that had been thought impossible. For instance, the improved exposure times of the instantaneous process meant that the slight movement of trees caused by light breezes—these had driven Wilson to despair—could be adequately stilled. He was, however, unable to operate under stiffer breezes. Now, too, he could take photographs of those atmospheric effects caused by mist and low cloud which are a feature of Scottish landscape and which had previously eluded the camera. When he visited Glencoe for the second time in 1860 the weather was misty. Whereas most photographers would have been deterred by this, Wilson used the wreaths of mist that obscured part of the mountains to heighten the air of romanticism that already surrounded a place celebrated for the grandeur of its scenery and for its historical associations (124).

Guide books described Glencoe as a place where 'the hills shoot up perpendicularly to a tremendous height, casting a deep gloom on this wild vale, calculated to strike the traveller with the deepest awe. At the head of the glen the disposition of the mountains becomes peculiarly grand and impressive. Their magnitude, form, and colour, all contribute to the greatness of the effect'.[138] Wilson's photographs closely echo these sentiments.

In an annual review of the year's progress in photography throughout Britain during 1860, the editor of *The British Journal of Photography* noted that 'Wilson of 1860, has materially advanced upon Wilson of 1859 in the "instantaneous" branch of photography', and that he was also 'pre-eminently successful in delineating some most interesting and picturesque subjects'.[139] Thomas Sutton in *Photographic Notes* readily acknowledged that Wilson 'has so thoroughly put his heart into the work, and is so persevering and undaunted in his efforts, that he has now achieved for himself a position which no other photographer has reached'.[140]

These testimonies to Wilson's progress and status are just two examples of the praise heaped upon him by the photographic world. Having achieved such status Wilson's main concern was with maintaining it. In order to do this he had continually to improve the technical and aesthetic qualities of his work and retain

his innovative lead. He relied firstly upon his abilities as a photographer and businessman, and then upon the special skills of camera, lens, and of the chemical manufacturers who were only too happy to submit their latest product for his approval. One manufacturer with whom Wilson had a particularly close and happy association was J. H. Dallmeyer. Dallmeyer had emigrated to Britain from Prussia in 1859 and after a brief period working for other London opticians had established his own business to manufacture lenses and cameras.

Before 1861 Wilson nearly always fitted his camera with a pair of 6 in. view lenses which gave him an approximate 30° angle of view. The lenses were fitted with a large ⅝ in. aperture for instantaneous views and a 3/16 in. aperture for ordinary subjects requiring longer exposures. The comparatively narrow angle of view given by these, and by the vast majority of mid-nineteenth century lenses, was considered a serious drawback to photography, and there were demands from photographers for new lenses with wider angles of view. Manufacturers applied their knowledge and ingenuity to designing a lens that gave a wider angle without sacrificing definition or the transmitting power that photographers expected. Dallmeyer was one of the first manufacturers to succeed with his Triplet lens which gave what was considered an unbelievable angle of 70°. Wilson was sent a No. 1, 7 in. lens in early 1861 for trials and because of the remarkable covering power of the lens he fitted it to an ordinary, rather than stereoscopic, camera to test to the full its capabilities. The results excited interest: the lens produced 'the widest angle . . . yet seen effected on a flat surface.'[141] Wilson was able to keep the lens during the summer months when he made his second photographic tour to London and the South Coast. He made several trial views under differing circumstances. The results were first publicly exhibited in Manchester at a photographic exhibition organised in conjunction with the Annual Meeting of the British Association, where they were widely admired. These photographs were also used by Dallmeyer in promoting his lens and were sent to those photographic societies and associations who had written to him asking for details of his new lens. No doubt both Wilson and Dallmeyer saw the advantages of linking their names in the pro-

motion of a lens that was a significant development in optics. In later years the Triplet was sometimes referred to as the Wilsonian lens.[142]

The superiority of this lens over its competitors soon became apparent as it was 'fast acting' and gave even illumination over a large plate (7 in. × 4¾ in. was the sized favoured by Wilson) without any loss of definition in the corners where it was most expected. Wilson saw the commercial potential offered by a lens that was ideally suited to landscape photography. During 1861 he began using it to build up a stock of negatives that would yield large single prints rather than stereograms. Stereograms were still attracting all the attention of commercial publishers, photographers and the public, but Wilson realised that there would soon come a time when their popularity would wane so a commercial advantage would be gained by those who had suitable alternatives to offer in sufficient quantities.

His idea that single prints were commercially viable was reinforced by several enquiries following the exhibition, but before bringing the photographs to the public he was 'anxious to have some stock of them printed before they are announced'.[143] Wilson placed the publication and distribution of the photographs in the hands of Marion & Company, London, perhaps thinking that the photographs stood a better chance of acceptance with the public if they had the authority of Marion's support.

On 1 May 1862 Marions announced the publication of 'series of Cabinet views, size 6¾ in. × 4½ in. Photographed by G. W. Wilson.'[144] This announcement heralded the introduction to the world of commercial landscape views available as single prints. The choice of the title Cabinet was most likely Marion's rather than Wilson's idea, and as such was probably intended to have a French rather than English connotation, the current fashion being dominated by Paris and all things French. When the series was reviewed later that year, the significance of their publication was quickly appreciated. 'It is quite certain that one barrier to the extensive circulation of photographs, as works of art, has arisen from a certain difficulty as to the proper mode of keeping them; they are scarcely well suited for framing, at any rate they have not a certainly

recognised position in interior decoration; and an extensive collection, especially if the pictures be large, demands serious portfolio accommodation. Photographs of a size, then, capable of preservation in albums, especially if suitable albums be manufactured, are likely to become favourites with the public, and hence we conceive that Mr. Wilson in issuing this series will originate a style.'[145] The subject matter of these views was mainly Scottish and they often reiterated earlier stereoscopic views, for the most part taken around Aberdeen and Deeside (125, 126). The exceptions were the 'instantaneous maritime views' taken at Plymouth in 1861 when he first used the Triplet lens (127).

When initiating any new undertaking Wilson's entrepreneurial spirit was always tempered by financial prudence. He rarely overextended himself if the returns were not immediately apparent. So it was with the cabinet views which initially represented only a fraction of his total output. His main emphasis was still on stereoscopy. The cabinet views provided a supplementary, rather than an alternative, form of income. Some of this caution may have been caused by Wilson's need to come to terms with the new aesthetic considerations imposed by the wide-angle lens and the single image which relied upon a different set of values from those of the stereogram, where the illusion of deep space was usually central to the composition. It may also have been caused by the need to take two cameras everywhere so that both forms of photograph could be accommodated. Once again Dallmeyer provided Wilson with the solution. He designed a camera (128) known as the Wilson camera that would function equally well as a stereoscopic or as a single image camera. This was achieved by removing a pliable central division which separated the two chambers of the stereoscopic camera, thereby converting it into an ordinary camera which could then be used with a single Triplet lens.[146]

In the autumn of 1863, following his first year's experience with cabinet views, Wilson decided to introduce another format to the public, the album print.[147] It measured $4\frac{1}{4} \times 3\frac{1}{4}$ in. and, like the cabinet, could be bought either loose or mounted on card. But unlike the cabinet its introduction was not stimulated by the development of a new lens or camera: it was, in reality, one half of a stereoscopic pair trimmed to a different format. This enabled Wilson to use most of his existing stereoscopic negatives without reshooting popular scenes, and his most popular views were included in the first issue (129, 130). This was a wise decision as many of the old favourites were now regarded 'not only as good as, but positively better than, new—that is to say, better than when we first saw them, for the retention of portions formerly of necessity sacrificed, adds materially to their value as pictures'.[148] Their only drawback—a consequence of technical constraint—was that horizontal views were impossible to achieve from existing negatives and therefore all the album views were vertical in format.[149] But despite this they proved to be a popular diversification away from the stereogram.

In the three years' work produced between 1861 and 1864 Wilson placed most emphasis on the introduction of the cabinet and album prints rather than on trying to innovate a new visual approach, as he had done with his instantaneous views. He was now in a sufficiently secure position within the British photographic hierarchy to capitalise on his achievements and reputation. To most critics, and perhaps to a significant section of the middle class photograph-buying public, Wilson's style was so well recognised as a standard against which others were measured that it would have been foolish for him to change. His numerous photographs from this three-year period are therefore mostly variations on the themes for which he was best known, namely instantaneous and picturesque views. What is evident, however, is the extension of his geographic territory, which during 1861, for instance, reached as far as Cornwall, where unusually poor weather and fog denied him many of the subjects he would have wished for.

During his visit to London in 1861 Wilson concentrated his attention on the picturesque qualities of the River Thames—then a continuous scene of waterborne activity as shipping from all parts of the world converged on the greatest commercial metropolis (131, 132). His series of 'The Thames at Greenwich, etc.' (catalogue numbers 329–35) conveys the feeling of this activity and portrays the river in an artistic and poetic way that gives no indication of the fact that it was known as 'a huge unquiet cesspool'. The following

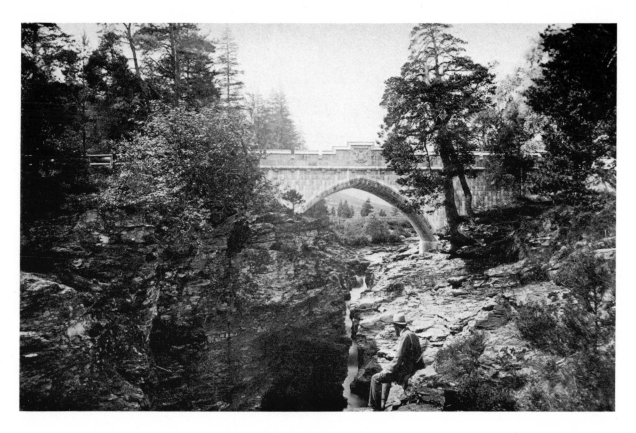

Plate 125. The Linn of Dee. Cabinet

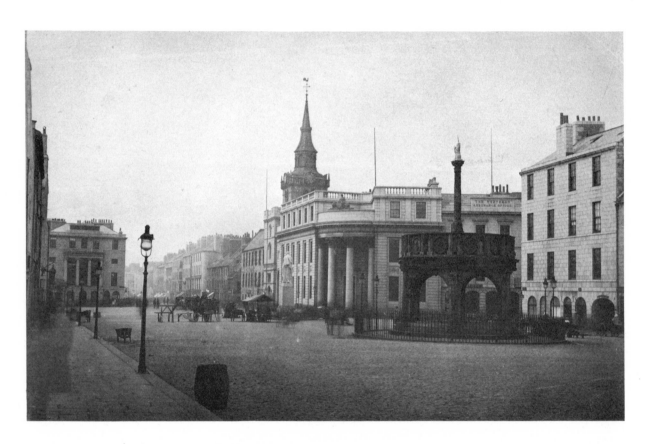

Plate 126. Castle Street, Aberdeen. Cabinet

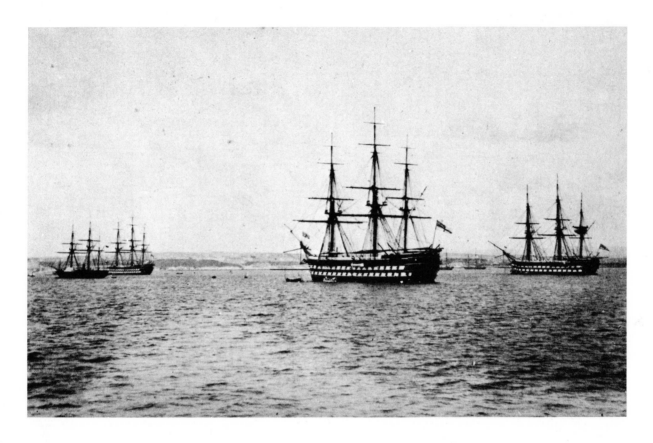

Plate 127. The Channel Fleet in Plymouth Sound. Cabinet

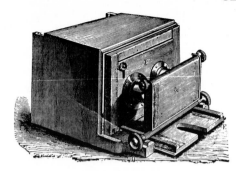

Plate 128. Dallmeyers' Binocular or Wilsonian Camera, 1862

year he added to these a further three photographs called 'Waiting for, The arrival of, and The Departure of the Boat' (catalogue numbers 410–2) from Greenwich which form a narrative sequence of great vigour.

His other views of maritime subjects were of naval rather than mercantile vessels; they were taken either in Plymouth in 1861 (catalogue numbers 313–23) or in Portsmouth during 1862 (catalogue numbers 423–30). Large naval vessels at anchor are not the most prepossessing subjects; their success as subjects for photographs depended very much on the patriotic attitude that the viewer brought to them. A reviewer of the photographs felt it was his duty to explain that the HMS *Revenge* was 'the flag-ship of 800 horsepower, and mounting 91 guns'[150] before criticising the photograph.

Only occasionally was Wilson able to overcome the difficulties posed by having a large and featureless expanse of water as foreground to his photographs. In his view of HMS *Impregnable* (134, 313) he found a point on shore which gave him a perfect frame of oak branches and leaves for the vessel. We shall never know if, with this particular foreground, there is a deliberate allusion to the Navy's 'hearts of oak'. One of the other problems involved in photographing naval vessels, particularly when they are at anchor and in port, is that they appear most unlike fighting ships, presenting themselves with solid immobility. It was therefore especially fortunate that Wilson's visit to Plymouth in the early summer

Plate 129. Aberdeen, The Market Cross. Album

of 1861 coincided with the Navy's testing of canon. This created a perfect opportunity for some lively photographs.

The ship which had been chosen to test Sir William Armstrong's rifled cannon was the HMS *Cambridge*, and throughout 1861 she was involved in proving the accuracy and range that rifling gave the ordnance.[151] It has been claimed that Wilson's position as 'Photographer to the Queen' influenced the Navy to lay on a special demonstration of their fire power for his photographic benefit. As the tests were already under way when Wilson arrived in Plymouth,

Plate 131. *The Thames at Greenwich—Barges coming up with the Tide*

Plate 130. *Windsor Castle, The Garden Terrace. Album*

it is more likely that he used whatever influence he could to get permission and cooperation from the Navy. Not only did he have to get himself and his camera into a suitable position, but he also had to have contact with the *Cambridge* in order to co-ordinate the sensitising of his plates with the firing of the guns. In one of the several

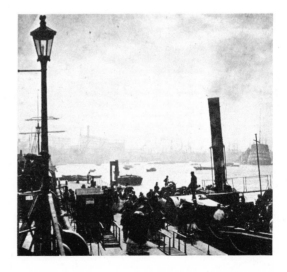

Plate 132. *On the Thames at Greenwich—Arrival of the Boat*

versions (135) a figure is clearly visible on the stern of the ship and perhaps it was he who formed the necessary link between Wilson and the gunnery officer. The photographs were warmly received and said to be 'perhaps the most perfect specimens of instantaneity which have yet been produced'.[152] Singled out for special attention was the ruffled surface of the water caused by the concussion of air from the explosion.

Wilson continued with the series of cathedrals that he had begun in 1859 and 1860 with St. Paul's and Salisbury, and during the three seasons' work of 1861 to 1863 he added Durham, Exeter, Gloucester, Peterborough, Winchester and York to his collection, with a substantial number of exterior and interior views of each (136–139). Cathedrals occupied a special place in the Victorian scene. They were the symbols of ecclesiastical authority and also a major attraction for tourists. Tourists were drawn to cathedrals by the wealth of history, the architectural detail, and the splendour of the whole. One Victorian writer tells of his feelings on entering Winchester Cathedral.

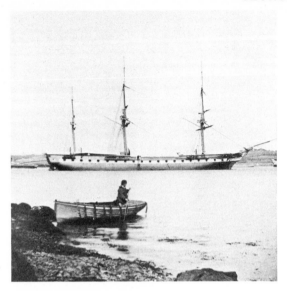

Plate 133. HMS Orlando

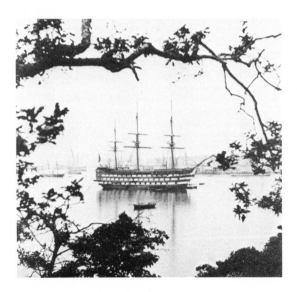

Plate 134. HMS Impregnable

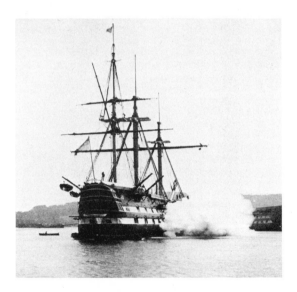

Plate 135. HMS Cambridge—Great Gun Practice

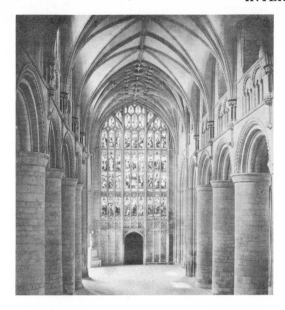

Plate 136. Gloucester Cathedral, The Nave

Plate 137. York Minster, Interior of the Lantern Tower

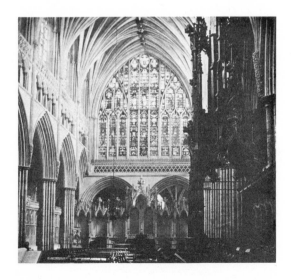

Plate 138. Interior of Exeter Cathedral—The Choir, looking East

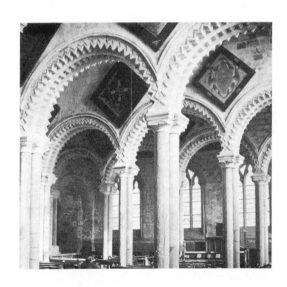

Plate 139. Durham Cathedral, The Galilee

When we walk in a fabric like this, venerable with the flight of
nearly a thousand years, and build up again in imagination its
jewelled shrines, rear aloft its glittering wood, replace all its
statues of gold, and silver, and chiselled stone, and see once
more—with the mind's eye—there assembled the stately kings
and queens, mitred prelates and throngs of proud warriors and
nobles of past times, amidst the magic tide of music and the
imposing drama of high mass, we must prepare to confess that if
the people were superstitious it was not without great tempta-
tion; for never did human wit achieve so fair temples, or animate
them with pageantry of worship so seducing to the imagina-
tion.[153]

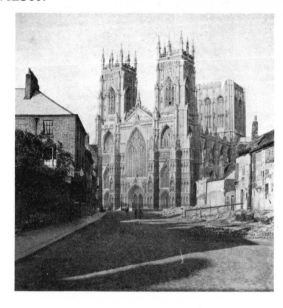

Plate 140. York Minster, West Front

Cathedrals, like warships, can be photographed from a great many
points of view and present similar difficulties when it comes to
foregrounds. Their sheer size kept the photographer at a distance
and this distancing led to many an empty or uninteresting fore-
ground. Wilson's photograph of the West Front of York Minster
(140) taken in 1862 is one such example, where the empty street and
half-demolished buildings on the right do little to enhance the view.
But his other view of the Minster taken from Monk-bar (141) has a
purely picturesque foreground of roof-tops and smoking chimneys
out of which the massive bulk of the cathedral rises majestically. In
both views it is immediately apparent that Wilson chose the
circumstance of his lighting with great care so that it either
describes, and gives relief to, the ornamental decoration on the
exterior (as in plate 140) or adds emphasis to the jumble of roofs
that make up the foreground of plate 141. Lighting was equally
important, and much more difficult to realise in interiors, where
Wilson's aim was to convey the feeling of space and volume
through the use of light. As the interiors of some cathedrals are
notoriously dark with strongly contrasting patches of light, this was
no easy task. Great technical virtuosity and patience were required
(142, 143).

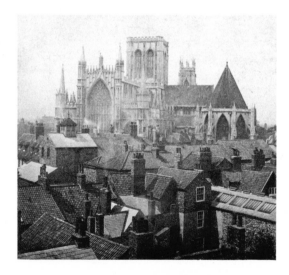

Plate 141. York Minster, from Monk Bar

The remaining photographs that still have to be discussed from
this period are the Scottish views that were Wilson's main stock-in-
trade. During 1861 and 1862 he confined his Scottish photography

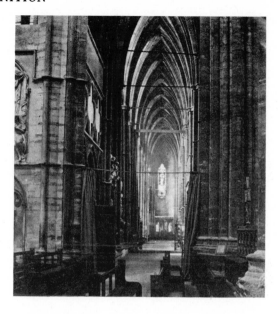

Plate 142. Westminster Abbey, The Choir, looking East

Plate 143. Westminster Abbey—South Aisle

Plate 144. Path to the well, Tobermory, Mull

Plate 145. Bracklinn Falls, near Callander, Perthshire

to the popular tourist areas that were already familiar to him. Not surprisingly he revisited the Trossachs, Loch Lomond, and Deeside, and made occasional views in the surrounding districts (144, 145). It can be seen that the geographic range of this photography fell within the boundaries carefully defined for the tourist by the guide book which, at this time, largely ignored the remoter regions of the Highlands in favour of the more popular and well-established tourist areas. Although it may appear that Wilson was not now as wide-ranging as he had been on his English travels, the decision to revisit these areas was probably forced upon him by the great popularity of his photographs. It was all a question of supply and demand, and in the early 1860s the demand must have outstripped his printing output. As negatives were printed by daylight the output was directly related to the weather conditions. It can be estimated that the average output was five prints per day, which meant that a single negative gave approximately 1500 prints per year. When demand was beyond this figure Wilson, mindful of profits, had no real alternative but to revisit the area and make a further set of negatives to supplement his existing stock and increase his printing capacity. This is not to suggest that Wilson was unmindful of the need to find new locations and subjects. On the contrary, his search was continuous: during slack times in the winter and spring he made surveys of little-known areas to assess their potential for photography.

Following one such visit he and his assistant Gellie set out in the early October of 1863, to Loch Maree and Gairloch in Ross and Cromarty. Despite the grandeur of the mountains and the appeal of Loch Maree, this was a region largely unfrequented by tourists (146–148). The lack of hotels and adequate transport made any journey a test of endurance. It is likely that Wilson's intention was to bring the most important aspects of this little-known area to the general attention of tourists. In later years it was stated that through his photography 'he had done more for opening up Scotland generally, than Sir Walter Scott had done for the Trosachs (sic)'.[154] This may exaggerate Wilson's influence, but it does acknowledge his role in the growth of Scottish tourism. Only one extract from Wilson's diary has survived. It records his experiences on this trip and is worthy of inclusion here for the insight it gives into the working life of a landscape photographer.

1863
Left Aberdeen on the 6th Oct. and came to Inverness accompanied by W. Gellie as assistant in a photographic tour. Arrival at Inverness at half-past 10, having stayed an hour at Elgin. Next morning called upon Stuart the photographer and saw through his place. . . . As the day did not clear up we came on to Beauly and after getting some lunch came on by dog-cart to Contin. . . . Tried a view of the Falls of Rogie but did not get the view I wanted because of the wind blowing the trees. After a halt at Auchnamilt came on to Auchnasheen where we staid (sic) all night.

7th Oct.
 Left at 7 and came into Kinlochewe to breakfast. The Hills as we came along covered on the tops with snow and as it was clear and frosty we were in hopes of getting some fine views of them in this state. After breakfast however it clouded up and we did nothing all day as it came on to rain.

8th Oct.
 Windy and rainy occasionally. We drove down Loch Maree 6 miles to see if anything could be done but Ben Slioch was in a mist. As we came up met Mr. McKenzie of Targhan who told us that they had had 5 weeks of rain.

9th Oct.
 Fair but still windy and cloudy. Drove down as far as the head of Loch Torridon. Found they had put up a new wooden bridge across the river. Missed some fir trees which formed a picturesque object last year on this side of Loch Clare. Found they had been used for making the bridge.

 The weather very squally and after feeding the horse drove up the glen. Got some glimpses of Ben Luigeach through the mist, and when we came to the keeper's hut the mist cleared up and we

PASS OF BEALLACH-NA-BA. LOOKING UP.

Plate 146. *Pass of Beallach-Na-Ba, looking up. Cabinet*

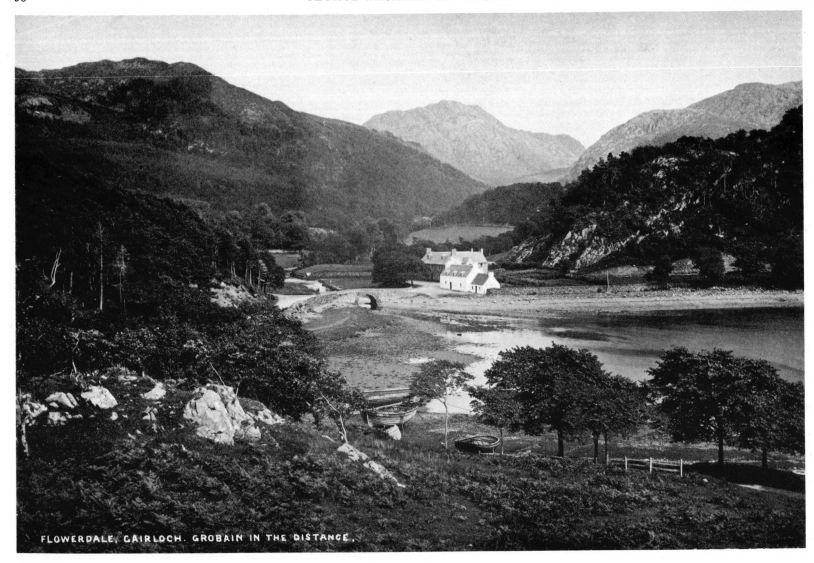

FLOWERDALE. GAIRLOCH. GROBAIN IN THE DISTANCE.

Plate 147. Flowerdale, Gairloch, Grobain in the distance. Cabinet

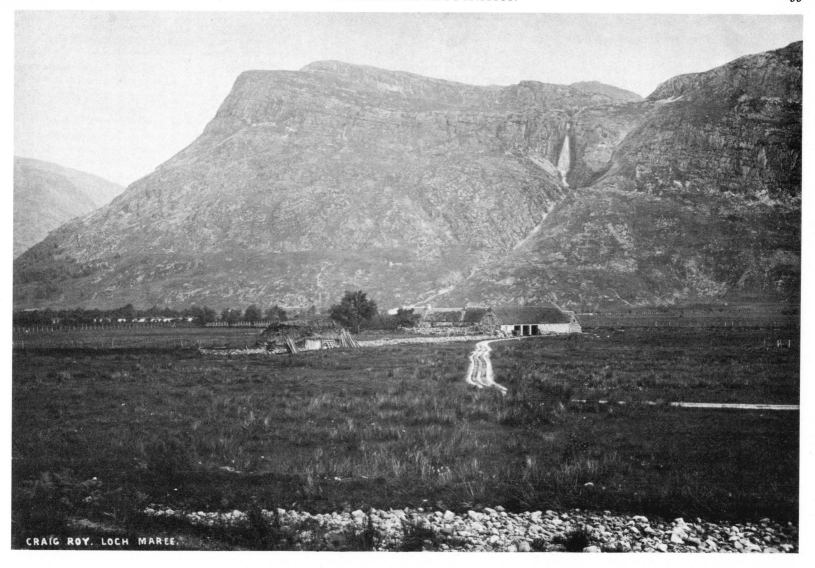

CRAIG ROY. LOCH MAREE.

Plate 148. Craig Roy, Loch Maree

pitched our tent and tried to take Ben Luigeach. The sun was too far round, however, and after trying a plate or two of Ben Eay we came home.

10th Sunday.*

After breakfast Gellie and I took a walk up a footpath which leads to the Corrie of Ben Eay. Saw on our way a capital view looking down a gullie towards Craig Roy. Went on to the end of the footpath about 3 miles and had a splendid view of Ben Eay. After going a little further over the quartz rocks saw down the glen by the back of Ben Luigeach and Ben Alligan. We then went up a hill to the right some distance and saw a peep of Loch Maree and had a fine view of Ben Slioch, Craig Roy and the mountains beyond. . . . Came on to rain. We got a soaking before reaching the inn at Kinlochewe.

The morning looking promising we started for the Corrie of Ben Eay, the coachman carrying the basket and camera up the hill. It got dark before we reached the first corrie looking down to Craig Roy, and we pitched our tent then and tried a view without sunshine. Rain before we got down. Another day we tried a view of the Inn but Ben Eay would not come out [of] the mist. It cleared up however about 12 and we got a view of Craig Roy with Mr. McKenzie's houses in the middle distance.

Rained all night—cleared up about 9 and we set off for Glen Torridon. Stopped at Loch Clare for an hour. The loch was like a mirror but the views taken did not look very satisfactory. . . . Went further down the glen and tried a view looking up the side of Luigeach but after one negative the sun went behind a cloud and did not appear again. Came home to dinner about 5 o'clock.

Left Kinlochewe and drove down Loch Maree. Pitched our tent some 7 miles down and tried to get Slioch. The sun however would not come out, and though we waited till 12 o'clock we got nothing satisfactory. Went to Gairloch stopping at a waterfall which although very dark we got some negs. of. Rain came on and continued all the way to Poolewe which was reached about 5 o'clock.

* Despite the fine weather, photography was not attempted because of the strong sabbatarian views held in that part of Scotland.

Raining in the morning but about 10 it cleared up and we went up to Sir Kenneth McKenzie's Lodge at the foot of Loch Maree and tried to take the crag opposite. We got no sunshine however, but as we came back the sun came out and we took a view of the village.

We then drove up the road trying to get a photo of a collection of huts at the road side, but it came on to rain in torrents and although we tried a plate or two between the pelts of rain they are not satisfactory.[155]

So it went on with day after day of mist and rain and hardly a photograph to show for all the effort until the telegram came summoning Wilson to Balmoral to photograph Queen Victoria and her family. This he did with much more success.

By the early 1860s, Wilson's position in photography was well-established. Through his own diligence and artistic understanding he had advanced the art of photography and promoted his own name, particularly with his instantaneous views. His commercial publications were achieving such widespread sales throughout Britain that they ensured a healthy future for him and his family. Yet curiously, up to 1862, he had never received an award or medal in recognition of his widely acclaimed landscape photography. His first and only medal had been awarded for portraiture at the 1859 Aberdeen Mechanics Institute Exhibition.

It was the 1862 International Exhibition in London that gave photographers the opportunity to match themselves against each other in open competition for the awards. The idea of holding the exhibition was originally proposed in 1858. The hope was that it would open in 1861 to coincide with the tenth anniversary of the 1851 Great Exhibition, but general economic uncertainty and the war in Italy caused the scheme to be dropped. It was revived in 1860 by Prince Albert, who, to show his good faith in the exhibition, personally guaranteed ten thousand pounds if other subscribers would put down the two hundred and forty thousand pounds necessary for its funding. From the start it was planned to

be even bigger and more splendid than the 1851 exhibition, and when it finally opened its doors to the general public in May 1862 there were over twenty-nine thousand exhibitors ready to display their various skills, manufactures and wares—an increase of fifteen thousand over the 1851 exhibition (149). The death of Prince Albert in December 1861 and the outbreak of Civil War in America created a mood of despondency and uncertainty which prevented the 1862 exhibition from achieving the attendance and attention it deserved. But so far as photography was concerned, while the 1851 exhibition had been important for the fact that photographs were for the first time exhibited on an international basis, on all other counts—of content, quality, and the importance of the images—the 1862 exhibition was of much greater significance. The eleven years between the exhibitions had brought major new improvements in processes, lens design, and camera construction which gave the photographer a confidence in what he was doing and allowed him to establish his visual identity with more assurance.

Unfortunately for photographers, the Commissioners of the exhibition had very clearly defined principles to guide them in the classification and arranging of the exhibits. They were 'to group the raw materials employed in industry, then to group the machinery used to convert them into utilities, and, lastly, to group the utilities as manufactured products.'[156] Photography was classified among machines and mechanical processes, rather than under the traditional 'Fine Arts' of painting, sculpture and engraving, where the majority of photographers justifiably felt they belonged. Despite long and heated arguments, the matter was never satisfactorily resolved and the Commissioners finally allowed photography 'to hover over the confines of art, more as an attendant than as companion'.[157] The grievances of the photographers were further aggravated by the treatment, siting, and hanging of their work, a situation not helped by the damp walls which ruined many of the photographs.

However, these problems did not concern the jury whose difficult task it was to select from the numerous entrants those photographers they thought most deserving of an award. The competition for the prizes was fierce; entrants submitted their work from all

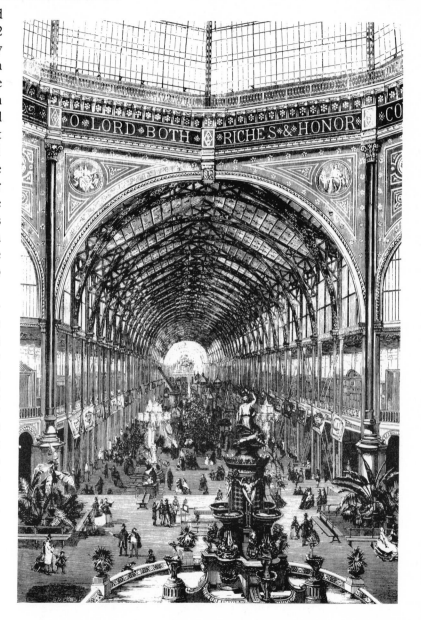

Plate 149. *The International Exhibition of 1862; view of nave*

over the world, though the highest number of entries came from
Britain and France. The published list of awards makes an inter-
esting commentary upon the attitudes of the jurors towards parti-
cular photographers' work. For instance, D. O. Hill and O. G.
Rejlander, whose places in the history of photography are secure,
were thought to be deserving of only 'Honourable Mentions', while
the unfamiliar J. Sidebotham and J. D. Piper emerged triumphant
with medals for their photography. Despite the unfamiliarity of
these two names the list of award winners does read rather like an
index of nineteenth century photographers, as most of the names
are to be found there, including Wilson's. He won his medal 'for
the beauty of his small pictures of clouds, shipping, waves, &c.,
from nature',[158] and his was the only medal awarded to a Scottish
photographer (150).

Plate 150. Sunset on sands

CHAPTER EIGHT

Technique and Aesthetics

In the technical evolution of photography the physical involvement of the photographer has steadily decreased. Compare a modern camera which requires no manipulative skill for loading with film and no knowledge for making an exposure, with a wet-collodion camera of the nineteenth century. The photographer was then totally responsible for making decisions, based on judgement and experience, at every stage of the process. He had to acquire his skills and knowledge over a period of time and with considerable practical experience. This inevitably meant that each had his own particular methods for achieving results. Some remained incompetent dabblers whose results achieved a soot and whitewash quality that was derided by all who saw them. Others achieved complete mastery of the process in all its complexities and produced prints that revealed every nuance of tone. It is not surprising that the photographic journals, sensing a need, devoted much of their space to technical articles which either educated the uninformed or offered alternatives to the proficient. They also announced, with depressing regularity, 'improvements', the chemical or optical variations of which were perhaps never adopted or were soon abandoned. Those writers of exhibition and critical reviews, whose ability to write cogently about aesthetic matters was somewhat uncertain, not unnaturally turned their attention to the more easily recognisable and measurable features of lens definition, print quality, and tonal gradations.

This preoccupation with technique led not only to photographers laying great store by it, but also to their being judged by it. Consequently, no photographer comes readily to mind whose aesthetic judgement outweighed a deficient technique. The only possible exception was Julia Margret Cameron whose intense preoccupation with her sitters combined with an amateurish technique to give highly individual results. Contemporary opinion was sharply divided about her work.

Unlike Mrs Cameron, Wilson was universally acclaimed for his technique which was recognised as being virtuoso and an integral part of his aesthetic. His work was seen as an example and as the ultimate goal for other photographers to work towards. Yet there was nothing special in his technique, nothing different or exceptional in what he used. Like others he used the wet-collodion process. As early as 1858 he maintained that 'a little artistic knowledge, and a little common sense are more to be depended upon than peculiarities in the developing solution'.[159]

The wet-collodion process announced by F. Scott Archer in March

1851 had a profound effect on the development of photography as it released the medium from many of the difficulties experienced with the calotype and daguerreotype. The essential difference lay in the use of glass as the support for the light sensitive emulsion which gave the negative a transparency and fidelity previously unattainable. The process was, in theory, comparatively simple, though in practice its several stages of preparation made it difficult to use.

The collodion solution was, for the most part, commercially prepared by dissolving gun cotton in ether. The photographer then used this viscous mass to coat a glass plate which had been carefully

Plate 151. Coating the plate with collodion

cleaned and degreased (151). After an even coating had been applied, the ether present in the solution evaporated, leaving a moist absorbent film adhering to the plate. This was then made sensitive to light by dipping it into a bath of silver salts which were readily taken up by the collodion film. After the excess solution was drained off, the still moist plate was secured in a light-tight plate holder so that it could be taken into the light and to the camera for exposure. These manipulations were carried out by the photographer in almost total darkness with only a hint of yellow light for illumination. Once exposed, the plate was developed in the same subdued light, in a solution of pyrogallic and acetic acid. During development the plate was carefully scrutinised by the photographer who used his experience to judge when the image had achieved the correct density. The image was made permanent by fixing it in a solution of either hypo or potassium cyanide, which, although a deadly poison, was widely used. The handling of the poison led to frequent tragedies. Some photographers regularly washed their hands in the solution to remove the dark silver stains, and one even went so far as to bite through a large lump of it so that he could get it into his narrow mouthed bottle. Only prompt action saved his life.[160]

There was always an urgency about the process: the plate had to be sensitised, exposed and developed in three, almost continuous, steps. Only while the emulsion remained moist was it sensitive to light and receptive to the developer. If it dried out, the plate was entirely spoilt. Because of this essential requirement of the collodion process, photographers were obliged to take their darkrooms and paraphernalia with them whenever they ventured out of the studio to photograph. These portable and ingenious constructions often took the form of small tents, though some ambitious photographers converted vans and carriages into truly mobile darkrooms. The freedom of movement increased the range and scope of the photographers' activities.

The first known occasion on which Wilson was obliged to photograph away from the studio was in 1854, with his first visit to Balmoral, when he recorded the new castle under construction and the keepers with the stags shot by Prince Albert. Little is known of how he worked in the field at this time, but the results at Balmoral confirm the belief that he was already experienced in handling the collodion process out of doors.

Ten years later, when his skill with the process was widely recognised, he was urged by *The British Journal of Photography* to write about his apparatus and working methods for the benefit of their

readers. The information came in a series of letters that Wilson wrote during his ample free time on a trip to the Lake District when it rained and blew for nearly a fortnight. He began by describing the selection and preparation of his glass plates. 'I use the best patent plate of about three-sixteenths of an inch in thickness. . . . The plates are first rubbed over with dilute nitric acid, and well rinsed immediately with water flowing from a tap. They are then polished on one side slightly and on the *best* side thoroughly with a chamois leather and plenty of "elbow-grease", and then stored up in plate boxes holding two dozen each. Four of these boxes I take with me on a journey, and, if occasion requires, have as many more forwarded to me by rail afterwards, packed in bundles, with clean writing or blotting paper between each glass, the packing-box in which they arrive being used for returning finished negatives ready for printing.'[161]

The quality of the glass used in photography was of some importance; uneven surfaces, bubbles and scratches revealed themselves as defects in the print. Wilson's practice was to obtain the best glass available, for in the end it proved to be the cheapest. He bought his from Chance Brothers of Birmingham, who were renowned for the fine quality of their glass.[162] The eight dozen plates mentioned were his expected requirements for a four- to six-week excursion and were only part of the miscellany of equipment needed to sustain him; the chemicals came next.

The chemicals I pack in two bottle baskets, made especially strong and light; one of them—the larger—is a stock basket containing about six one-pint bottles of nitrate of silver bath, four pints of collodion, two pints of glacial acetic acid, two pints of varnish, one wide mouthed bottle filled with protosulphate of iron, and another with cyanide of potassium. . . . The spaces between the bottles and the top contain a plate holder for polishing plates, a pneumatic holder for use in coating them, clean chamois skins, one quire of white blotting paper, and another of brown wrapping-paper, a ball of twine, and some spare two ounce bottles for use in varnishing.[163]

This larger basket was so cumbersome that Wilson left it at his lodgings and drew from it the smaller quantities of chemicals necessary for a day's work. These he packed into a smaller basket, designed to be slung over one shoulder and compartmentalised to carry everything in safety.

It is fitted up with a glass bath in a wooden case (the dipper and the bath secured from breakage by jamming a cork tight between the former and the side of the bath), three sixteen-ounce bottles of nitrate of silver solution, one sixteen-ounce bottle containing developing solution, a small wide mouthed bottle for holding crystals of protosulphate of iron, another of the same shape fixing solution of cyanide of potassium, eight two-ounce corked bottles of collodion, three two-ounce bottles of glacial acetic acid, small bottle of convenient lumps of cyanide of potassium, developing cup, a small glass funnel, a small gutta-percha ditto, three tent pegs with cords attached, two towels, pneumatic plate holder, dropping bottle for nitrate of silver and a small portfolio containing filtering paper. The rest of the *impedimenta* consists of the camera. . . . A tripod of the ordinary kind for the camera, with a smaller ditto for tent, enclosed, when folded up, within the larger one, the whole being secured with a strap and buckle, also two tin cans and a tin jug, fitting into each other so as to make but one package. All this may seem to be a great quantity of material, but it does not look so much in reality as it does in the description, and after a good many years' experience in working with wet collodion, I find it is scarcely possible to get on with less, if one expects anything like satisfactory results.[164]

It was scarcely possible to manage all this equipment (152) without the help of an assistant, and Wilson readily admitted that he was unable to do so without the help of William Gellie who accompanied him on the photographic tours.[165] When loaded up with their various baskets, jugs, tripods, and so on they presented such a bizarre sight that they were sometimes mistaken for itinerant umbrella menders, or, as once happened at Devonport, as Highland bagpipers![166] Over the years of their working together they had

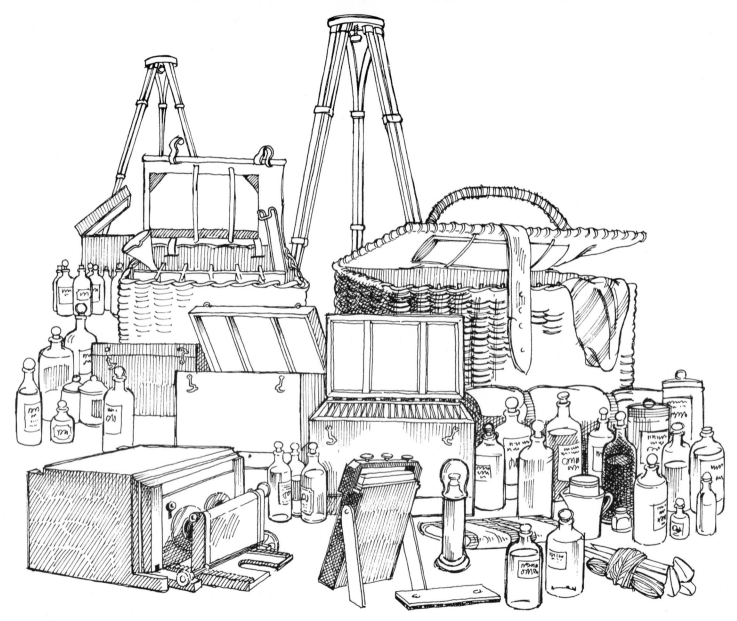

Plate 152. Wilson's photographic paraphernalia

evolved a routine in which each understood his part and each shared the labour, though not the skills, of the photography. Having reached the chosen spot, they unloaded, and Gellie would set about unpacking the chemicals and erecting the tent, while Wilson chose his viewpoint and set up the camera. The tent was simple, light and of Wilson's own design. It was made from two layers of black calico cut and stitched to form a bell tent. In one side was cut a small window which was covered with a double layer of yellow calico to render the incoming light non-actinic. It could be pitched in about half a minute over a tripod framework and the bottom of the fabric was weighted down with rocks.

Unless I am in a great hurry to catch some very transient effect, however, I usually shake the dust well out of it, water the ground on which it is to be placed and the stones which are to be placed round it inside, to keep the light from entering below. If the weather be very dry, and dust flying about, I also go over the inside of the tent with a damp cloth or sponge.[167]

Dust was an ever present hazard to the collodion process because of the imperfections it caused, and every photographer had his own particular method of keeping it down. While water kept the dust down, little could be done during the summer to combat the persistent and ferocious Scottish midges. Finding themselves trapped inside the tent and dizzy with the ether fumes, they wildly spiralled about, wreaking havoc once they found themselves ensnared in the sticky emulsion.[168] Wilson's own deterrent for midges was what his wife called 'that beastly tobacco' which, despite her protestations, he greatly enjoyed smoking.

With the tent erected and dampened, Wilson carefully laid out his various trays, developing cups and dropping-bottles in a specific order. Then while he was giving a final polish to the plate, Gellie trotted off with the jugs to find water, which was not always as pure or as clean as required (153).

In general I use the water from the spring or pool nearest my camping ground . . ., and I find it, except in the chalk districts,

usually sufficiently pure for the purpose. Immediately after rainy weather, when I am working amongst the hills, the water often requires to be filtered to get rid of small seeds, bits of moss &c., which would otherwise make pinholes in the collodion; and I have sometimes found it labour not in vain to dig a well with my hands near a promising spring, . . . so as to have a nice clear pool to fill the can at some future time.[169]

By planning ahead in this way Wilson was able to save many hours of fruitless effort later. On dull days he invariably set off to 'hunt up foregrounds' to the subjects he had decided on photographing and to make sketches and notes so that he could find them easily again.

Crouched on his hands and knees inside the tent, with Gellie holding the flap tightly shut, Wilson set about the difficult task of coating and sensitizing the plate. This achieved, he loaded it into a dark-slide and emerged gratefully into the open air. What effects the ether had upon Wilson is hard to determine, but there is evidence to suggest that he could have been addicted to its fumes.[170]
Placing the dark-slide into the camera he was ready to make his exposure.

Some days when, owing to the variation of the intensity of the light on the amount of shadow in the views, I have begun the morning with an exposure of ten seconds, I have ended in the afternoon with one of three minutes, without losing a plate from either over or under exposure during the day.[171]

The modesty of this statement disguises Wilson's true ability in assessing the actinic power of the light and relating that to the length of his exposure. There were no devices to help the photographer determine his exposure; it was arrived at purely by a combination of eye and experience.

The plate being exposed, I get myself shut up in the tent and develop in the usual way by dashing on the solution as quickly as possible. If it is an instantaneous view all the details should come up slowly and distinctly; but I keep on moving the plate for two or three minutes, so as to get all that I can up before washing off

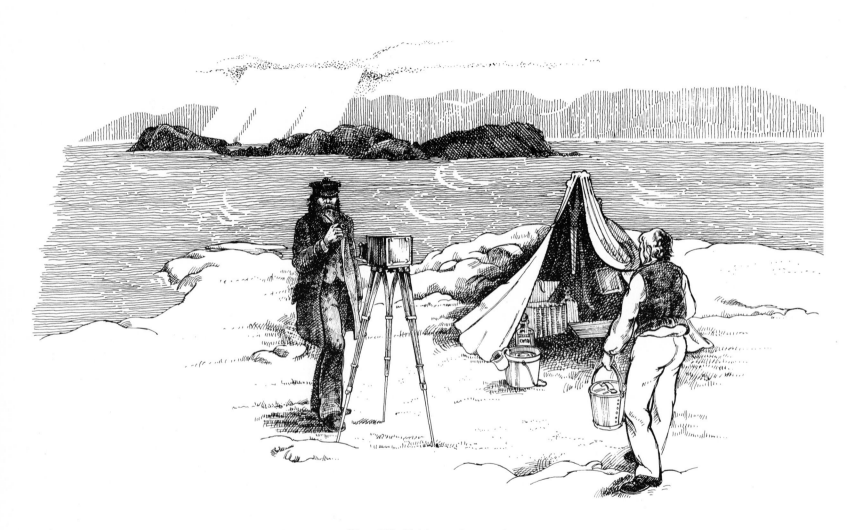

Plate 153. Taking a photograph

the developer. This I do carefully and slowly, and as the negative in this stage is very thin in deposit, I pour from my dropping-bottle a small stream of nitrate of silver along the side of the plate, and let it flow over the whole surface, before dashing on a fresh dose of developing solution, keeping the plate moving as usual. When this has acted for a minute or so, I wash off again very carefully, and repeat the process, sometimes three or four times, if necessary, until the requisite printing density is attained; then after washing, I bring it outside the tent, wash thoroughly and fix with cyanide of potassium.[172]

The development and intensification stage of the process was, like all the other stages, one that required the intervention of human judgement and skill. This rather brief account reveals nothing about Wilson's ability and explains only his methods.

One task that he would have gladly handed over to anyone was the varnishing of his negatives to protect them and prepare them for printing (154). This was messy under perfect conditions, but when it had to be done in the less than ideal surroundings of a lodging house bedroom in front of the fire, Wilson compared it to 'roasting oneself for a couple of hours over a slow fire on a bright day in August'.[173] All in all, it was a job that he detested, but it was essential for the preservation of the negatives.

In the first place, I require a clear fire for varnishing; and, if I can manage to get this in my bedroom, my first proceeding is to lock the door to prevent anyone suddenly opening it and raising a cloud of dust whilst I am in the act of pouring on the varnish. . . .

When the fire burns clear I remove the fender and fire-irons, and spread some sheets of brown paper on the hearthstone to catch drops of varnish, and avoid making a mess. I then stick a (pneumatic) plate-holder on the back of the plate, wipe the dust from the surface with a gilder's brush, pour on the varnish as if coating a plate with collodion. . . .

When all the plates have been gone over in this way, I examine them for pinholes and spots, fill up the former very carefully with lamp-black, so as to conceal them and nothing more; and if there are any opaque spots I dig them out very gently with the point of a pen-knife. When all are touched up I proceed to varnish them all over again. . . .

This second varnishing fixes the touches of colour in the pinholes and enables the negative to yield a greater number of proofs than it would otherwise do—a matter of some importance when printing for commercial purposes. The sharpness of the negative is sometimes slightly deteriorated by this double varnishing, but not much; but then I have printed for four or five years constantly from such a negative, when it would have been worn out in one season with only a single coat of varnish to protect it.[174]

Finally the negatives were cleaned and packed into boxes between sheets of blotting paper and despatched back to Aberdeen for printing.

It has been mentioned in an earlier chapter that Wilson used his Crown Street premises for all his printing, both landscape and portraiture. This must have created problems when the volume of landscape photographs grew. In order to meet these demands and also to rationalise space elsewhere, Wilson altered the layout and nature of the three properties he owned, firstly in 1860 and again in 1861. This second alteration probably involved moving his printing premises to the outskirts of town where he had rented some buildings in the disused Glenburnie Distillery (155). The printing process in those days was carried out in daylight and the rate of printing was governed by the intensity of the light. The fact that the new site was 'beyond the smoke of the city'[175] was of some importance. The other asset was the continuous supply of running water from the Glen Burn which ensured the adequate washing of the prints to remove the chemical residue and make them permanent.

Daylight printing was the only practical method then available and whilst it was tedious, slow and time-consuming it yielded marvellous prints unmatched for their richness and tonality. Firstly, the glass negative was placed in direct, emulsion-to-emulsion contact with a specially prepared printing paper, its sensitivity to light being extremely low. The negative and paper were then bound

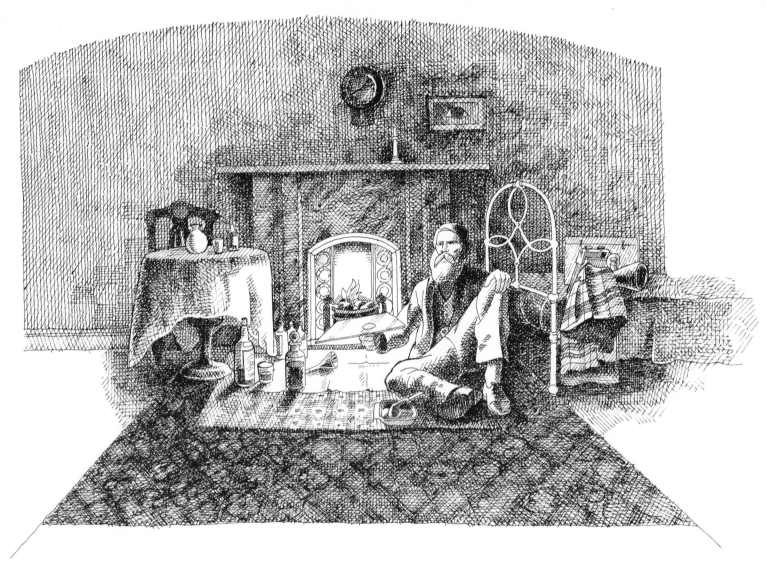

Plate 154. Varnishing the plates

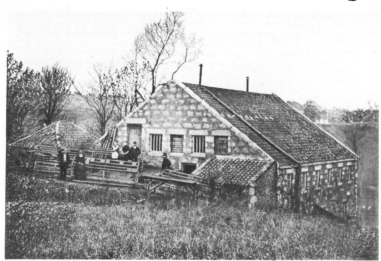

Plate 155. Glenburnie Distillery, used as a photographic printing works, 1869–1876

judged, as indeed can Wilson's financial status as a photographer, from the print production and turnover figures for 1864/5, the only such statistics to have survived. In that year the combined output of the landscape and portraiture came to 553,331 prints.[177] This total was achieved only by having over 400 printing frames out daily and a team of printers working long hours, six days a week. The human effort was truly prodigious. Using the earlier example which showed that each print required at least ten labour-intensive stages to get it to a finished state ready for despatch, and relating that figure to the 553,331 prints made at Glenburnie, one may calculate that there were well over five million stages involved in their production.

In breaking the printing process down into a number of finite stages and making each stage the responsibility of an individual, or a group of individuals, Wilson had taken the concept of the division of labour that governed factory production and applied it to his photographic business. He employed mainly women as they were considered ideally suited to the dull, repetitive work of loading the printing frames and checking them continually during the exposure (156). Some of the women were also responsible for washing, drying, turning, spotting, mounting and despatching the photographs, and they were probably assisted in this by children. The supervisory jobs

together under pressure in a wooden frame, and placed outside on a printing rack, with the negative facing the sky. The printing paper slowly darkened with the action of the light until a print of the required density was reached, when the frame would be taken indoors and the print removed, fixed, washed, gold-toned, washed, dried, burnished and finally trimmed and mounted. In essence this is what every photographer had to do in order to make a print on albumen paper. Despite the knowledge that developing the print's latent image would have speeded up the process, it was never taken up seriously as it was thought to yield inferior prints. The number of prints that could be made from one negative in one day depended upon a number of variables—the negative, the season of the year, and the day in question. An average was established by Wilson's son Charles who calculated that with a perfect negative up to six prints per day could be made during the summer months, dropping to two or three prints from the same negative in winter. On some days the weather was so bad that the printers were sent home.[176]

The scale of the printing establishment at Glenburnie can be

Plate 156. Printing staff from Glenburnie Works

were undertaken by men and the whole works was managed by Wilson's assistant, William Gellie. Such large photographic printing works were not common; photography was regarded as a solitary or small scale exercise in which the operator had to be prepared to manipulate every stage of the process himself. The notion that factory methods could be used did not gain ground until after the introduction of the *carte-de-visite*, when the huge demand, fierce competition and dwindling profits, forced mass production techniques on to photography. Other photographers like Disderi and Mayall had been among the first portrait photographers to mass produce prints, but Wilson was certainly one of the earliest to apply the principle to the production of landscape views.

The move to Glenburnie was undoubtedly an important stage in the expansion of Wilson's business. The move had originally been made to alleviate the pressures at Crown Street. Now the larger premises showed the potential of mass production techniques. In 1864/5 the total sales of the business, taking into account both landscape and portraiture, amounted to £10,770. 19s. 9d. Significantly, the landscape photographs accounted for the larger share, with sales of £6145. 2s. 10d.[178] These figures, of course, do not represent profit; that is impossible to establish as there are no comparative figures showing the outgoings on materials, labour and travel.[179] But whatever these outgoings were, one can be sure that with a turnover in excess of ten thousand pounds Wilson's income must have been substantial. One indication that this was so is the way in which Wilson used his income to improve his way of life. The house in Crown Street, purchased in 1852, was a well-built though modest property that over the years underwent several structural alterations to accommodate a growing family and prospering business. When the largest part of the business moved out to Glenburnie, leaving Crown Street freer than it had been for a long time, Wilson decided that the time had come for him also to move out to the suburbs where he could build a house that would reflect his position as 'Photographer to the Queen' and positively establish his position in Aberdeen society.

In order to achieve this objective it was important that the design of the new house should break away from the traditional, four-square architecture that characterised Aberdeen's middle class housing. Together with J. Russell Mackenzie, a local architect, he designed a house that was symmetrical in its plan, picturesque in its elevation and continental in its overall appearance. No expense was spared in its specifications and many of the latest design features of the period were incorporated in it. It had large plate, rather than sheet, glass windows, and was the first house in Aberdeen to be equipped with central heating.[180] The top of the house was richly encrusted with ornamental ironwork supplied by the Saracen ironworks of Glasgow to designs that they had displayed at the 1862 International Exhibition. With such a mass of metal thrusting up into the sky, Wilson thought he had better not tempt providence, so he sought protection with a lightning conductor—another novelty for a private house. In 1865 when the house was completed and the gardens laid out, the Wilsons left Crown Street and took up residence (157–159). Just a few years later, when the junction on which the house stood was properly laid out, and the roads made up, it was given the name of Queen's Cross. Although this name had nothing to do with Wilson's royal connections at Balmoral, it must have pleased him that the name had been chosen.

The style and comfort that Wilson sought at Queen's Cross contrasted sharply with the rough and ready accommodation that was often his lot on his frequent photographic trips. One gets the feeling that these excursions represent an alternative side to Wilson's character. Whereas at home he was closely bound up with the conventions and the social niceties that ordered his family life, he was liberated once he set off on his travels. When he made his first visit to the Trossachs with George Walker in 1859 they seem to have thoroughly enjoyed themselves. Walker tells us how they 'bathed in the loch, in spite of the monster pike we saw, and we hid ourselves in the braken, which was in many places eight feet in height'.[181] The midges they disturbed attacked Walker with ferocity and brought his face and neck out in bright red swellings. He was puzzled that they left Wilson entirely alone and wondered whether it was 'in consequence of the fumes of chloroform and collodion with which his clothes were saturated'.[182]

Even more ferocious insects were to attack them the following

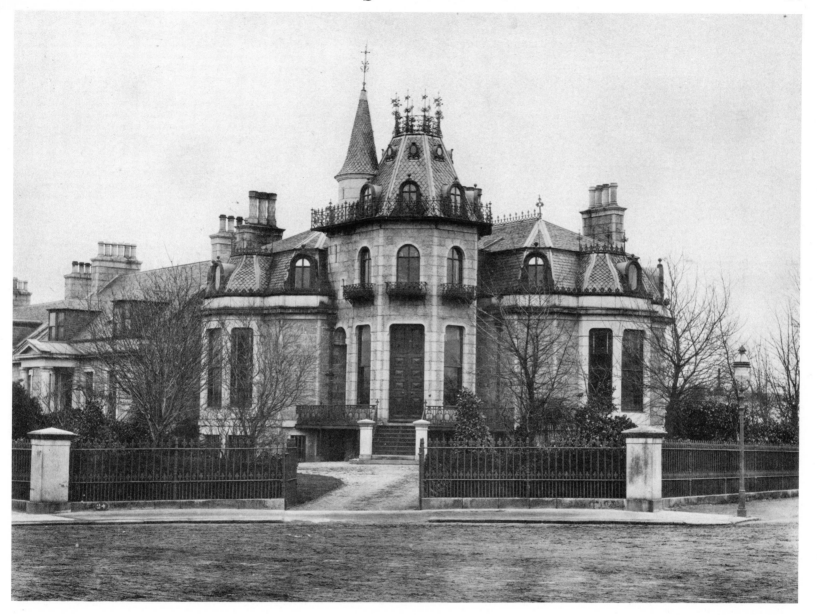

Plate 157. Queen's Cross

Plate 158. The Drawing Room, Queen's Cross

Plate 159. The garden, Queen's Cross

year when they were visiting Glencoe. Once again it is Walker who recalls the experience.

> We went off to Glencoe, where we staid (*sic*) in a vile little carriers' Inn in the Glen for some days, photographing busily and profitably. The beds in the place did not seem at all clean, being chiefly used by drovers, and as I had a horror at the bare possibility of catching the itch, I stripped to the skin before lying down believing that there was more danger in them attaching to the clothes than to the skin. I had not been asleep for a couple of hours when I was roused by finding I had more bedfellows than was agreeable. . . . Luckily we had ordered a bottle of whisky the night before but not finding it made palatable toddy, it was little used. Getting up I washed myself all over with it and turning down the blankets gave the bed a good sprinkling, and lay down again getting three hours comfortable sleep, when I repeated the dose with capital effect. The beggars were forced to break the pledge.[183]

They were equally suspicious of the food as the meat that they were served was always highly spiced.

> Wilson who was very particular about food, began watching the coaches, and hunting about the premises to see what it was, and found that we had been living on 'braxie' mutton, meat that came from sheep found dead on the hills, 'which spoiled his stomach for it'.[184]

Whatever the vicissitudes of staying in highland inns, the compensations of being self-employed and a free agent must have outweighed the brief discomforts. Wilson wrote:

> I often do not know the evening before I start, for what place I may chance to take my railway ticket on the morrow. There are so many places which I am told I ought to visit, and so many beautiful scenes in this beautiful country of ours, that I often have difficulty in deciding whether I ought to go to the seaside in search of clouds and shipping, to the English cathedrals for

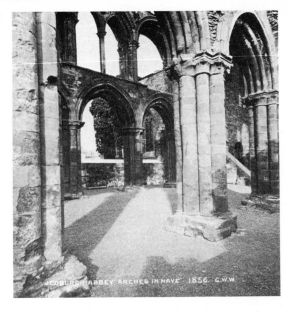

Plate 160. *Jedburgh Abbey, Arches in Nave*

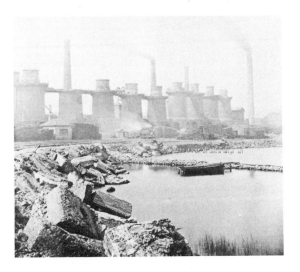

Plate 161. *Glengarrock Ironworks, Ayrshire*

picturesque interiors, or to the mountains and lochs for rocks and foliage and calm water.[185]

Once the decision was made and an unfamiliar destination arrived at he was just like any other tourist whose knowledge of the region was drawn from the pages of a guide book. And like a tourist he eagerly sought out his subjects, but as a photographer he took care to find suitable foregrounds to enhance the final picture. Even in this he had to think like tourists and consider their ways.

The difficulty in finding a suitable foreground is also increased by the circumstance that I have to study popular taste as well as my own, and must try not only to get a pleasing picture of a place, but one also that can be recognised by the public; and the public is not much given to scrambling to out-of-the-way places where a superb view may be had of a celebrated spot, if it can see it tolerably well from the Queen's highway.[186]

In Wilson's work there was a blending of the influences arising from his classical art training and of the special requirements which popular taste and geographic circumstance imposed upon his camera vision. Unfortunately he felt unable to write about the aesthetics of his own photographs, preferring to leave that to the numerous critics who wrote at length in the various journals. One principle guided him throughout his work;

I am never satisfied unless I can get the objects comprehended, even in a stereoscopic-sized plate, to *compose* in such a manner that the eye, in looking at it, shall be led insensibly round the picture, and at last find rest upon the most interesting spot, without having any desire to know what the neighbouring scenery looks like.[187]

The composing of pictures in such a way as to keep them self-contained and 'whole' is a recurring feature in Wilson's photographs. On some occasions, he had to content himself with making what he called, photographic 'bits'. In particular, he disliked those situations 'where the sky line of a mountain comes to an abrupt

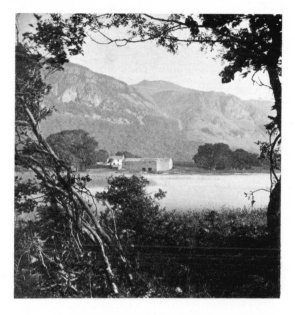

Plate 162. Wallow and Falcon Crags, Derwent Water

Plate 163. Goblin's Cave, The Trossachs

termination at the side of the picture, tantalising the spectator with suggestions of lovely scenery lying beyond the limits of the photograph'.[188] Whenever possible he overcame this by using a variety of visual devices that either contained the image within the frame or helped resolve the composition. These devices by themselves were not particularly elaborate or sophisticated, but when used together in combinations of two or more they contrived to create a stimulating visual effect.

Wilson's use of foregrounds shows his mastery in arranging his pictures within the frame. Instead of dominating the picture, which they so easily could have done, the foregrounds are placed so as to create a base, whilst giving the viewer access to the picture. In his view of the 'Upper Fall on the Garr-Valt, Braemar' (164) the foreground is taken up by a richly textured and well-lit bank of heather. In the stereoscope this resolves itself into a sweeping diagonal which creates a spatial link with the bridge on the extreme left while contrasting sharply with the smooth white boulders on the right. The bank also acts as a counterbalance to the arching span of the bridge by offering itself in a reverse curve. At the very top of the frame another foreground of branches hangs down to interrupt what would have otherwise been a blank sky. In the view of the 'Hermitage Bridge, on the Braan, Dunkeld' (165) the dark moss and lichen-covered rock that occupy most of the foreground give a feeling of security and stability to the viewer looking down into the deep chasm. The Hermitage building is partially screened by intervening foreground leaves which help to reduce its dominance and it is further subdued by the balancing effect of the brightly lit rock in the foreground.

Contrasts, both in the textural sense and in the relationship of lights to dark, were often used by Wilson to help him articulate the space within his foregrounds. The distant view of Oban (166) with its large silvery grey expanse of smooth sea is redeemed by the mass of dark and richly textured foliage that grows up from the base of the picture. Another view showing the 'Brig o' Balgownie' (167) near Aberdeen is a virtuoso performance because of the way in which he handles the various contrasts. The satin smooth reflections carried in the water are interrupted by a shingle bank;

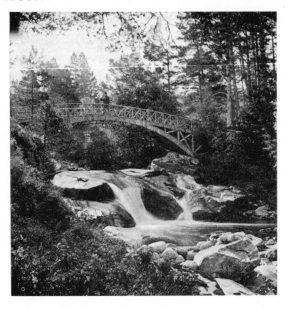

Plate 164. Upper Fall on the Garr-valt, Braemar

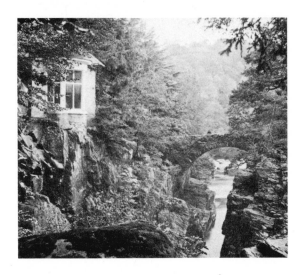

Plate 165. Hermitage Bridge on the Braan, Dunkeld

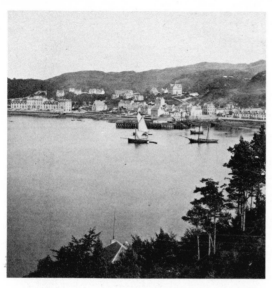

Plate 166. Oban

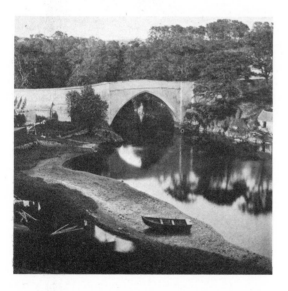

Plate 167. The Brig o' Balgownie on the Don, near Aberdeen

this in turn is interrupted by a dark boat drawn up out of the water. The snaking diagonal of the shore line naturally leads the eye towards the bridge where another highlight in the water holds the attention. Parallel to this first diagonal is a second, more sinuous, line created by a shadow cast from a high bank. This otherwise dark and blank area is punctuated by a line of washing that animates the darkness by moving. To the left of it, spars and other pieces of washing make their own contribution to the whole.

This use of darkness in the foregrounds was a part of Wilson's photographic aestheticism: he deliberately employed the technique wherever possible. This would have been loudly applauded by followers of the picturesque code and by Gilpin himself, who personally believed that 'a dark foreground makes, I think, a kind of pleasing gradation of tint from the eye to the removed parts of the landscape. It carries off the distance better than any other contrivance.'[189] Often the effect was entirely natural and was brought about by Wilson's realisation of the lighting and his awareness of the changes that would occur when the natural colour was converted into monochrome by the photographic process. On other occasions the darkness was introduced artificially. It is particularly noticeable in the larger format album views (168, 169) where the dark foreground has been created by shifting the lens to a position in which it is unable completely to cover the plate, leaving a portion without any image. This then prints as solid black. Sceptics might question the validity of this interpretation, but an examination of other album views of the same date shows that the lens could adequately cover the entire plate when required to do so.[190]

Architectural subjects created their own special problems when it came to finding suitable foregrounds, as frequently the well-ordered gardens and lawns or roads were all that flanked the building (170). This was especially true at Balmoral Castle where the large lawns made a grey uninterrupted expanse. In one view from the south all that Wilson could do to break the monotony was to introduce a cast-iron garden seat and a figure. The effect is incongruous and contrived. However, in his view of the Castle from the north west (171) he is much more successful in finding a line of birch trees to act as a screen through which the Castle can be seen. Cathedrals,

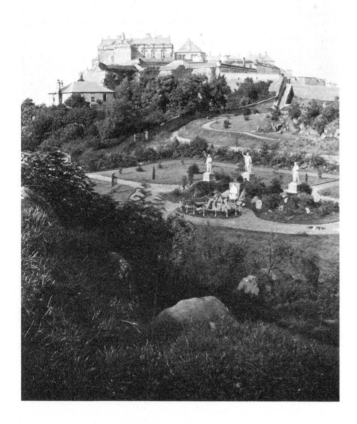

Plate 168. Stirling Castle

Plate 169. Holyrood Palace

like castles, produced problems associated with their scale and settings. As noted earlier, Wilson solved the difficulties of presenting an overall view of York Minster by going above the roof tops and then using them to give variety and texture to the foreground. He used this device again in a view of Lincoln Cathedral (172) which is given added charm by a horse and cart in the corner of the frame.

Where photographic 'bits' were likely to occur because the horizon line ran up hard against the edge of the frame, Wilson often placed sidescreens on each side of the picture to soften the impact. This is well demonstrated in his view of Ellen's Isle, Loch Katrine (173) where the dark and decorative mountain ash creates a perfect frame whilst masking the horizon line. Elsewhere these screens are used to form a boundary to the edge of the frame or to balance an uneven

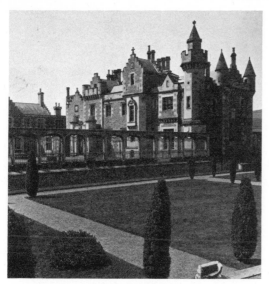

Plate 170. Abbotsford—The Garden Front

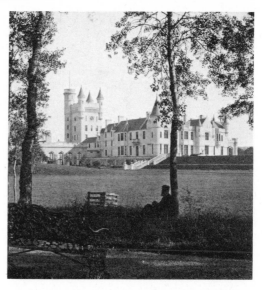

Plate 171. Balmoral Castle from the Northwest

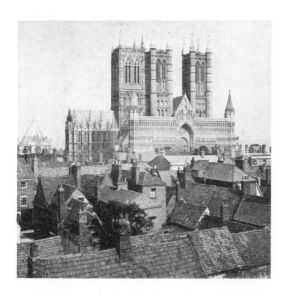

Plate 172. Lincoln Cathedral, from the Northwest

Plate 173. Ellen's Isle, Loch Katrine

composition. One good example of this is the view of 'Melrose Abbey—the Nave' (174) where a band of ivy-covered masonry is deliberately brought in from the right to create an edge for the empty space of the window. The dark granite piers supporting the 'Cornwall Railway at Saltash' (175) serve a similar purpose by forming a frame for Brunel's viaduct and, on the right, interrupting the horizon line of a distant hill. Stonework of a different sort appears on the extreme right of a view of the 'Linn of Quoich' (176) where it combines with a dark band and a diagonal support to suggest the underside of a bridge. Wilson's care in choosing to place these elements at the very edge of his frame can be seen by comparing this image with the whole area of the negative from which it was taken (177).

Occasionally, Wilson was able to use the side screens in such a way that they not only bounded the edge of the frame but also directed the eye towards the rest of the subject. In an interior view of Glasgow Cathedral (178), the fluted column on the left is set at a diagonal plane away from the viewer and its position is further emphasised by the perspective lines created by the horizontal joints of the stonework. These converging lines are the starting point for a dialogue between the several opposing diagonal planes that recede deep within the picture. This use of the diagonal as a structural element of his photographs was another favourite device of Wilson's. Already it has been seen at work in relationship with foregrounds where it had an enclosing effect. He also used it as a visual pathway for the eye to follow, as in his views of the Pass of Killiecrankie (179) and Fingal's Cave (180). The diagonals in these images are used in a classical way that has been taken from an earlier tradition in painting. Less customary is the powerful image of the 'Cauldron at the Rumbling Bridge, Dunkeld' (181), where a dynamic tension is created by the vortex of diagonals. The effectiveness of the diagonal as a compositional element depends largely upon the emphasis which it is given, and Wilson's skill lay in knowing how and when to use this. In the view of Edinburgh Castle (182), Wilson cleverly used the neat and regimented order of the recently completed Princes Street gardens as a series of crisp diagonals to point up the picturesque jumble of the distant Castle. In the study of Pike Fishing (183) the delicate line of the rod only

Plate 174. Melrose Abbey, The Nave

Plate 175. Cornwall Railway at Saltash

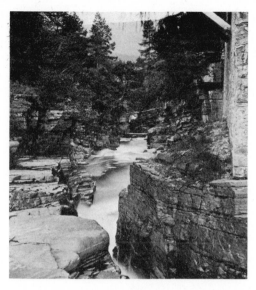

Plate 176. Linn of Quoich, Braemar

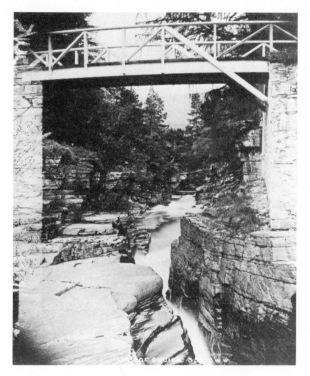

Plate 177. Linn of Quoich, Braemar

Plate 178. Glasgow Cathedral, The Rood Screen

slightly interrupts and creates a pause in the succession of horizontals that give the picture its tranquility.

Much technical information comes from Wilson's own writings in *The British Journal of Photography* where he freely explained his working methods. Before presenting the last instalment of Wilson's articles, the editor took the opportunity to dispel some popular misconceptions about photography, using Wilson as a model for his argument. He began by condemning many 'would-be-photographers as meddlers and muddlers without the energy, patience and perseverance to carry anything out successfully'. It is these people, he points out, who

seem to live in the idea that artists like Mr. Wilson must be possessed of some peculiar secret, which they are disinclined to give

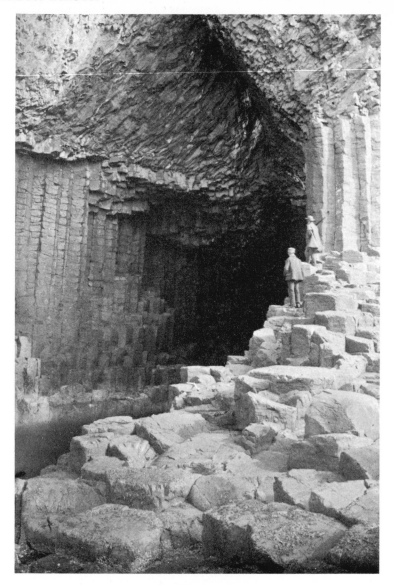

Plate 179. The Pass of Killiecrankie

Plate 180. Fingal's Cave, Staffa

Plate 181. *Cauldron at the Rumbling Bridge*

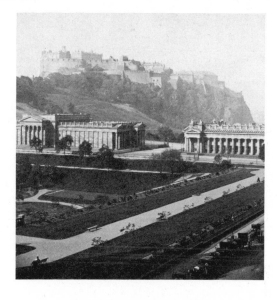

Plate 182. *Edinburgh Castle*

Plate 183. *Loch of Park, Pike Fishing*

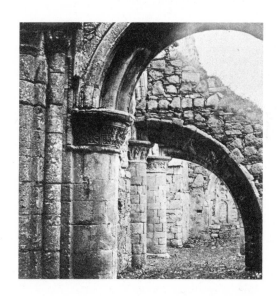

Plate 184. *Iona Cathedral—The South Aisle*

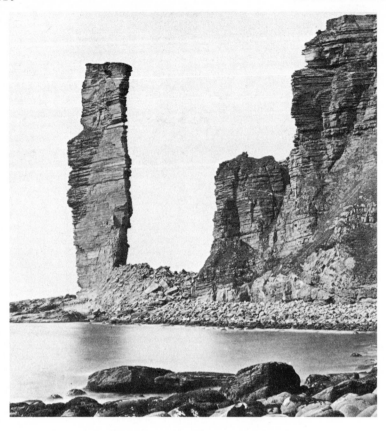

Plate 185. The Old Man of Hoy

way which he considered the best for good effect; and all this under circumstances of personal discomfort which few of us would care to undergo. . . .

Artistic photography, therefore, is not quite so easy a thing as is generally imagined; for it requires not only skilful manipulation—a power which can easily be acquired by practice—but, above all, the operator must possess energy of purpose, patience under difficulties, and a higher quality still, which cannot be acquired, although, when present, it may be cultivated, namely, 'artistic taste and feeling'.[191]

to others. They fancy their photographs are executed with surprising facility, and not by the exercise of great patience and perserverance, not to speak of other qualities; but let them now learn, after carefully perusing these articles, that it is the *man*, and not any peculiarity of his manipulations, that stamps a character on the works which he can execute. . . . Many again, have supposed that artistic photographs of scenery can be produced at any time with ease and certainty. Mr. Wilson's experience tells a different tale. We have known him wait for more than three weeks for the purpose of securing a single view, illuminated in a

CHAPTER NINE

Commercial Considerations

In the preface to their book *Ruined Abbeys and Castles of Great Britain,* published in 1862, the authors, William and Mary Howitt, explain their reasons for including real photographs as illustrations to their text. 'It appears to us a decided advantage in the department of topography to unite it with photography. The reader is no longer left to suppose himself at the mercy of the imaginations, the caprices, or the deficiencies of artists, but to have before him the genuine presentment of the object under consideration.'[192] To reinforce their point they had chosen to include work by the leading topographical photographers of the period including Bedford, Fenton, Ogle, Sedgefield and Wilson. In Wilson's case, however, their selection of eight prints was not entirely happy as these were untypical of his work. One reviewer at the time said, 'I regret to see some of Wilson's , of which I know him to possess finer versions of the subject.'[193] It is difficult to understand why these finer versions were passed over in favour of the mediocre selection that was finally presented. The only explanation that offers itself arises from the fact that Russell Sedgefield was responsible for printing all of the photographs in the book: Wilson was perhaps unwilling to surrender his most popular negatives to him.

Almost as a prelude to a later publication, Wilson provided the frontispiece to Scott's *The Lady of the Lake,* published by A. W. Bennett of London in 1862. The majority of the illustrations for the text, however, were provided by Thomas Ogle of Preston. Wilson's photograph was one of his more popular images from the stereoscopic series and showed Sir Walter Scott's Tomb at Dryburgh Abbey (186). In this the dark trees of the foreground contrast well with the lighter colour of the Abbey and create a suitably romantic setting for the contemplative figure against the railings.

It was appropriate that Wilson should be chosen by the publishers, A. & C. Black of Edinburgh, who had been copyright holders of Scott's work, to illustrate jointly with Birket Foster and John Gilbert their edition of *The Lady of the Lake,* published in 1866. The eleven photographs, with one exception, are album sized prints (each approx. 4¼ × 3¼ in.) mounted within a larger border that also carried a title and an appropriate, footnoted, couplet from the poem (187). Whereas Foster's and Gilbert's drawings rely entirely on the events of the narrative for their context and content, Wilson's photographs become the topographical record of the region in which the poem is set. Despite his interpretive efforts to create romantic images and picturesque effects, the photographs can never match the highly charged and subjective drawings;

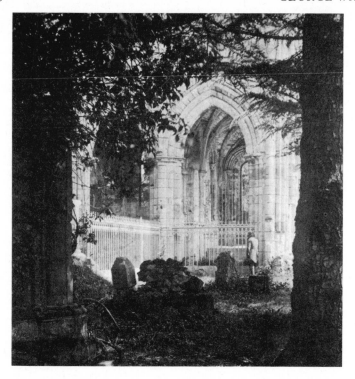

Plate 186. Dryburgh Abbey—The tomb of Sir Walter Scott

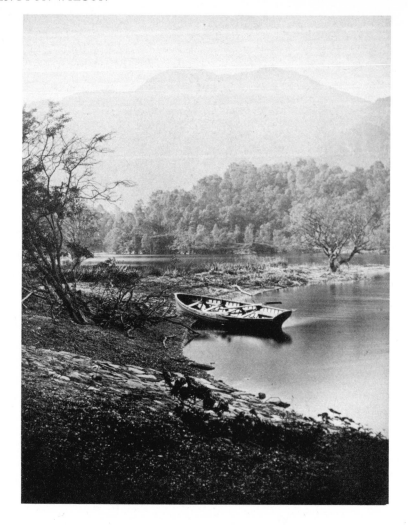

Plate 187. The Silver Strand, Loch Katrine

instead they are means whereby the reader can relate more easily to the 'actual' setting of the poem.

Following his success at the 1862 International Exhibition and after the introduction of the cabinet and album prints, Wilson began to think of other ways in which he could extend the range of his photographic activities. He was already well experienced in the tastes of the photograph-buying public and was well aware of their preferences for certain views and the way in which these grouped themselves within particular regions. He also had some slight experience of the publishing world through his book illustrations. Perhaps it was the combination of all these factors that made him take up an earlier suggestion made in *The Photographic Journal*: 'how charming would be a volume of Scottish illustrations on this small scale, which would at once illustrate the perfection of the art, and be within the power of anyone to acquire at a moderate rate! We recommend this hint to Mr. Wilson's consideration.'[194]

The first two volumes of a much longer series were published under Wilson's name in 1865 with the general title *Photographs of*

English and Scottish Scenery. These slim, dark green volumes each carry twelve photographs accompanied by a page of text written by Wilson, who relies on a mixture of his own experiences and guide book information for the description. Ten further volumes were published between 1866 and 1868, and in 1867 Wilson sold the publishing rights to A. Marion, Son & Co. of London who were already distributing his royal portraits and stereograms. Looking at the series as a whole one sees the titles of the best known tourist resorts of Scotland. They include Edinburgh (1865 and 1868), Glasgow (1868), Aberdeen (1867), Braemar (1866), Balmoral (1866), Staffa and Iona (1867) and Scottish Abbeys (1868). English resorts fare less well; the only two titles to appear are not of scenery as such but deal with the cathedrals at York and Durham (1865) and Gloucester (1866). Wilson did not take photographs specifically for publication in this series, but instead used his existing negatives (188–192). As nearly all the prints are album sized (3⅛ × 4¼ in.) and come from one half of a stereoscopic negative, they are usually of a vertical format. It will be remembered that in 1868 Wilson also published his folio of forty-two photographs to illustrate the *Queen's Book.*

Through these publications we may see Wilson's gradually changing attitude to his photography and his audience. Whereas previously he had been primarily concerned with establishing his reputation and market by means of innovation and publicity, with financial rewards as a secondary though still important concern, he was now beginning to place increasing emphasis on the commercial aspects of his work. The publication of the books is not innovative as his earlier work had been; the books followed established prototypes of book production. Furthermore the photographs were taken from existing negatives. Only the presentation of topographic subject matter can be said to be at all new, although even here there were some precedents. In short, the books were a speculative commercial venture designed to improve sales.

The shift from creativity to commercialism is also shown by the decline in the submission of new work to the photographic journals for critical review. This practice had begun in 1857, was built up to reach a peak in 1862/3, and gradually declined thereafter. Initially

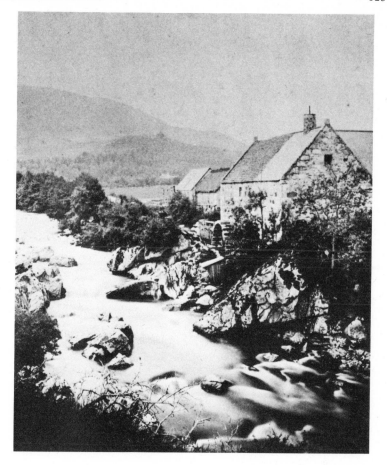

Plate 188. Mill on the Cluny

the reviews served Wilson well, but after 1862/3 they became superfluous and repetitive, simply extolling virtues of his work and confirming his already well recognised position. He did not stop exhibiting during this period. Exhibitions were now serving a different purpose: usually they centered upon competition to find the best prints in the show. To these events Wilson continued to send his best work, albeit sporadically, and was so successful that by 1891 he had won twenty-seven prize medals from all parts of the world.[195]

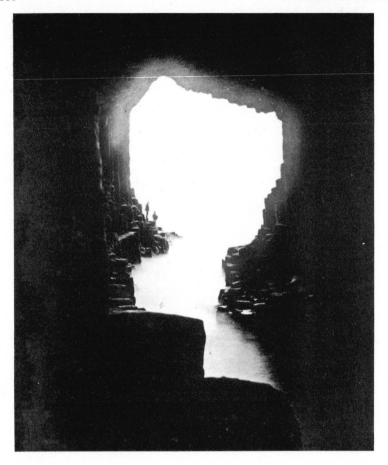

Plate 189. Interior of Fingal's Cave, looking to Iona

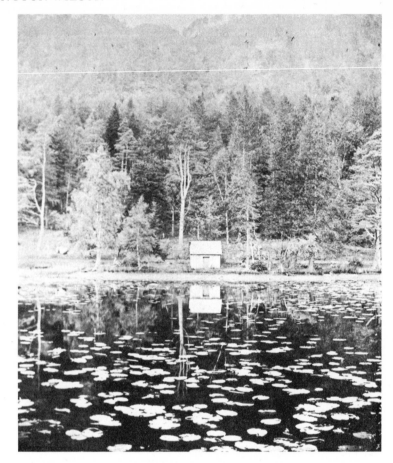

Plate 190. Loch Polney, Dunkeld

It was as if the business which had started out as a small concern was now growing at such a rate that if Wilson did not attend to its economics it would founder. Even if Wilson had continued to publish only stereograms there would have been an increasing demand for his pictures because of the growing numbers of tourists visiting Scotland each year and the expansion of his retail outlets to include Europe, North America and Canada. The introduction of the cabinet and album views created an additional demand for prints. There was an all-round increase. Initially, album prints created less of a logistical problem than cabinet views as the immediate demand could be met and stocks could be built up from existing negatives. On the other hand, the larger format of the cabinet print required Wilson to revisit many of his old locations to make the required negatives. As the popularity of both the cabinet and album prints became ensured by the mid 1860s, he was increasingly employed in simply adding new negatives of old views to the

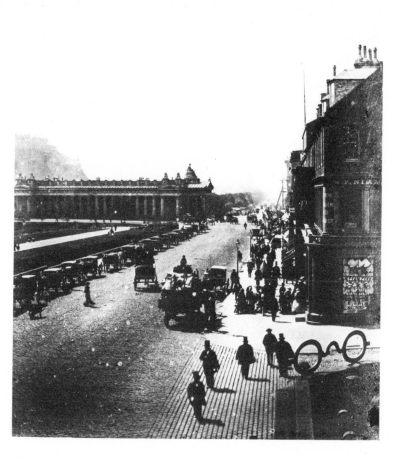

Plate 191. Princes Street, looking West

Plate 192. Durham Cathedral—from the river

files. Even the negatives for album and stereoscopic prints (one and the same thing) could not keep abreast with demand as their output was limited by the constraints of process and weather. To have more negatives was the only answer.

While the view department was flourishing vigorously, the addition of a second glass house in 1864 greatly improved the facilities at Crown Street. This, coupled with a reduction in the prices of *cartes-de-visite*, brought even more customers into the studio. The 'cartomania' craze of collecting celebrities' portraits gave an enormous boost to most branches of photography. Landscape photographers began offering views as alternatives to portraits. Wilson introduced carte views in the autumn of 1868, thereby adding a fourth size to his repertoire of print sizes.[196] The cartes he offered were further adaptations of half stereo prints, being tightly cropped versions that often produced unhappy compositions within the dominant vertical format of 2½ in.×4 in (193–196). This sacrifice

Plate 193. Glasgow Bridge. c.d.v.

Plate 194. Fountains Abbey,
from Robin Hood's Well

Plate 195. Friar's Crags,
Derwent Water

Plate 196. Fountains Abbey,
The Chapter House

of the original compositional intent of his photographs because of fashion is another indication of Wilson's increasing surrender to commercial pressures.

By 1868 the family had moved out of the house at Crown Street and were living at Queen's Cross where Wilson kept a small office so that he could work and still be close to his family. The main office was at 24-25 Crown Street and probably occupied part of the space vacated by the move to Queen's Cross. It was here that the orders from wholesalers, retailers and private individuals were received. The relevant information was then passed on to Glenburnie for printing. The orders, once completed, were returned to Crown Street for checking, invoicing and despatch. This extended line of communication between office and factory must have required an efficient system for operation under an increasing work load. A visitor to the factory in 1871 noted that Wilson 'is now possessed of a store of negatives—which, for number and excellence, I believe, will not soon, if ever be surpassed'.[197] These negatives, he says, were stored in a 'large square block of masonry filled with streets of receptacles for his negatives, all methodically arranged, labelled, and dated, so as to be easily found when required'.[198] What the actual number of negatives were the visitor had no means of knowing, but he had heard a few years earlier that Wilson had 'left off numbering the proofs he had taken from them and sent out—at that time amounting to millions—which are now profusely scattered over the habitable globe.[199] The pressure of this work meant that in 1872 Wilson employed 'thirty assistants who are constantly occupied in printing, toning, mounting, and filling his numerous orders'.[200]

Faced with the pressure of keeping abreast with demand, Wilson must have been tempted to lower his standards and values. For example, it would have been easy for him to skimp on the printing by cutting down on the washing time. Such a measure would not have been visibly apparent until much later when the prints began to fade. But this he steadfastly refused to do. Instead he insisted on maintaining a rigid quality control over the prints he sent out. He skimped nothing. As his reputation had partly been built upon the quality of his prints, to sacrifice that would have been foolhardy.

His aesthetic attitude towards the photograph also changed very little during the same period. He still took the same care with the composition and lighting of his subjects as before. This was particularly true of his stereoscopic work where there is little perceptible difference between the work of the early 1860s and that of the early 1870s. His cabinet photographs had, from the very outset, required different compositional considerations from the stereogram. The single print did not need any of the devices that help create the feeling of deep space expected of the stereogram; consequently there are very few of those images that rely on dark foregrounds and side screens for their effect. The wide angle view of 70° given by Dallmeyer's triplet lens and the fact that everything was now perceived two dimensionally, altered the relationship between the viewer and his subject. The enclosing completeness of the stereogram had been replaced by a wider vista, one that looked across, rather than through, the foreground to the main subject. In the stereoscope the observer was unaware of the print's surface and edges, and the effectiveness of the third dimension relied on getting past these boundaries into the image. A print pasted into an album, on the other hand, had a physical presence in which one was made very aware of its surfaces and edges. They are the very things that carry and contain the image. With a single print the viewer was no longer disturbed by those things that were so carefully avoided in a stereogram. The abrupt meeting of a skyline with the apparent edge of the frame in a stereogram was tantalising because the viewer felt that by moving either to the left or right he would be able to see just that little bit more. In a single print the problem was overcome because it was so obviously two-dimensional that no amount of movement would alter one's view of it. Having realised that, Wilson was able to use the horizon as an integral part of his overall compositions (197-199).

His new concern with economic strategy may have been responsible for Wilson's decision to form a partnership and create G. W. Wilson & Company: Exactly what motivated the decision is not known. The new partner, George Brown Smith, is a shadowy figure in the history of the firm. He first made his appearance in the Aberdeen directories in 1867/8 as a photographic warehouseman in Balmoral Place. As such he perhaps supplied Wilson with the materials, chemicals, and numerous sundries necessary to maintain Wilson's business. Evidence strongly suggests this possibility. Certainly they became acquainted, and over the years the links between them grew stronger until in 1871 Smith moved his business to Wilson's premises at 24 Crown Street. This was merely a prelude to the formation of the partnership. In the following year they drew up and signed the necessary documents and G. W. Wilson and Company came into being.[201] Precisely what Smith brought to the firm is unclear, but it is likely that he had capital and also knowledge of the wholesale photographic world that would enable the company to obtain its supplies at advantageous rates.

One of the first actions taken by Wilson after the foundation of the company was to consolidate its position by having his self-assumed title of 'Photographer to the Queen' officially ratified in accordance with the procedure described in Chapter Four. His application to the Lord Chamberlain's office was successful and the warrant appointing him to that position was issued on 17 July 1873.[202] It was obviously important for the status of the firm to announce that they were 'By Special Appointment'. Unfortunately the warrant was made out personally to Wilson as an individual and not to the company. To overcome this, the partners took the liberty of changing the original wording of the warrant by pluralising 'photographer' to 'photographers' which happily allowed them to imply in their advertising that it was the company that had received the honour.

After a lapse of several years Wilson also thought it prudent to begin exhibiting again. His return was warmly greeted, though not without a comment on his long absence. 'Those who imagined Mr. G. W. Wilson has been indulging in laisser-aller of late years from the fact of his not having contributed to the Photographic Society's Exhibition, will have by this time become aware that if he had been in a somnolent condition he has become thoroughly roused, and, as if refreshed by his late period of inactivity, is "out" with greater power than he has ever before displayed. Certainly we have never seen any of this great artist's previous work that could equal, much less surpass, the fine collection of twenty four choice views of Scottish scenery.'[203]

Plate 197. Iona Cathedral from the Southeast

Plate 198. Pitlochry and Ben Vracky

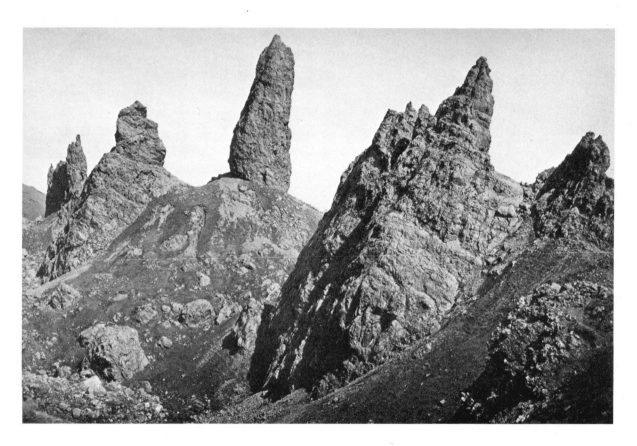

Plate 199. The Old Man of Storr, Skye

ESTABLISHED 1852.

G.W. WILSON & Cº

ÆBERDEEN.

PHOTOGRAPHERS to HER MAJESTY in SCOTLAND.

IMPERIAL, CABINET, CARD & STEREOSCOPIC,

sizes of views of Scottish scenery sold
by all the leading booksellers, and at the
principal Railway book stalls in Scotland.

Sets of views of Edinburgh, Loch
Lomond, Trossachs, Melrose, Abbotsford,
Stirling, Dunkeld, Balmoral, Staffa & Iona,
Glencoe, Skye &c in green cloth & Morocco,
Bindings for Souvenirs and Gift books from
12/ to L. 10.10.0.

Marion Imp. Paris

Plate 200. Advertisement from reverse of c.d.v.

For the first few years everything went smoothly for G. W. Wilson and Company. Wilson enthusiastically busied himself with the seemingly endless task of photographing and re-photographing old views for the new formats. Many of the expeditions were as strenuous as before and involved the usual hard labour associated with the wet-collodion process. Some of the journeys took him to new and remote parts, including the north coast of Scotland between Cape Wrath and Wick, and also to Orkney and Shetland (201, 202).

He was now over fifty years old and his age was beginning to tell. In a letter to an American journal he said how much he regretted getting old and how the exertions to which he had accustomed himself in his early days as a photographer, when he thought he could work night and day with impunity, affected him now.[204] To help him with his journeying he had constructed a mobile darkroom that was fitted up with everything he needed: cistern, sink, shelves, racks and a folding seat on which to perch during processing. It was altogether more spacious and easier to work than the suffocating confines of the portable dark tent, which he still had to use in those places the carriage could not reach. The curiosity of the inhabitants of Edinburgh was aroused 'by the appearance of a new style of cart which was being driven about in various parts of the city, and stopping from time to time in some of the most unlikely places . . . opinions differed widely as to what it really was.'[205]

The appearance of the mobile darkroom in the streets of Edinburgh coincided with the introduction of the Imperial view, 10×7 in., which first made its appearance in 1875.[206] The large camera with its associated lenses, dark slides and tripod would have been a considerable burden on their own, let alone with a portable dark tent as well. The imperial view became the fifth size of print that Wilson offered and its introduction to the market points to his confidence and optimism for the future (203–207).

Just a little earlier his resolve had been put to the test when the property company owning the land at Glenburnie warned him that they would not renew his lease when it next came up for consideration, as they required the land themselves for development into a select residential suburb. As the printing establishment was so much at the heart of the business, its re-siting would need very careful consideration. Many things had to be taken into account: the constant provision of running water; clean, smokeless air; room for future expansion, and if at all possible, somewhere to accommodate the offices from Crown Street. Converting suitable premises, as he had done at Glenburnie, would have been one solution, but this usually meant compromising the activities to the existing situation and was therefore not ideal. The only real answer lay in building a works that met all the general requirements of space, light and water, and which also took into consideration the specific details necessary to the several processes. No doubt after some

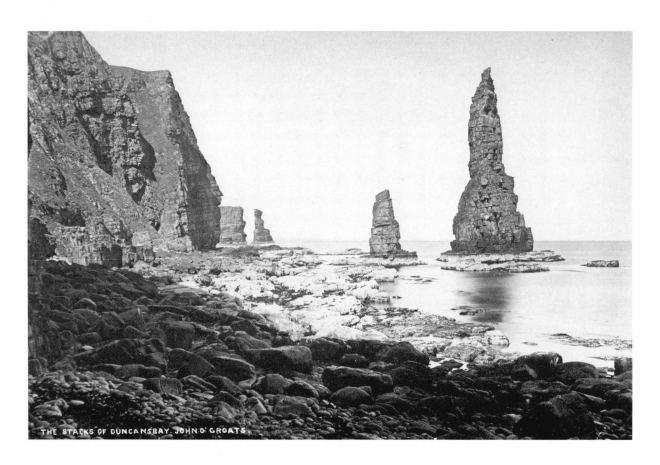

Plate 201. The Stacks of Duncansby, John o' Groats

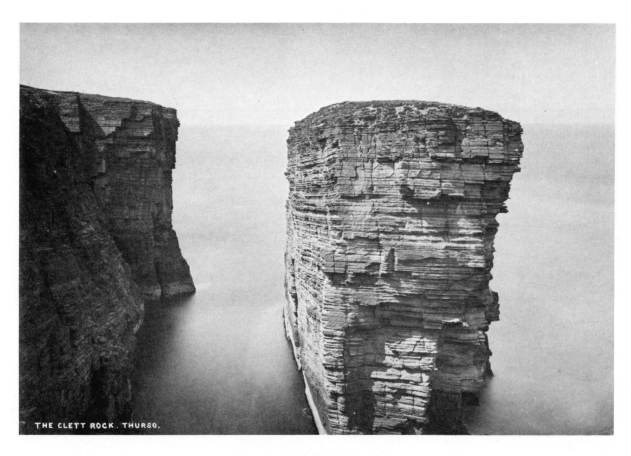

THE CLETT ROCK. THURSO.

Plate 202. The Clett Rock, Thurso

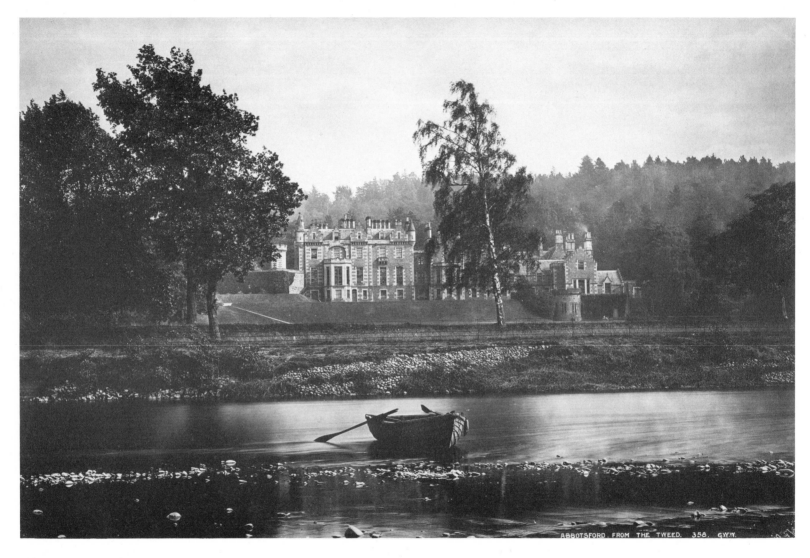

Plate 203. Abbotsford from the Tweed

Plate 204. The Long Canal, Hampton Court

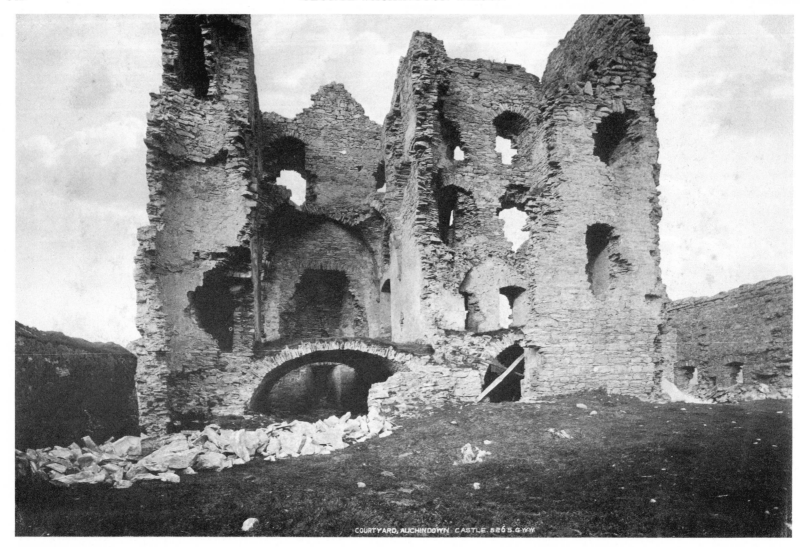

Plate 205. Courtyard, Auchindown Castle

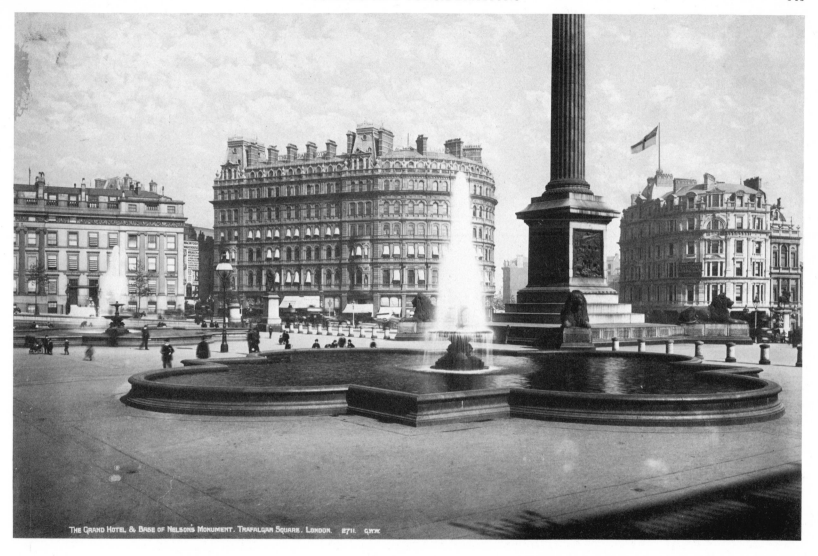

Plate 206. The Grand Hotel and Base of Nelson's Monument, Trafalgar Square, London

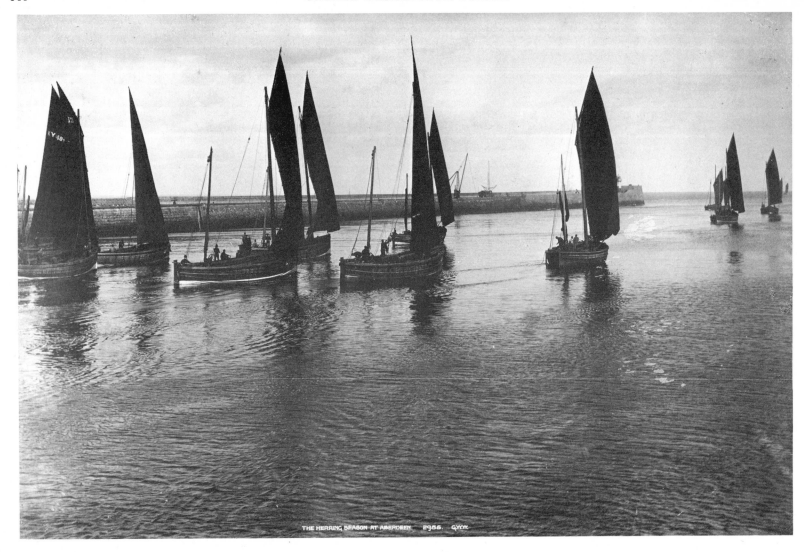

Plate 207. The Herring Season at Aberdeen

tormenting moments of doubt and worry, Wilson decided upon the latter course. Not that it was a lone decision as Smith was doubtless consulted in order to resolve the myriad problems associated with such a project. The first priority was a suitable site. Fortunately, the search was brief. Close to Queen's Cross, in St. Swithin's Street, was a large and vacant plot that conveniently adjoined his garden. It was owned by the Aberdeen Land Association who were responsible for much of the residential development in the western suburbs. As Wilson had been one of the founding subscribers of the Association he was able to feu the land without difficulty. The agreement was drawn up and signed on 6 March 1875. Work commenced immediately.[207]

Plate 208. Plan for the development of St. Swithin's Street

The accompanying plan (208), drawn up for the agreement, shows the size and disposition of the plot in question and its relationship to the garden of Queen's Cross. The darker grey buildings shown adjoining the narrow lane are not the dwelling-house, but are the stables and coach-house at the bottom of the garden. The design and overall conception of the works was based upon Wilson's considerable practical experience and knowledge, and he took the opportunity to incorporate all that was new in machinery and ideas. It was also possible to include office buildings to replace those in use at Crown Street and bring together the whole of the publishing business on one site. The portrait studio, however, remained at Crown Street. The building work went on rapidly throughout 1875 and by the late autumn of 1876 the works were sufficiently complete to begin the delicate task of transferring all the negatives and other stock from Glenburnie. As winter inevitably slowed down the tempo of work it was a good time to settle in and for the staff to become accustomed to the new layout and routine. By the spring of 1877 everything was ready for the annual rush of orders that heralded the summer's arrival.

Shortly after its opening, St. Swithin's was visited by the Edinburgh correspondent of *The British Journal of Photography*, John Nicol, PhD, whose detailed description of the works and their operation is worth quoting at length:

> On entering by a capacious gate—which, but for a large plate with the words 'G. W. Wilson and Co.' might easily be mistaken for the entrance to the coach-house and stable—the visitor is brought face to face with the enlarging house, autotype enlargements being a branch recently added—not of their own work merely, but for the trade generally. The enlarging house measures 48 feet by 36 feet, and is unequally divided into two apartments. The outer division is fitted up for the purpose of cleaning and albumenising the plates, and contains the only open fire I saw in the establishment, all the other departments being well heated with hot water pipes. . . . The inner room is practically the camera, and measures about 20×15 feet. . . . I saw the operator in that department coating, exposing, and developing plates of 36×28 inches with apparently as much ease as I could manipulate a 12×10 plate.[208]

Autotype, or carbon printing as it was also known, was a lengthy

and complicated process that demanded much of its operators but yielded a permanant photographic image that was not subject to fading. Workers in the process were granted licences for its use by the Autotype Company of London who also supplied many of the materials. In his 1877 catalogue under the heading of 'Photographic Specialities' Wilson offered a limited number of subjects printed by the carbon process. They were to be had in two sizes, 17×11½ and 24×18 which cost 10s. 6d. and 15s. 0d. respectively. They could also be bought hand-coloured, which increased the price to 25s. 0d. and 35s. 0d. respectively. Clearly, Wilson thought highly of the carbon print and its commercial future as he devoted a good deal of space to its operation at St. Swithin's. Apart from the enlarging house there was another large room in the main office building where the transferring and developing of the prints was undertaken. Elsewhere in this building was Smith's office which was 'at once stockroom and office, and contains on its capacious shelves probably a larger number of photographs than it has been the good fortune of many to see brought together. They are kept—each variety by itself—between millboards, and so perfectly registered that, not withstanding the thousands of subjects, no difficulty is experienced in finding any particular one that may be required.'[209]
It was here that customers' orders were received and those not available from stock were passed on to the printers who, having completed the order, returned the dry prints to offices where, in a long and well-lit room, they were trimmed, rolled, mounted, spotted and labelled, before being returned to Smith's office for checking and despatch.

The general layout of the works is best seen in the accompanying photograph (c.1880s) taken from a point farthest from St. Swithin's Street looking back (209). The office building is in the distance squarely facing the camera and on the right are the autotype enlarging rooms. The long building on the left of the picture housed the main printing rooms which Nicol visited next.

The printing, toning, and washing departments . . . are carried on in a building measuring, roughly calculated, some 100 by 30 feet. It is two stories in height, or rather one story and an attic, and is oriented east and west, with a northern exposure for printing. On the north side the roof descends, penthouse fashion, at a gentle angle to within about four feet of the floor, the lower nine feet being glass, and forming a kind of shed jutting out from the main building, of eighteen feet in width. Under this shed, or more properly, printing gallery are arranged, side by side, twenty strong tables mounted on wheels which run in grooves formed in a concrete or cement floor, and work so smoothly that even when loaded with forty frames a very slight push is sufficient to move them from one place to another. In this way eight hundred frames are easily attended to by three assistants, and with twice that number of 'fillers' and 'carriers' a tolerably large day's work may be accomplished. For so considerable an amount of work the movable tables are exceedingly convenient. In suitable weather they are pushed out into the open air; but on the appearance of a coming shower the whole can in less than a minute be safely placed under glass.[210]

No mention is made of the larger, and more vertical, printing racks that ran down the centre of the yard. These are a later addition and were brought into use when the increasing demand for prints required that more frames be put out. By the mid 1880s it was reckoned that anything between one thousand five hundred and two thousand frames were regularly in use on the racks.[211]

The principal part of the main building is occupied by a room seventy by about twenty feet, having along one side a double row of presses, the shelves of which are grooved like ordinary plate boxes, and in which are stored over 45,000 negatives, representing very nearly five tons of glass. On the other side of the room is a long table, above which are a series of windows admitting only yellow light, and on this the filling and emptying of the frames are carried on . . . where such a large quantity of work has to be done the frames must, to economise space, be as nearly the size of the negatives as practicable; and that they may lie close together they must be free from projecting parts.[212]

The large numbers of negatives mentioned by Nicol shows how

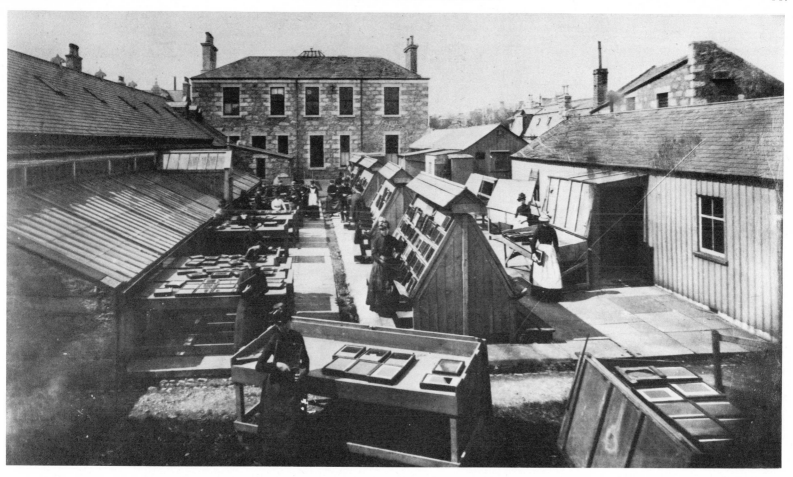

Plate 209. St Swithin's Photographic Printing, Enlarging and Publishing Works

rapidly Wilson had expanded his stocks in preceding years. By comparing the catalogues of 1863 and 1877 one can see just how great was this expansion. In 1863 Wilson offered around 330 views either as stereograms or as album prints. Fourteen years later, in 1877, the number of views available had risen to over 2500. One has also to remember that by 1877 views were offered in three distinct negative sizes, stereoscopic, cabinet, and imperial (210). Most views

Plate 210. Cover of print envelope

were available as either stereograms or cabinet views; the imperial size was rarer having been introduced only two years earlier. With such a variety of locations and negative sizes, and remembering that popular views often required duplicates to achieve an adequate turnover, the total number of 45,000 negatives becomes perfectly plausible. What such a store of negatives does, however, is to call into question Wilson's authorship of each of them. It may just have been possible for Wilson to expose something like 3000 negatives a year during the preceding fourteen years, but it is highly unlikely. It is much more probable that he relied upon assistants to go out and retake many of the repeat views to his precise instructions, perhaps using the original photographs as masters for the new. Although there is no evidence to show that this was the case, the sheer number of negatives suggests that it was probably so. Even Wilson's enthusiasm and indefatigable energy could not have achieved quite so much.

To return to St. Swithin's, where Nicol's description continues with the toning and washing departments:

A door at the west end of the filling room leads into an apartment thirty-six by twenty-eight feet, devoted to toning and washing operations . . . 'Are we going to be let into the secret of how the beautiful tones which have been so long admired are produced?' I think I hear some of my readers asking. In reply I am unfortunately under the necessity of saying 'No'—simply because there are no secrets in connection with the establishment . . . I may say that the tones I saw produced during my visit . . . were got by ordinary lime water, gold, and acetate of soda.

On one side of the washing-room there is a kind of sink running the whole length of the apartment, and in which are placed ten circular porcelain syphon washers, with the syphons plugged-up, or which are not used, changing by hand being preferred. Over each are taps supplying hot and cold water. The other side has a similar sink with hot and cold water taps, but instead of the porcelain washers there is under each pair of taps a glass plate. From each of the taps there hangs a brass tube about two feet long fastened at one end by a universal joint, and at the other terminating in a rose of fine holes . . . a batch of prints may be toned, fixed, and perfectly washed in a little more than an hour, the *modus operandi* being somewhat as follows:—The prints are toned in rather a subdued light at one end of the long sinks, and removed to a small apartment devoted exclusively to hypo. From this they are brought to what I may call the 'syringe sink', placed for a few minutes in warm water, and moved about during the whole time. They are treated in the same way to a second water, and then placed one by one on the plate of glass under the rose. The water is turned on, and the print subjected to its action, combined with gentle friction on both sides. When the whole batch has been thus syringed, the prints are transferred to one of the circular washers, where they are treated to six changes of water, generally warm, and kept constantly in motion.

A stairway leads from the washing room to the attic, where the

prints are dried. It is furnished with the two sets of parallel rails about three feet apart, and the same distance from the floor. They run the whole length of the room, and are used to support the cloth on which the wet prints are spread out to dry. I may add that a similar arrangement is in use in the mounting room for drying the prints after being mounted.[213]

After a brief description of the room where lantern slides and stereoscopic transparencies were made and of the carpenter's shop used for running repairs and the manufacture of special apparatus, he concluded that

St. Swithin's as a whole . . . is certainly the most extensive and complete [photographic establishment] that I have yet had the pleasure of visiting, and I say with confidence that, whether for the quality of the work, perfection of arrangements, happy comfortable and cheerful appearance of the employees, or genial courtesy and attention of the principals, there is very little room for improvement.[214]

No mention was made by Nicol of the all-important sensitisers whose job it was to prepare the albumen paper for printing. They were accommodated in the main printing house close to the 'fillers' and 'carriers'. Charles Wilson remembered that 'Every morning the sensitizers had to start floating sheets [of paper] on the silver bath contained in large shallow porcelain dishes, allowing about two minutes before removing each sheet, when they were hung up by the corners to dry. The paper was then handed to the trimmers who would cut it to the various sizes required.'[215] He also estimated that during the busy summer season they would use between two and three reams (each of which contained 480 sheets) of albumen paper each day. When such quantities of paper were used there must have been a correspondingly high consumption of silver nitrate, chloride of gold, and other basic materials. Water in vast quantities was always used; in 1877 the annual flow was calculated at four hundred thousand gallons. Economies were made wherever possible and in a special outbuilding large casks were set into the floor to receive the

exhausted fixer that was rich in 'waste' silver. From this source, and from the trimmings of the prints, about forty-eight percent of the original cost of the silver was reclaimed.

The hours of work were long, over a fifty-hour week, and the times rigidly laid down in the company rules. 'The daily working hours, except on Saturdays, from 1st March to 31st October to be from 8 a.m. to 1 p.m., and from 2 to 6 p.m. The hours on Saturdays to be from 8 a.m. to 3 p.m., with an interval of half-an-hour. Sensitizers to commence at 6 a.m. on Mondays only. The hours from 1st November to 28th February to be arranged from month to month as the length of the days renders necessary.'[216]

Having planned and brought into production a complex and highly organised printing establishment, Wilson was faced with the task of realising its full production potential. Even at the outset, with 45,000 negatives and eight hundred printing frames in use, it was running below its capacity. During the next few years Wilson had to contend with the incessant pressures imposed on him by the demands of his works and of the general public; both required more and more negatives of new subjects. In addition, there was growing competition from other photographic publishers who were all as anxious as Wilson to expand their sales. Notable amongst these publishers were Bedford, Frith and, of the greatest importance, Valentine of Dundee. James Valentine was one of the oldest established photographers in Scotland. He had begun his career as an engraver before the invention of photography. His fine landscape views had been brought to the attention of Queen Victoria who commissioned several volumes and folios of his work. In November 1868, Valentine was appointed as 'Photographer in Ordinary to Her Majesty': this gave him five years precedence over Wilson but the public would not have readily distinguished the difference between an official and a self-assumed title.[217] Like Wilson, Valentine also depended for his income upon the sales of his photographs to tourists and, although he never achieved the same dominance and status as Wilson, his output still created a positive threat. It was a standing joke in the Wilson family that Valentine's photographs so closely resembled their father's that they 'must have used the same tripod holes to achieve their results!'[218]

The twin stimuli of capital investment in St. Swithin's and competition from other photographers spurred the company into new activity and the enhanced production necessary to maintain its commercial success. During this period, which lasted from 1876 to the 1890s, Wilson gradually relinquished his personal control over many aspects of the business. It has already been suggested that before 1876 Wilson relied to some extent upon assistant photographers. Now he came fully to depend upon them as it was no longer possible without their help to add new negatives to the files at the rate the business demanded. These staff photographers travelled widely throughout Britain gathering new material and, with the introduction of the dry plate which gradually replaced the wet-collodion process throughout the 1880s, they were able to travel much more freely than before. This was because exposed negatives could be kept and later returned to St. Swithin's for developing. In certain instances local photographers were commissioned to do work on the company's behalf as a cheaper alternative to sending someone from Aberdeen. Once the copyright had been secured, the negatives passed into anonymous authorship by appearing under the company trade mark of 'G.W.W.'. Inevitably, the style which had so distinguished Wilson's work during the early part of his career was gradually replaced by a much more heterogeneous approach. The work of the 1880s and 1890s comes largely from second and third generation photographers who followed the visual traditions established by their predecessors but did not possess the deeper understanding that an artistic training would have given them. Their work lacks the individuality of the early photographers.

To what extent photographers influenced public taste, or public taste the photographers, is a moot point, but during this same period there was a discernible shift away from the old values. For one thing, there was an increase in the number of people who could now afford holidays.

One historian writing of the period noted that throughout the middle classes holidays away from home were becoming more regular and 'some important classes of workmen, not the least well paid, provided themselves (and perhaps their families) with leisure time at their own expense'.[219] The democratisation of holidays—with more of the middle classes, artisans, and some of the working classes now travelling—brought a corresponding increase in the demand for photographs. One way to meet this demand was to photograph familiar subjects exhaustively from every angle and to search out new subjects in the less popular districts. Two examples from a later Wilson catalogue will illustrate the point. Fourteen views of Durham Cathedral were available as stereograms to the public in the 1877 catalogue, but by 1896 this number had more than quadrupled to sixty three views which came in both imperial and cabinet sizes. Every imaginable point of view and subject was represented though some, like the lectern, sanctuary knocker, and cloister door, were of lesser importance. The catalogue also illustrates how the smaller resorts were sought out, diligently photographed and added to the files. Even if the subject matter had only local interest it was photographed because of its potential sales value. Matlock, a small watering place in Derbyshire, found itself represented in the catalogue by fifty three views (211), including some of the Grand Dining Hall, Billiard Room and Smoking Room of Smedley's Hydropathic Establishment, the most grandiose in the town. Such prosaic subject matter was to be found recurring throughout the catalogue, with the inclusion of hotels, hydros, town halls, libraries, markets, railway stations, docks and even cemeteries. The catalogue entries for each location read very much like an inventory of the town's public buildings and local curiosities, and the objective documentary nature of the photographs is evident.

The policy of the company in getting as many negatives as possible on their files becomes obvious when one realises that by the 1890s they were offering over twenty-five thousand views of English and Scottish subjects alone. The excellent work of Lawrence in Ireland and Bedford in Wales kept Wilson's photographers away from these locations, and apart from a small series on the Giant's Causeway and a few views of Bangor, Llandaff and St. David's cathedrals, they are not represented. Instead, the company sets its sights on more distant horizons and offered an extensive series of views in Gibralter, Spain, Morocco, South Africa and Australia.[220] (212, 213) Additionally, they offered a wide range of photographic specialities that reflected the taste of the period. All

Cabinet Scraps, 8×5, 1s. each. Album Scraps, 5×4 or 4×3, 6d. each **49**

When ordering quote number and size of subject

IMPERIAL.	CABINET.	
8801	...	Smedley's Hydropathic Establishment,Grand Dining Hall
8802	...	Do. do.
8673	8673	Do. do. Billiard Room
8799	8799	Do. do. Smoking Room
3904	3904	Matlock Bridge and Matlock Bank
8732	...	Do. do.
8763	8763	Do. and High Tor, from Smedley's Hydropathic Establishment
...	8060	Do.
8651	...	Crown Square, Matlock Bridge
...	8650	Cable Tram Car do.
8028	8028	Parish Church, do.
8268	8268	Matlock Bath, from Cat Tor
8676	8676	Do. and High Tor, from Royal Hotel
8677	...	Do. do. and Riber Castle
...	8680	Do. and Riber Castle, from Upper Wood Road
8764	8764	Do. from High Tor
3905	3905	Do. from Jacob's Heights
3906	3906	Do. looking to Heights of Abraham
3907	3907	Do. from the Pavilion
3908	3908	Do. from E.
8267	8267	Promenade, Matlock Bath
4483	4483	Pavilion, do.
3916	3916	Royal Hotel, do.
8274	8274	New Bath Hotel, do.
3911	3911	Cat Tor
3909	3909	High Tor, from the Derwent
3910	3910	Do.
...	8679	Do. upright
8762	8762	Do. from the Derwent, upright
8797	8797	Do. from Matlock Bath
8675	8675	Do. from Heights of Abraham
...	8800	Switzerland View, from High Tor
4838	4838	On the Derwent, Matlock Dale
8276	8276	Via Gellia
8277	8277	Do.
8278	8278	Do.
8279	8279	Do.
8280	8280	Do. Tufa Cottage
8731	...	Do. do.
...	8282	On the Derwent, near Matlock Bridge
...	8281	Cromford Church
8269	8269	Cromford Bridge
8275	8275	Weir on Derwent, Cromford
8270	8270	Black Rock, do.
8271	8271	Willersley Castle, do.
6778	6778	Lea Hurst

Plate 211. Page from G. W. Wilson & Co, Catalogue of English Views, 1896

TRADE MARK **G. W. W.** REGISTERED.

CATALOGUE OF

Landscape, Architectural, and Figure

PHOTOGRAPHS

IN

Gibraltar, South of Spain, and Morocco,

PRINTED AND PUBLISHED BY

G. W. Wilson & Co.,

2 ST. SWITHIN STREET,

·ABERDEEN.

Photographers to Her late Majesty in Scotland.

Plate 212. Cover of Catalogue of photographs of Gibraltar, South of Spain, and Morocco, 1890s

their views could be had in over two hundred styles of plush mounts or made up into glove, handkerchief and trinket boxes. They were also available as photographic panels and as opalines, and they could be reduced for inclusion on notepaper, Christmas and birthday cards. The work of leading photographers was separately offered under their own names. Charles Reid's animal

TRADE MARK G. W. W. REGISTERED.

CATALOGUE OF

Photographs of Life and Scenery
IN
SOUTH AFRICA.

Photographed and Published by

G. W. Wilson & Co.,

2 ST. SWITHIN STREET,

·ABERDEEN.

Photographers to Her Late Majesty in Scotland.

Plate 213. Cover of Catalogue of photographs of South Africa, 1900s

factor was the decision by Wilson to bring three of his sons into the business—a natural thing for him to want to do. He had tried to give all his children the best education and opportunities that he could provide. Besides, bringing in and training three sons to the business would keep it in the family. John and Louis joined the company in 1881, both having left other professions to join their father and learn the intricacies of the business. The third brother, Charles, was to join them a few years later after having served his time in an accountant's office.

On the evening of 14 June 1882 a fire broke out in the offices at St. Swithin's. Only the design of the works, which separated the offices from the other buildings, and the prompt action of the fire brigade prevented the fire from spreading. But this was not before it had completely gutted the building with loss of nearly all the stock of prints and mounting materials and much of the machinery (214). The cause of the fire was never discovered.[221] The Court circular printed in *The Times* for 17 June 1882 carried a notice of the fire under the heading 'Royal Sympathy'.

> On Wednesday night the printing establishment in connexion with the studio of the firm of Mr. G. W. Wilson, the well known photographic artist, in Aberdeen, was burnt to the ground. The Queen on hearing of the fire, sent Mr. Wilson a telegram from Balmoral, expressing her regret at hearing of the fire, and a hope that Mr. Wilson had not lost any of his valuable negatives. The negatives referred to were not destroyed having been stored in a part of the premises which was saved.[222]

The company recovered its losses and the offices were rebuilt within the remaining fabric, but it had been a narrow escape. If the negatives had been destroyed then all would have been lost. Shortly after the fire it was planned to extend the printing capacity and relieve the pressure at St. Swithin's by opening another works in the adjoining Stanley Street. Here, to avoid any future risk to the negatives, a large fire-proof store was built with walls eighteen inches thick, a sliding iron door and window shutters. It came into operation in 1885 and was put in the care of Charles, who had now joined the company.

studies tantalisingly offered 'studies from life' of animals recently extinct and the popular works of F. M. Sutcliffe were available 'printed by a permanent process'.

The capitulation to commercial pressures and popular taste was complete. In its anxiety to keep ahead of competitors the company had unwittingly hastened its own decline. A further contributory

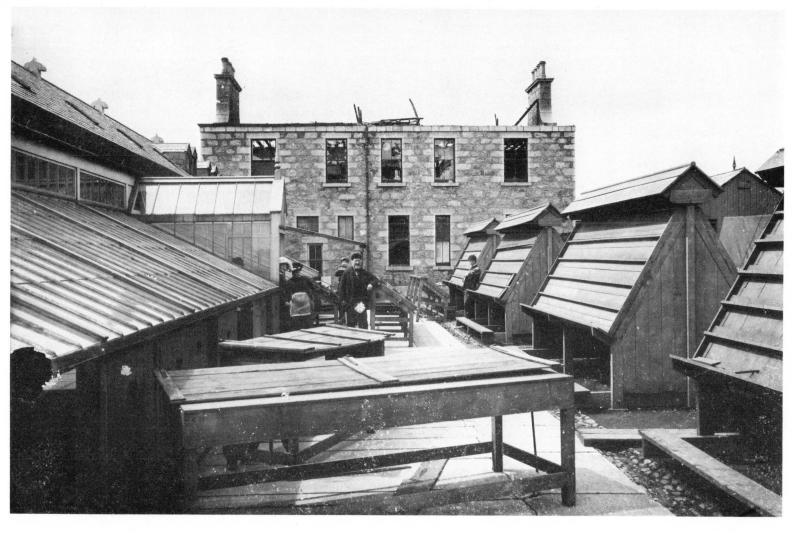

Plate 214. *View of St. Swithin's Street after the fire*

Wilson reached his sixtieth year in 1883 and though he still played an active part in the running of the business and was still taking photographs,[223] his age was beginning to tell. The strenuous efforts of his youth, when he worked hard to establish himself, and the many hours of close confinement in a dark tent heady with ether fumes, had taken their toll. As his sons became more conversant with the management and everyday affairs of the business, he felt increasingly confident about handing control over to them and retiring. John, who had been managing the portrait studios at Crown Street, moved there in 1883 and married the following year. Louis and Charles still lived at home with the rest of the family. Of the three sons, it was only Charles who showed any interest and promise as a photographer and on the many trips he made with his father he had learnt much about the art. His promise was later fulfilled by a marvellous series of instantaneous street views in London which are testimonies to a photographer's ingenuity (215, 216). Charles remembers how 'we used to hire a covered van from Pickfords and stand with our camera under the awning fairly well out of sight of the passers by and then with the lens ready focused and capped and a dark slide in position ready to draw out the shutter, used to direct the driver to stop near the kerb opposite some specified building and watch our chance to make the instantaneous exposure'.[224]

In 1887 the first of a series of events that led to Wilson's retirement took place. It was known that on his retirement Wilson's title as 'Photographer to Her Majesty' would automatically lapse and the status that went with it would be lost. As the only photographer of the three, Charles' name was put forward to the Lord Chamberlain's Office. On 4 May 1887 the appointment was made and the royal connection maintained.

With the increasing reliance upon his sons, Wilson felt that the partnership with G. Brown Smith was no longer necessary. Smith was bought out and the partnership dissolved, and the whole business acquired by Wilson on 31 March 1887.[225] Four days later, a new agreement was signed which created a partnership between Wilson and his sons. In celebration, and to advertise the fact, they issued a stamp (217). It bore a portrait of Wilson in a central medallion and had the initials of the four partners at each corner. As in colour, size and general appearance it resembled the standard postage stamp, the postal authorities took exception to it and ordered it to be withdrawn.

In the following year Wilson retired completely and returned to painting for relaxation. Despite his formal retirement, however, he must have kept a close watch on the progress of his sons and given them whatever advice he could. One imagines that they would have welcomed this as they were comparatively young to be in charge of such a large and diverse business. The eldest, John, was thirty-one, Louis twenty-eight, and Charles twenty-three. Wilson's retirement had been forced upon him by growing infirmity exacerbated by an increasing frequency of fits, diagnosed as epileptic. It is unlikely that epilepsy was the true cause of the fits, as epilepsy does not suddenly appear in old age. It is much more likely that the term 'epilepsy' was a euphemism used to cover a variety of diseases. Perhaps Wilson was a victim of his own profession and was suffering from chemical poisoning that had slowly ingested itself into his system to produce mental disorder. It could have been Bright's disease which in its advanced state gives rise to cerebral disturbance and which was claimed to be an occupational disease common amongst photographers.[226] Another possibility is the insidious effects of the ether fumes which must have been Wilson's almost daily lot for nearly thirty-five years. Initially, the inhalation of ether gives a pleasant light-headed feeling and a sense of relief, but with continual exposure it takes an addictive hold over the inhaler who becomes increasingly reliant upon its use. Its effects upon photographers' health was discussed in the journals.[227] Maupassant, in his short story 'Dreams', describes the visionary effects ether produces. Whether or not Wilson was addicted to ether, or whether it was a contributory factor leading to his fits, we shall never know. It is certain, however, that from 1890 his health declined rapidly as the fits became more frequent.

For the brothers running the business their father's ill health simply added to their growing anxieties. For a number of years the profits of the company had been declining, with falling sales and rising wages and overheads. Despite the investment in new views

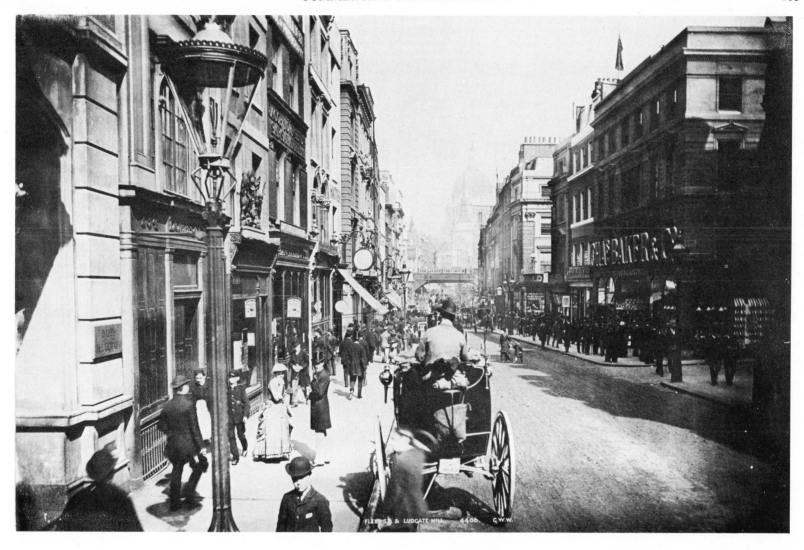

Plate 215. Fleet Street and Ludgate Hill

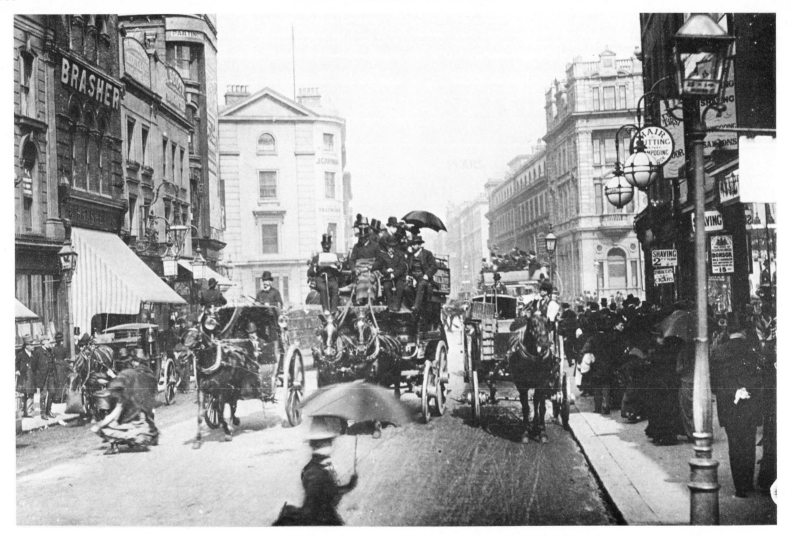

Plate 216. Oxford Street, London

Plate 217. G. W. Wilson & Co.'s advertising stamps, c.1887

Plate 218. Portrait of G. W. Wilson, c.1890

and speciality lines, there seemed to be no way in which the trend could be reversed. Perhaps with more experience and positive leadership they would not have been in the desperate situation they found themselves in by the closing months of 1892. In their difficulties they turned to the company's legal advisor for help, without telling their father, perhaps thinking that such knowledge would only aggravate his condition. The lawyer suggested that they should turn the business into a limited liability company, and after some consideration they agreed upon this course of action. Wilson was told of his sons' plans on a visit to the advocate's office a little while later. What he thought of their scheme goes unrecorded. The preparation of the various documents necessary for the formation of the limited company were drawn up by the lawyer during the first months of 1893 and were signed on 24 February by all parties, including Wilson, whose hand appears shaky and unsteady. Other

papers were in preparation, and on the evening of 8 March, after spending a day in town on business, Wilson retired to bed quite normally. At one o'clock in the morning he was seized with an intense fit. The family were called to his bedside and with great presence of mind the brothers managed to obtain his signature finally authorising the formation of the limited company.[228] The fits continued unabated throughout the night and at 8.45 on the morning of 9 March 1893 Wilson died.

Wilson's death brought to a close an era of landscape photography which had been born forty years earlier with the introduction of the wet collodion process, an era when artistic values were placed before pecuniary advantage. The new era placed commercial values above all else. By signing the legal papers on the eve of his death it was as if Wilson understood that there was a symbolism about his passing.

CHAPTER TEN

Winding Up

The illness that afflicted Wilson in his later years cast its inevitable shadow over the rest of the family and caused them considerable anxiety. Apart from the private stress of having to deal with the recurring fits there was the additional burden of having to keep up public appearances. The grief that followed Wilson's death must have been more than slightly tinged with a sense of relief that at last it was all over.

George Walker, calling on the family at Queen's Cross to pay his last respects, found that Mrs Wilson 'had now recovered her usual tranquility, and was comforted in thinking that her husband had died without pain, and that those fits partly apoplectic and partly epileptic, did not land him in an asylum'.[229] This hint of the seriousness of Wilson's condition suggests that the last years of his life had been particularly difficult for everyone, and that it was only his social position and ability to afford private medical care that kept him out of an institution.

A few days after Walker's visit the funeral took place and, as one would expect with such a prominent member of Aberdeen society, a large number of mourners formed a cortege behind the oak coffin as it was borne from the house to Nellfield Cemetery. In addition to members of the immediate family and various relatives, many of

Wilson's former colleagues, friends and business associates were present; the entire staff of Wilson and Company were given the day off in order that they too might pay their last respects.

It was customary for a family such as the Wilsons to go into a period of deep mourning immediately after the funeral. For the Wilsons this period of mourning was interrupted by the news that the Inland Revenue was enquiring into the transfer of the business by Wilson to his three sons in 1887, by which they received the whole stock in trade and goodwill of the firm. In return, they had paid no cash but instead agreed to pay him an annuity equivalent to 5 per cent of the value of the stock in trade during his lifetime and to their mother on his death, when they would, in addition, discharge all claims on their father's estate. The Inland Revenue maintained that, whilst the transfer of the business was a voluntary settlement, the annuity received by Wilson reserved his interest in the business and was therefore liable for duty.

In December 1893 the Lord Advocate, on behalf of the Inland Revenue, brought an action against the three brothers for the duty outstanding and set the date of the trial for May 1894. Realising that the trial was likely to be both protracted and expensive—particularly if the verdict went against them—Mrs Wilson decided to sell

Queen's Cross and to move to a more modest house in Carden Place (219). The sale of Queen's Cross to a local newspaper editor was completed in early 1894. Further cash was raised in June by auctioning Wilson's collection of paintings and drawings by local artists including works by Cassie, Dyce and Phillip.[230]

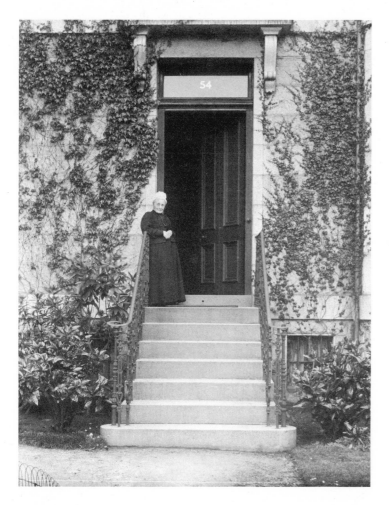

Plate 219. Mrs G. W. Wilson outside 54 Carden Place, Aberdeen, c.1905

During the two months of the trial it became evident that the case was based on a fine point of law. The Inland Revenue was apparently anxious to establish this as a test case in support of the Customs and Inland Revenue Act of 1889 (52 Vict. C 7) which itself was an amendment of an earlier Act passed in 1881. In spite of the vigorous defence put forward by the Wilsons the verdict was given in favour of the Inland Revenue.[231] The costs of the case are unknown but they must have been considerable, and the financial implications of the verdict marks the point at which the business went into obvious decline. Evidence given to the court makes it clear that the business was no longer as profitable as it had been during the 1860s. According to John Hay Wilson 'The business had not been a paying one for several years prior to 1887. I cannot say what were the average profits—perhaps about £200 . . . when the business was handed over to us we had no hesitation in taking it. We had doubts whether we would make a profitable thing of it.'[232] However, their combined efforts raised the profit level for a brief period before it fell again, and it became clear to the brothers that if they were to survive they would have to raise additional capital and inject new life into the company. In the event, this attempt at a recovery was only partially successful and the new limited company never really established itself. Like many other partnership conversions at the time, registration with limited liability represented the last gasp of a dying concern.

In an attempt at rationalisation, parts of the company were closed down and the premises sold. The printing plant and negative store at Stanley Street went almost immediately (late 1893) and a few years later, in 1897, the historic links with the foundation of the business in 1852 were severed when the portrait studios in Crown Street were sold to another photographer.[233] Still the business declined. Attempts at modernisation and diversification proved unavailing and at an Extraordinary General Meeting of the share-holders, held at St. Swithin Street on 17 March 1902, it was agreed that the limited company be voluntarily liquidated.[234]

In 1901, by which time it had already become clear that the company was about to fail, two of the brothers John and Charles, resigned their directorships to set up a new company, Wilson

Brothers, whose speciality was the manufacture of lantern slides. Their premises were established on the outskirts of town at Loch Head House, large rambling premises that had originally been built as Scotland's first hydropathic establishment. For their stock in trade the brothers had access to negatives of G. W. Wilson & Co. Ltd., which they used in the production of their lantern slides. Under what terms this access was given is not known, but without it Wilson Brothers could not have existed. In the public's eyes the two businesses were as one. The catalogues were issued jointly and subjects from G. W. Wilson's catalogues were available as lantern slides only through Wilson Brothers.

A reporter from the photographic press, on a visit to the premises during the summer of 1901, was told by the brothers that they had 'so many claims on their attention, it was impossible for them to give slidemaking the necessary time to develop the trade as it seemed to demand. Furthermore . . . the photographic business at St. Swithin Street had grown to such proportions that it was imperative to install additional machinery.[235] Knowing the subsequent fate of the company during the following year a less charitable view of the transfer would see it as an attempt by the brothers to secure the only financially viable branch of the company for themselves.

When the parent company of G. W. Wilson & Co. Ltd. went into voluntary liquidation in 1902 it must have come as no surprise to those closely associated with the company's affairs. John Hay Wilson was called upon to act as liquidator and wind up the company. Instead of finally extinguishing the business, there emerged a new company with an old name, G. W. Wilson & Co., which maintained the ownership of the premises, negatives and stock of the former company. In effect, the assets of the old company were transferred to the new concern and business continued as before.

In liaison with Wilson Brothers, the new company attempted to regain its footing and re-establish its position as a leading publisher of photographic views. They issued new catalogues in which only the most popular views were listed, they extended the range of their activities to include gold-blocking, collotype printing, and even

publishing postcards in order to exploit their growing popularity. But there was always a certain futility in whatever they attempted: burdened by out-of-date premises and stock and seriously under-capitalised, they were almost bound to fail. By 1908 it had become clear that they could continue no longer. Having come to this decision they acted decisively and called in John Milne, auctioneer, to prepare a sale of 'The Whole Plant and Stock in Trade' (220).

Plate 220. Cover of auction catalogue for the sale of G. W. Wilson & Co.

The catalogue of the sale, which was to take three days, and the records of the purchases of the 900 lots make interesting but sad reading. The very bones and fabric of a once prosperous business holding a supreme position within the photographic world were laid bare for all to see and pick over. Nothing appears to have been spared: the fine Honduras Mahogany 12×10 landscape camera outfit sold for £7. 15s. 0d. while at the other end of the scale a trestle table fetched sixpence.[236] Perhaps the most significant lots were the negatives, all 65,000 of them, offered as 66 lots, county by county, area by area. On the day of their auction interest in the negatives was only moderate and the prices ludicrously low. A number of lots remained unsold, including one lot, *No. 266, Scottish stereoscopic, 1668 subjects,* which represented almost the whole of Wilson's life's work and ambition. It was Wilson's claim in the 1860s that each of his negatives would be worth at least £10 if he were to sell them and a great deal more if he were to keep them and sell prints from them.[237] On a good day with everything working in his favour it was possible to make twenty negatives which had a potential earning power of over £200, yet the entire sale realised a total of only £284. 3s. 9d. More than anything else, this exemplifies how far the fortunes of the company had fallen. It also illustrates how attitudes towards the value and place of landscape photographs had changed. Their popularity had waned and they were fast being replaced by the cheaper forms of visual representation made possible by the use of high quality half-tone printing in book illustrations and picture postcards.

Notes

CHAPTER ONE

1 Parish Register for Alvah, County of Banff, Scotland. Entry for 25 November 1851. New Register House, Edinburgh
2 Robert Wilson, M.A., 'An octogenarian's reminiscences', *The Aberdeen Daily Journal* 12 March 1902
3 Ibid.
4 Ibid.
5 William Barclay, 'The Schools and Schoolmasters of Banffshire', *Banffshire Journal* (Banff 1925), pp 8–9
6 G. Wilson to G. W. Wilson, Waulkmill, 22 October 1846. Author's collection
7 A. Gibbon to G. Munro, Glassaugh, 21 July 1846. Author's collection
8 Thomas Sutton, M.A., ed., *Photographic Notes* 1 January 1860, p 12
9 G. W. Wilson, 'A voice from the hills: Mr. Wilson at home' *British Journal of Photography* 30 September 1864, p 375
10 Charles Wilson to H. Gernsheim, nd, Aberdeen, *c.*1950. H. Gernsheim, Switzerland
11 E. H. Corbould to G. W. Wilson, Rutland Gate, London, 28 June 1849. Author's collection

CHAPTER TWO

12 *Black's Picturesque Tourist of Scotland,* 21st ed (A. & C. Black Edinburgh: 1876), p 343

13 *Transactions of the Aberdeen Philosophical Society 1840–1880,* printed for the Society, Aberdeen (1884), I, ix
14 Information about Wilson's addresses and his various moves are contained in the Aberdeen Post Office Directories, the complete run from the early nineteenth century being held by Aberdeen Public Library
15 The Wilson scrapbooks were assembled by Wilson's youngest son, Charles, and the eleven volumes contain watercolour sketches, notes, letters, and a large quantity of photographs. They are held by Aberdeen Public Library
16 The illustration from which Wilson made his copy appears in *The Art Union* January 1846, p 11, and the copy is in the Wilson scrapbooks
17 'Photography', *The Aberdeen Herald* 20 August 1842
18 Ibid.
19 Ibid.

CHAPTER THREE

20 Advertisement for John & James Hay, *The Aberdeen Herald* 4 January 1851
21 Advertisement for John Hay Jnr, Photographic Gallery *The Aberdeen Journal* 7 September 1853
22 Charles Wilson letter to H. Gernsheim, nd, Aberdeen *c.*1950s
23 Advertisement for Messrs Wilson and John Hay, photographers, *The Aberdeen Journal* 5 April 1854

24 Invoice from Wilson & Hay, dated 2 December 1854, Royal Archives, Windsor Castle, Privy Purse Accounts, Z/7/4932

25 'Report of the Judges', Catalogue of the Photographic Exhibition, 3 December 1853, Aberdeen Public Library, Pamphlet Collection

26 Advertisement for Messrs Wilson & John Hay, *The Aberdeen Journal* 7 December 1853

27 Anderson letter to Wilson & Hay, Aberdeen 23 March 1854, Aberdeen Public Library, Pamphlet Collection. The manuscript letter is pasted in the fly of the *Hawaian Historical Society Proceedings* 1938 which contains an article by W. F. Wilson (G. W. Wilson's fourth son) on Anderson's visit to Honolulu in 1859 where W. F. Wilson later resided.

28 Queen Victoria, *The Letters of Queen Victoria* (London: John Murray 1908), II, pp 194–5

29 Ibid. note 24

30 Advertisement for Wilson & Hay, *The Aberdeen Journal* 13 September 1854

31 Robert F. Wilson to G. W. Wilson, Old Deer, 7 November 1854. Author's collection

32 Ibid. note 30

33 Ibid. note 22

34 John Nicol, PhD, 'Notes from the North' *British Journal of Photography* 30 March 1877, p 151

35 'Collodion process of photography' *The Aberdeen Journal* 18 April 1855

36 G. W. Wilson, *A practical Guide to the Collodion process in photography* (London: Longman & Co 1855), pp 14–15

37 Ibid.

38 Ibid. p. 29. Wilson recommends Burnet to his readers when they are faced with the problems of artistically posing a sitter

39 John Burnet FRS, *Practical Hints on Light and Shade in Painting,* 7th ed (London: J. & J. Leighton 1864), p 20

40 These journals contain a unique record of life in nineteenth-century Aberdeen as well as the observations on Wilson and his family. Interspersed throughout the text are many of Wilson's photographs. Aberdeen Public Library, Reserve Collection

41 George Walker, MSS Journals, pp 255–6. Aberdeen Public Library, Reserve Collection

42 The original masters, arranged by Wilson and Walker, for these photomontages are held by Aberdeen Public Library. Original prints of groups are held by Aberdeen City Art Gallery and the author. These two groups were revived by G. W. Wilson & Co who republished them with a further six nineteenth-century groups in 1907.

43 Wilson's *carte-de-visite* prices are given in the leaflet published by him in March 1864. Author's collection

44 Ibid.

45 Charles Wilson to H. Gernsheim, nd, Aberdeen *c.*1950s. C. Wilson here quotes turnover and production figures for the year 1864/5

46 G. W. Wilson, *A dialogue on Photography or Hints to Intending Sitters* (Aberdeen: A Brown & Co, nd [*c.*1863/4]) Author's collection

CHAPTER FOUR

47 Queen Victoria (ed A. Helps), *Leaves from the Journal of our Life in the Highlands, 1848 to 1861* (London: Smith, Elder & Co 1868), p 103

48 Ibid. p 111

49 Ibid. p 133

50 Ibid. p 114

51 Advertisement for G. W. Wilson, 'Photographer to the Queen', *The Aberdeen Journal* 20 February 1856

52 Ibid. p 135, note 47

53 E. Becker to Wilson, Balmoral, 4 October 1858. Author's collection

54 C. Ruland to Wilson, Windsor Castle, 19 November 1860. Author's collection

55 C. Ruland to Wilson, Buckingham Palace, 16 March 1861. Author's collection

56 Ibid.

57 The diary entries made by Wilson covering this episode still survive. The excerpt was taken bodily from the original diaries by Charles Wilson who passed them to H. Gernsheim for his research use. The Gernsheim Collection, University of Texas at Austin, USA

58 Charles Wilson to H. Gernsheim, nd, Aberdeen *c.*1950

59 'Cartes-de-Visite', *British Journal of Photography* 12 March 1869, p 125

60 'By Her Majesty's Command', *British Journal of Photography* 9 June 1865, p 305

61 This album, along with many others, was discovered as a result of the help given to the author by the Factor of Balmoral who kindly organised a search of the castle for photographic material

62 Sampson Low, *The English Catalogue of Books 1863–1872* (London: Sampson Low, Marston, Low & Searle 1873), II, p 412

63 Lord Chamberlain's List of Warrant Holders—Tradesmen, MSS LC5/245, p 26, The Public Record Office, London

64 Ibid. LC5/246, p 153

65 John Brown to Wilson, Osborne, 15 July 1873. Author's collection

CHAPTER FIVE

66 'The Rise and Progress of the Scottish Tourist', *The North British Review*, vol XLII, March 1865, p 1

67 Ibid. p 10

68 Ibid. p 9

69 Ibid.

70 Samuel Johnson, *A Journey to the Western Islands of Scotland* rep. (Oxford: University Press 1979), p 16

71 Ibid. p 9

72 Ibid. p 26

73 Thomas Pennant, *A Tour in Scotland; 1764* (Warrington: printed by W. Eyres 1774), 3rd ed, p 196

74 William Gilpin, MA, quoted in *Annual Register for 1789*, 2nd ed, printed by assignment (London: J. Dodsley 1802), p 173

75 Sir Uvedale Price, *On the Picturesque* (Edinburgh: Caldwell, Lloyd & Co 1842), p 47

76 G. Ripley & B. Taylor, *Handbook of Literature and the Fine Arts* (New York: George P. Putnam 1852), p 576

77 William Gilpin, MA, *Observations on several parts of Great Britain particularly the Highlands of Scotland*, 3rd ed (London: T. Cadell & W. Davis 1803), vol II p iii

78 R. D. Altick, *The English Common Reader* (Chicago: University of Chicago Press 1963), p 386

79 *Black's Picturesque Guide to the Trossachs*, 19th ed (Edinburgh: A. & C. Black 1866), preface, p iv

80 Between 1842 and 1862 there were eight separate editions of the Waverley Novels, the most expensive at 16 guineas for twelve volumes, and the cheapest at 1*s.* 6*d.* per volume

81 R. D. Altick, *op. cit.*, p 383

82 *The Scottish Tourist and Itinerary*, 5th ed (Edinburgh: Stirling & Kennedy 1834), p viii

83 *Black's Picturesque Guide to Scotland*, 9th ed (Edinburgh: A. & C. Black 1852), p 6

84 Quoted in Queen Victoria's *Leaves from the Journal*, p 20

85 *Where Shall We Go?* (Edinburgh: A. & C. Black 1869), 6th ed, preface, p vi

86 Ibid. p. 242

87 *The Scottish Tourist and Itinerary*, p x

88 Revd E. Bradley, pseud, Cuthbert Bede, *A Tour of Tartan Land* (London: Richard Bentley 1862), p 180

89 *Black's Picturesque Tourist of Scotland* 3rd ed (Edinburgh: A. & C. Black 1844), p 319

90 *The Scottish Tourist and Itinerary*, pp. 31–2. This is a description of the Trossachs

91 *Black's Picturesque Guide to Scotland*, 9th ed preface

92 *The Scottish Tourist and Itinerary*, p 384

93 *Black's Picturesque Guide to Scotland*, 9th ed, p 21

94 *Handbook of a trip to Scotland* (Leicester: T. Cook 1846). This gives the itinerary and a detailed description of the tour

95 *Handbook for travellers in Scotland*, 3rd ed (Edinburgh: J. Murray 1873), p 13

96 *The Art Journal* 1 September 1866, p 290

CHAPTER SIX

97 Advertisement for Messrs Wilson & Hay, *The Aberdeen Journal* 13 September 1854

98 Advertisement for G. W. Wilson, *The Aberdeen Journal* 25 April 1855

99 'Stereoscopic Views by G. W. Wilson', nd, *c.*1856, single sheet, pamphlet collection, P 393, p 130, Aberdeen Public Library. Although this sheet is undated, evidence strongly suggests that the date of publication was 1856

100 G. Walker, 'Manuscript Journal', p 255. Aberdeen Public Library

101 Advertisement for James Wood, Princes Street, Edinburgh, in the 'Catalogue of the First Annual Exhibition of the Photographic Society of Scotland', 1856. Edinburgh Public Library, pamphlet collection, item no 8375

102 'Exhibition of Art Treasures at Manchester', *Liverpool and Manchester Photographic Journal* 1 August 1857, p 156

103 'London Photographic Society's Exhibition', *British Journal of Photography*, 15 January 1861, p 37

104 'The Photographic Exhibition', *Journal of the Photographic Society* 21 February 1857, p 214

105 'Exhibition of the Photographic Society', *Photographic Notes* 15 April 1857, p 141

106 'On developing negatives with iron', *Photographic Notes* 1 May 1858, p 114

107 *Photographic Notes*, 1 November 1858, pp 252–3

108 Ibid.

109 'Exhibition of the Photographic Society', *Photographic Notes* 15 April 1857, p 141

110 'Photographic Exhibition in Edinburgh', *The Aberdeen Journal* 24 December 1856

111 *Photographic Notes* 1 November 1858, pp 252–3

112 Ibid.

113 These prints show a thin band of unnaturally pale sky on the horizon line where the misalignment of two plates during printing would have been most noticeable. A. Jammes of Paris has prints in his collection which show similar faults, suggesting they were also made from two negatives

114 'Photographic Contributions to Art', *The Photographic Journal* 1 December 1859, p 294
For one year, 1859, *The Liverpool and Manchester Photographic Journal* changed its name to *The Photographic Journal* but after pressure from the Photographic Society of London, whose own journal bore that title, it changed its name to *The British Journal of Photography*

115 Ibid.

116 'Stereograms of Scottish Scenery', *The Photographic News* 27 January 1860, p 248

117 *Photographic Notes,* 1 October 1859

118 Ibid.

119 'Mr Wilson's Scottish Gems', *British Journal of Photography* 15 January 1860, p 23

120 Ibid.

121 *Photographic Notes,* 1 January 1860, p 12

122 'Mr Wilson's Scottish Gems', p 23

123 *Photographic Notes,* 1 January 1860, p 13

124 S. Fry, 'Instantaneous Photography & Composition Printing', *British Journal of Photography* 1 December 1860, p 348

125 Census Returns 7 April 1861, 23 Crown Street, Aberdeen. New Register House, Edinburgh

126 Aberdeen City Valuation Rolls, 22, 23, 24, Crown Street, 1860/61. Aberdeen City Council Offices, St. Nicholas House, Aberdeen

CHAPTER SEVEN

127 'Mr. Wilson's Scottish Gems', *British Journal of Photography* 15 January 1860, p 23

128 'Scottish Gems', *British Journal of Photography* 1 January 1860, p 7

129 'Mr. Wilson's Scottish Gems'.

130 Professor Wilson, quoted in *Black's Picturesque Tourist of Scotland,* 3rd ed, p 266

131 Ibid.

132 'Stereograms of Scottish Scenery', *The Photographic News* 27 January 1860, p 248

133 This explanation is put forward in *Photographic Notes* 1 November 1860, p 289

134 *The Illustrated London News* 30 June 1860, p 623, states that the Fleet were at anchor for 14 days and departed on 23 June

135 *The Aberdeen Journal* 25 July 1860, press cutting in G. Walker's Journal, p 290, Aberdeen Public Library

136 'A voice from the hills; Mr. Wilson at home', *British Journal of Photography* 16 September 1864, p 353

137 *Photographic Notes* 15 January 1861, p 20

138 *Black's Picturesque Tourist of Scotland,* 3rd ed, p 355

139 *British Journal of Photography* 1 January 1861, p 1

140 *Photographic Notes* 15 January 1861, p 20

141 'Panoramic Photography', *The Photographic News* 28 March 1861, p 156. The comment about the flat surface was intended to distinguish this lens from Sutton's panoramic lens and camera which used curved plates to maintain definition. The camera was never commercially successful.

142 *British Journal of Photography* 27 March 1868, p 153

143 'Compound lens for views', letter by J. H. Dallmeyer in which he quotes from a letter sent to him by Wilson, *British Journal of Photography* 7 March 1862, p 119

144 The date of announcement is given by Dallmeyer in the preceding note. The title and review appears in *The Photographic News* 8 August 1862, p 375

145 Ibid.

146 For a description of this camera see *The Photographic News* 29 August 1863, p 413, and 26 September 1862, p 462

147 British Journal of Photography, 1 September 1863, p 353, and *The Photographic News* 30 October 1863, pp 518–19

148 *British Journal of Photography* 1 September 1863, p 353

149 Because each of Wilson's negatives gave twin 4¾ in. × 3½ in. vertical images and because the stereoscopic effect can only be achieved by mounting the images side by side, it was not possible to turn the existing album views into any format other than vertical

150 *British Journal of Photography* 15 February 1862, p 65

151 Unfortunately the ship's log of the HMS *Cambridge* is not to be found in the PRO, but the index to Admiralty letters ADM/2/691 clearly shows that HMS *Cambridge* was in the Hamoaze testing Armstrong's new gun

152 *The Photographic News* 10 January 1862, p 22

153 William Howitt, quoted in *Black's Guide to The South Eastern Counties of England; Hampshire and the Isle of Wight,* 1st ed, (Edinburgh: A. & C. Black 1862), pp 704–5

154 G. Walker, *Aberdeen Awa* (Aberdeen: A. Brown & Co., Edinburgh: J. Menzies & Co 1897), p 208

155 Reference to this Diary is given in note 57 above, and I reproduce a portion of it here by kind permission of H. Gernsheim

156 'Photography at the International Exhibition of 1862', *British Journal of Photography* 15 June 1861, p 215. This article quotes in full the letters sent by the various protagonists in the argument over the classification of photography. The quotation is from a letter by Dr L. Playfair, a Commissioner for the Exhibition

157 *The International Exhibition of 1862. The Illustrated Catalogue of the Industrial Department,* volume 1 (London: Printed for Her Majesty's Commissioners 1862), p 85

158 'Jurors awards in the Photographic Department of the International Exhibition', *British Journal of Photography* 1 August 1862, pp 290–1

CHAPTER EIGHT

159 G. W. Wilson, 'On developing negatives with iron', *Photographic Notes* 1 May 1858, pp 113–14

160 'The dangers of cyanide', *The Photographic Journal* 16 November 1865, p 200

161 G. W. Wilson, 'A voice from the hills: Mr. Wilson at home', *British Journal of Photography* 16 September 1864, p 353

162 G. W. Wilson 'On outdoor Photography', *British Journal of Photography and Photographer's Daily Companion* (London: Henry Greenwood 1870), p 117

163 G. W. Wilson, 'A voice from the hills', p 353

164 Ibid.

165 William Gellie (1826–1900) was Wilson's friend and assistant throughout his photographic career. A letter from Wilson to Gellie dated 1851 (Author's collection) shows from its tone and content that already they were friends and possibly working together. In later life Gellie became manager/overseer of the St. Swithin Street works, retiring in 1888 coincident with Wilson's own retirement. Gellie died in Aberdeen at the age of seventy-four

166 G. W. Wilson, 'A voice from the hills', p 353

167 G. W. Wilson, 'On outdoor photography, p 117

168 G. Walker, *Aberdeen Awa,* p 205

169 G. W. Wilson, 'A voice from the hills', p 410

170 See Chapter 9, p 154

171 G. W. Wilson's 'On outdoor Photography', p 118

172 Ibid. p 119

173 G. W. Wilson, 'A voice from the hills', p 140

174 Ibid.

175 G. W. Wilson. In a pamphlet advertising his new glass-house and his prices for portraiture, dated 10 March 1864. Author's collection

176 Charles A. Wilson to H. Gernsheim, Aberdeen 28 November 1951

177 Charles A. Wilson note to H. Gernsheim, Aberdeen, nd, *c.*1950s

178 Ibid.

179 One indication of the outgoings was the cost of silver nitrate used to make prints. In 1864/5 this cost £550 of which £208 was recovered through collection of the silver wastes. Charles A. Wilson, note to H. Gernsheim, nd *c.*1950s
 Photographic assistants were estimated to earn, on average £1 per week in 1863. *The Photographic News* 27 February 1863 p 103

180 Charles A. Wilson, *Aberdeen of Auld Lang syne* (Aberdeen: Henry Munro 1948) p 60

181 G. Walker, Manuscript Journal, p 272, Aberdeen Public Library

182 Ibid.

183 Ibid. p 292

184 Ibid.

185 G. W. Wilson, 'A voice from the hills', p 353

186 Ibid. p 375

187 Ibid.

188 Ibid.

189 W. Gilpin, quoted by C. P. Barbier in *William Gilpin* (Oxford: Clarendon Press 1963), p 122

190 Further support for this interpretations is provided by the prints Wilson supplied for the photographically illustrated *Lady of the Lake* (Edinburgh: A. & C. Black *c.*1866) where the prints are trimmed to a variety of different heights within a printed border. These differences in height seem to be based on whether the vignetting is included or not. This suggests that its inclusion was a conscious decision by Wilson

191 'Mr. Wilson's negative process', *British Journal of Photography* 21 October 1864, p 409

CHAPTER NINE

192 W. & M. Howitt, *Ruined Abbeys and Castles of Great Britain* (London: A. W. Bennett 1862), preface

193 S. Thompson, 'Photography in its application to book illustration', *British Journal of Photography* 1 March 1862, p 88

194 *The Photographic Journal* 15 February 1860, p 157

195 Reverse of cabinet photograph listing all Wilson's medals, Royal Archives, Windsor

196 *Art Journal* 1 December 1868, p 286

197 J. Wood, 'The commercial aspects of photography', *British Journal of Photography* 17 February 1871, p 74

198 Ibid.

199 Ibid.

200 'Sketches of Prominent Photographers', *The Photographer's Friend* vol 2 (April 1872), p. 49, reprinted in *The Photographic News* 2 August 1872, p 368

201 *Aberdeen Post Office Directory* 1873/4, p 215

202 Lord Chamberlain's List of Warrant Holders, Tradesmen, MSS LC5/245, p 26, Public Record Office, London

203 'Exhibition of the Photographic Society', *British Journal of Photography* 6 November 1874, p 529

204 'Sketches of Prominent Photographers'

205 *British Journal of Photography* 23 July 1875, p 357

206 Although the imperial view first appears in the 1871 catalogue with a size of 8½×6½ in. and a limited range of 46 subjects its commercial potential came only with the introduction of the 10×7 in. format. This large size was first mentioned in a review of the Photographic Society's exhibition in London. *The Photographic News* 22 October 1875, p 511. I am indebted to Mr P. Wing for access to his copies of the 1871 and 1873 Wilson catalogues

207 A plan of the site giving the date of agreement is preserved. Author's collection

208 John Nicol, PhD, 'Notes from the North', *British Journal of Photography* 30 March 1877, pp 151/2

209 Ibid.

210 John Nicol, PhD, 'Notes from the North' *British Journal of Photography* 6 April 1877, p 162

211 Charles A. Wilson to H. Gernsheim, Aberdeen, 28 November 1951

212 John Nicol, PhD, 'Notes from the North' *British Journal of Photography* 30 March 1877, pp 151/2

213 John Nicol, PhD, 'Notes from the North', *British Journal of Photography* 6 April 1877, p 163

214 Ibid.

215 Charles A. Wilson, quoted in H. & A. Gernsheim, *The History of Photography,* 2nd ed (London: Thames & Hudson 1969), p 402

216 'Staff regulations at G. W. Wilson & Co.' Ibid, p 403

217 Lord Chamberlain's List of Warrant Holders, Tradesmen, MSS, LC5/244, p 247, Public Record Office, London

218 Mrs L. Fraser-Low, granddaughter of G. W. Wilson, in conversation with the Author, 1976

219 G. Best, 'Mid Victorian Britain 1851–75' (St Albans: Panther Books 1973), pp 227

220 In the event these overseas views helped to hasten the decline of the company. Whereas in Britain civic development was limited, in the new colonial settlements of South Africa and Australia the changes were much more rapid and apparent. So by the time the negatives had been sent back to Aberdeen and a stock of prints made and shipped out again they were virtually out-of-date and quickly became dead stock

221 For a full account of the fire see *The Aberdeen Journal* 15 June 1882, p 2

222 *The Times* 17 June 1882, p 7

223 Only the previous year Wilson had been at Fingal's Cave with his assistant when the boat from which the assistant was photographing, capsized. Wilson saved his assistant by means of his umbrella. *The Herald and Weekly Free Press* 23 September 1882

224 Charles A. Wilson to H. Gernsheim, Aberdeen, 25 August 1951, University of Texas

225 Letters relating to the dissolution of the old and creation of the new partnership, Wilson volumes, Aberdeen Public Library

226 *British Journal of Photography* 26 January 1877, p 47

227 For further information regarding photographer's health refer to: *British Journal of Photography* 1 January 1864, p 2, 3 August 1866, p 369, 9 October 1868, p 482; *The Photographic News* 8 July 1870, p 317, 19 June 1874, p 297

228 See Wilson's obituary notice in the *British Journal of Photography* 17 March 1893, p 166

CHAPTER TEN

229 George Walker, Manuscript Journals, p 3127 margin note. Aberdeen Public Library

230 Aberdeen City Valuation Rolls 1893/4. St Nicholas House, Aberdeen

231 Scottish Record Office, Report on the case with appendices, CS240/A/5/4

232 Scottish Record Office, J. H. Wilson in evidence, Appendix for reclaimers, Exchequer Cause 20 June 1894, p 14
The reason for this low 'average profit' was undoubtedly because it took into account what appears to have been an abnormal loss of £1198 for the year ending 31 March 1887. Evidence of Alexander Davie, cashier to Wilson & Co, p 16

233 *Aberdeen Post Office Directories* 1893/4 and 1897/8. The portrait studios were sold to A. Brown who continued in business for several years.

234 Scottish Record Office, Register of defunct companies, BT Z/2454, G. W. Wilson & Co. Ltd, letter dated 18 March 1902

235 *The Photographer Dealer* September 1901

236 Catalogue of sale of G. W. Wilson & Co 9–11 July, 1908. Author's collection. I am indebted to Frances Milne of John Milne, Auctioneers, Aberdeen, for providing me with details of the sale prices realised at the auction.

237 George Walker, Manuscript Journals, p 291

Appendix One

Reviews of the photographs of George Washington Wilson

It was Wilson's practice to submit each season's work to the editors of several photographic journals. If the editors thought anything of the work, they were more or less obliged to write and publish a critical review. Such reviews served to publicise Wilson's name and work. For the historian of photography they are valuable in that they permit the accurate dating of many of Wilson's stereoscopic views.

In compiling the following list I have tried to indicate those reviews of the greatest utility in this respect. As Wilson submitted his work to several journals, there is bound to be some duplication and I have cited only those reviews that provide the most useful information or are in some way unique. The earliest reviews are not editorial but are to be found within much longer exhibition reviews. These have been included, with the prefix E. R., as there is no alternative evidence for this work.

Many of the critical reviews were very specific. By giving the Wilson catalogue number and title as well as a description of the subject, they help to identify the photograph more exactly. In those cases where a number has been omitted, I have attempted (wherever possible) to ascertain the catalogue number. Such numbers have been given in parenthesis.

Despite this apparent wealth of information the list should be used with care for the methods Wilson adopted for updating and allocating catalogue numbers are potentially misleading. *Loch Katrine*, No. 9 reviewed in *The British Journal of Photography*, 15 April 1861, exemplifies several points concerning the dating of Wilson's photographs. This negative would have been made the previous year, probably during the late summer or early autumn, a time of the year preferred by Wilson for the clarity and quality of light. During the intervening months the negative would have been used to build up adequate stocks before the photograph was publicly released. This, I believe, was the rhythm that the seasons and circumstance imposed upon Wilson. Negatives made during the late spring or early summer, another favourite time for photography, were released during the autumn months. It would seem that reviews appeared approximately 4–7 months after the making of the negatives.

It might be thought that a low catalogue number indicates an early date. This simply is not so, as Wilson ascribed numbers to his work in a most erratic manner. In this particular example, the photography of *Loch Katrine*, No. 9 was reviewed alongside work made contemporaneously but given catalogue numbers around the 280s. I suspect that Wilson was filling up gaps in the early part of his catalogue or replacing an earlier and unidentified No. 9 with a new photograph. There are cases where he is known to have done both of these things.

A different sort of problem arising from the replacement of a view emerges when one consults the review in *The British Journal of Photography*, 1 December 1865, for listed here is yet another *Loch Katrine*, No. 9. In this instance Wilson was substituting a negative made in 1865 for one made in 1860. He probably did this because of changes at Loch Katrine following its use as a reservoir from October 1859. This caused the level of the water to rise with consequent changes to the shoreline.

If doubts remain concerning which version of a view one is looking at reference to the review can often clarify the matter because of the detailed description sometimes given of the pictorial content. One helpful method I have

used when all else has failed to place similar views in chronological order has been to compare tree and foliage growth and to look for the changes one would expect with the passing of years. I have found this to be particularly useful when ivy-clad buildings and ruins form part of the picture.

The list should be used in conjunction with the reprinted 1863 catalogue of stereoscopic and album views.

The abbreviations used for the journals are as follows:

The Liverpool & Manchester
Photographic Journal: *L & M. Ph. Journal*

The Photographic Journal: *Ph. Journal*
The British Journal of Photography: *B.J.P.*
Photographic News: *Ph. News*
Photographic Notes: *Ph. Notes*

The first three journals are effectively one and the same as *The Liverpool & Manchester Photographic Journal* became *The Photographic Journal* in 1859, but following objections from a journal of the same name changed yet again in 1860 to *The British Journal of Photography.*

A Chronological listing of Wilson photographs reviewed between 1857–1866

	Title	No.	Source
E.R.	Quarries of Rubislaw		*Ph. Notes,*
E.R.	Old Bridge of Don		15 Jan. 1857, p. 26
	The Bed of the Feugh, Aberdeenshire		*Ph. Notes,* 15 July 1857,
	Bridge on the Feugh		p. 262
	Muchals coast scene		
E.R.	A Reach of the Don		*L & M.*
E.R.	The Brig o' Balgownie		*Ph. Journal,*
E.R.	Aberdeen Granite Quarry		1 Aug. 1857, p. 156
	The Solar Eclipse		*Ph. Notes,* 1 Apr. 1858, p. 85
E.R.	The Linn of Quoich		*L & M.*
E.R.	Mill in Castleton, Braemar		*Ph. Journal,* 15 June 1858, p. 154
E.R.	Thunder Cloud		*Ph. News,*
E.R.	Aberdeen Docks		1 Oct. 1858, p. 53
E.R.	Reach on the Don		
	Oban Sunset		*Ph. Notes,*
	A Summer Morning on the Sands		1 Nov. 1858, pp. 252/3
	Fishing boats, Loch Fine at Inverary		
	Oban Evening		
	Inverary, Argyllshire		
	Fingal's Cave, 3 subjects		
	Bonnington Falls on the Clyde		
	Waterfall at Inversnaid		
	Loch Etive		
	Instantaneous portrait of child on rocking horse		
E.R.	Summer Morning on the Sands		*Ph. Journal,*
E.R.	High Tide Morning		5 Feb. 1859, p. 180
	Loch of Park, 6 studies	(120–5)	*B.J.P.,* 1 Dec. 1859, p. 294 (see also *P. News,* 27 Jan. 1860, p. 246)
	Balmoral Castle from South West and North West	132, 3	*Ph. Notes,* 1 Jan. 1860, p. 12
	Holyrood Chapel, Interior	87	
	The West Door, Elgin Cathedral		*B.J.P.,* 1 Jan. 1860, pp. 6 & 7
	South Door of Roslin Chapel	(92)	
	The Interior of Roslin Chapel ('Prentice Pillar)	(93)	
	The Tomb of Sir Walter Scott, Dryburgh Abbey	(104)	
	Balmoral Castle from the South	131	

The Trossachs and Ben Venue from above Inn	24	*B.J.P.,* 15 Jan. 1860, p. 23
The Pass of Beal-ach-nam-bo	(165)	
The Upper Fall of Foyers, Invernesshire	(155)	
Upper Fall on the Garr-Valt, Braemar	(137)	
Upper, Second and Lower Falls of Moness	(173/4/5)	
Fingal's Cave, Staffa		
Princes Street, Edinburgh	(110)	
The Breaking Wave	(79 & 2530)	
The Victoria Steamer		
Aberdeen Harbour, Twilight		
Waterfall in Glencoe	(152)	*Ph. News,*
Waiting for the tide		27 Jan. 1860,
The Gathering Mist, Muchals	(74)	pp. 246, 7, 8
Princes Street, Edinburgh	(188/9/90)	*B.J.P.,*
Regent Street, London	205	15 Oct. 1860,
The Quadrant, Regent Street	206	pp. 303/4
The Standed Collier	238	
Studies from Ryde Pier Isle of Wight	(239/40/ 1/2/3)	
The *Great Eastern* in Southampton Water	(219/20/ 1/2/3)	
HMS *Royal Albert*	(224/A/ B/C/D)	
HMS *Edgar*	225	
The Channel Fleet in the Firth of Forth	(226/7/8/ 9/30)	
Stonehenge—General View from East	207	*B.J.P.,* 1 Jan. 1861,
Stonehenge—from West	209A	pp. 11/12
Stonehenge—from South-east	211	
Salisbury Cathedral—South Aisle	214	
Salisbury Cathedral—The Transept	215	
Salisbury Cathedral— Entrance to Chapter House	216	

Salisbury Cathedral— The Cloisters	217	
St. Paul's Cathedral, Interior	203	
Westminster Abbey, The Nave	192	
Westminster Abbey, The Choir	193	
Westminster Abbey, The South Aisle	194	
Westminster Abbey, The Poet's Corner	195	
Westminster Abbey, The Cloister	198	
Westminster Abbey, Henry VII's Chapel	199	
Quiraing, Skye	263/4	*Ph. Notes,* 15 Jan. 1861, pp. 20/1
Loch of Park, Wild Duck Shooting	278	*B.J.P.,* 15 April 1861,
Loch of Park, Pike Fishing	279	pp. 145/6
Loch of Park, Twilight	280	
Loch of Park, 2 studies	281, 2	
Loch of Park, Evening	284	
Loch Katrine	9	
Loch Katrine	30	
Loch Katrine from Ben Venue	65	
Loch Katrine and Ben Venue	26	
Ben Venue from Loch Achray	59	
The Pass of the Trossachs	21	
Glencoe from above Clachaig	154	
Views in Glencoe	153/7	
View in Glencoe	272A	
Falls of Bracklinn	63/4	
Bracklinn Bridge, Perthshire	25	
Glamich, Skye	271	*B.J.P.,*
Scuir-na-gillean, Skye	268/9	2 Sept. 1861,
The path to the Well, Tobermory, Mull	(277)	pp. 308/9
Tobermory, Mull	255	
Aros Waterfall, Mull	257	
The Colonnade, Basaltic Pillars, Staffa	15	

Clamshell Cave, Staffa	16		Dropping Down with the Tide	330	
Fingal's Cave, Staffa	17		The Thames at Greenwich	331/2/4	
The ruins of the Cathedral, Iona	39		Loch Avon, Banffshire	337	
St. Martin's Cross, Iona	258		Craigellachie Bridge, on	349	
Maclean's Cross, Iona	259		the Spey		
Oban, Argyllshire	32A		Pines in the Forest of		
Ben Nevis, from above Corpach	(253/A)	(Despite the late review date all these subjects were taken during 1860, see reviews)	Rothiemurchus, Strathspey	353	
			Loch Insch, Insch	356	
			The Wolf of Badenoch's Castle		

Review of Wilson's first cabinet views, no numbers given

Exeter Cathedral, West Front	295	*B.J.P.,*	Aberdeen with Union Bridge	*Ph. News,*	
Exeter Cathedral, The Choir	296/7	1 Jan. 1862,	Aberdeen University	8 Aug. 1862, p. 375	
Exeter Cathedral, The Nave looking East	298	pp. 24/5	Castle Street, Aberdeen		
Exeter Cathedral, The Great West Door	300		Balmoral Castle, 3 studies		
			Braemar Castle		
Gloucester Cathedral, from North-west	301		Mill on the Cluny		
Gloucester Cathedral, Cloisters	304		Bridge on the Cluny		
Royal Albert bridge, Saltash	305/6		Bonnington Falls, on the Clyde	7A	*B.J.P.,*
The 'Cheesewring', Cornwall	307		Waterfall at Inversnaid	8A	2 Feb. 1863, p. 52
The Logan Stone, Cornwall	309		The Boat House, Loch Katrine	20	
Land's End, Cornwall	311		Pass of the Trossachs	22	
HMS *Impregnable*	313/A		Loch Katrine	28A	
HMS *Cambridge,* Great Gun Practice	316/7		Ellen's Isle, Loch Katrine	36	
HMS *Sheldrake* & *Sharon* in Hamoaze	325		Stonebyres Falls, on the Clyde	37	
			The entrance to the Pass of Ballater	42	
			A 'Bit' in the Trossachs	58	
Balmoral Castle from Craig-an-Gowan	12	*B.J.P.,*	The Interior of the Lantern Tower, York Minster	377	
The 'Lion's Face' Rock, Invercauld	48	15 Feb. 1862, pp. 65/6	Durham Cathedral, from the river	380	
Braemar, The Linn of Dee	144A		Durham Cathedral, The Galilee, Lady's Chapel	385	
HMS *Revenge*	318/C		Loch-na-gar	434	
HMS *Royal Adelaide*			Dhu Loch	436	
HMS *Conqueror* and *Centurion*	(321)		Island on Loch Muick	439	
Greenwich Hospital	326		Winchester Cathedral, Lady Chapel	407	*Ph. News,* 13 Mar. 1863, p. 122
Barges coming up with the Tide	327/8				
The Thames at Greenwich	329				

The Thames at Greenwich—		
'Waiting for the Boat'	(410)	
'Arrival of the Boat'	(411)	
'Departure of the Boat'	(412)	
The Thames at Woolwich	418	
The *Victory* Flagship,		
Portsmouth	(424)	
Album views, first reviewed.		*B.J.P.,*
All subjects reviewed		1 Sept. 1863,
previously as album views		p. 352
are re-released stereoscopic		
material		
Coniston Old Man, from above		*B.J.P.,*
the Mines	559	18 Nov. 1864,
Ewedale Crags	560	p. 462
Waterfall at Coniston	561	
At the Copper Mines	562	
Bowder Stone	(564)	
Borrowdale, from above the		
Bowder Stone	565	
Borrowdale, looking towards		
the Castle Crags	581	
Derwent Water from Friars Crag	582	
Wallow and Falcon Crags	(583A)	
Ambleside	(589)	
Rydal Mere (3 studies)	(591/3)	
Langdale Pikes from the		
Loughrigg Fell	594	
Melrose Abbey (from the S.W.)	97	*B.J.P.,*
Melrose Abbey (from the E.)	99A	9 Dec. 1864,
Dryburgh Abbey (Tomb of		p. 503
Sir Walter Scott)	104A/C	
Sir Walter Scott's Monument	114A	
Waverly Bridge and Old Town	117	
York Minster, The West Front	366	
York Minster, West Front with		
Chapel		
The High School, Edinburgh	525	
Fountains Abbey, from		
Robin Hood's Well	539	

Fountains Abbey, The		
Chapter House	548	
St. George's Church, Doncaster	552	
Furness Abbey, 3 Studies	(553/5)	
Abbotsford, Interiors	573/4/5	
Bronze Cast of Scott's head		
after death	577	
Holyrood Palace	906	
Loch Katrine (Path by the Loch)	9	*B.J.P.,*
Loch Katrine (and Ben Venue)	10/B	1 Dec. 1865,
Loch Katrine, The Silver Strand	18	pp. 609/10
Loch Katrine (with steamboat		
Rob Roy)	20C	
Pass of the Trossachs	21	
Ben Venue	24	
Loch Katrine (from the		
Trossachs Pier)	28	
Otter Island (Loch Katrine)	70	
Duncraggan Huts	85	
A 'Bit' on the Loch (Katrine)	(166)	
Loch Lubnaig, Perthshire	667A	
Loch Fyne, looking towards		
Duniquaich	670	
Duniquaich, Inverary	678A	
Balmoral from the River	14	*B.J.P.,*
Colonel's Bed, Braemar	142	2 Nov. 1866,
Linn of Dee	144A	pp. 526/7
Fingal's Cave	145	
Fingal's Cave, Interior	145A	
St. Martin's Cross, Iona	258	
Maclean's Cross, Iona	259	
Cottage opposite Balmoral Castle	716	
Firs at the Linn of Dee	719	
Iona Cathedral, South Aisle	731	
Dun Ji	737	
Iona Cathedral		
Loch Ness and Caledonian		
Canal		
Glencoe		

Appendix Two

Wilson's 1863 List of Stereoscopic and Album Views

Reprinted by courtesy of the Gernsheim Collection, University of Texas, Humanities Research Center

LIST of Stereoscopic and Album Views

No.

1 Mill on the Cluny—Braemar
2 Fall on the Garr-valt—Braemar
3 Corra Linn—on the Clyde
4 'Brig o' Balgownie'—near Aberdeen
4A 'Brig o' Balgownie'—near Aberdeen
4C 'Brig o' Balgownie'—near Aberdeen
6 Mills at Castleton—Braemar
7 Bonnington Falls—on the Clyde
7A Bonnington Falls—on the Clyde
8 Falls at Inversnaid—Loch Lomond
8A Falls at Inversnaid—Loch Lomond
9 Loch Katrine
10A Loch Katrine
10B Loch Katrine
11 West Door, Elgin Cathedral
13 Balmoral Castle, from S.E.
14 from N.W.
15 Basaltic Colonnade—Staffa
16 Clamshell Cave—Staffa
17 Fingal's Cave—Staffa
18 'The Silver Strand'—Loch Katrine
20 The Boat-house—Loch Katrine
20A The Boat-house—Loch Katrine
20B The Boat-house—Loch Katrine

20C The Boat-house—Loch Katrine
21 Pass of the Trossachs
22 Pass of the Trossachs
23 Ben A'an, from Loch Katrine
24 Inn at the Trossachs
24A Inn at the Trossachs
25 Bracklinn Bridge—Perthshire
26 Loch Katrine and Ben Venue, from
 the 'Dale of the Whitehorse'.
28 Loch Katrine
28A Loch Katrine
30 Loch Katrine
31 Craig Coynach—Braemar
32 Oban—Argyleshire
32A Oban—Argyleshire
34 Peak of Ben A'an
35 Linn of Quoich—Braemar
36 Ellen's Isle—Loch Katrine
37 Stonebyres Falls—on the Clyde
38 Glasgow Cathedral, from S.E.
39 Iona Cathedral and St. Martin's Cross
40 Iona Cathedral, from N.W.
40B Iona Cathedral, from N.W.
41 Falls of Corrymulzie—Braemar
42 Entrance to Pass of Ballater
44 Upper Fall on the Garr-valt—Braemar
46 Stirling Castle

46A Stirling Castle
47 Dunblane Cathedral
48 Lion's Face Rock—Braemar
49 The Brow of Ben Venue
50 Elgin Cathedral—West Towers
51 St. Mary's Aisle
52 Transept and West Towers
53 Chapter House
54 The Choir
55 Windows in S. Aisle
56 Bridge on the Cluny—Braemar
57 Bridge on the Cluny—Braemar
58 A 'Bit', in the Trossachs
59 Loch Achray
59A Loch Achray
60 Ben A'an, from Ben Venue
61 Church of Crathie—Balmoral
62 Rocks in the Pass of Ballater
63 Falls of Bracklinn—Perthshire
64 Falls of Bracklinn—Perthshire
65 The Trossachs and Loch Katrine
66 Braemar Castle
68 Interior of Fingal's Cave—Staffa
71 Castleton of Braemar
72 Invercauld House—Braemar
88 Interior of Holyrood Chapel
90 Holyrood Palace

92......The 'Prentice Pillar—Roslyn Chapel
93......South Door—Roslyn Chapel
94......Interior of Roslyn Chapel
95......Interior of Roslyn Chapel
96......Melrose Abbey, from S.E.
97...... from S.W.
98...... from S.
99...... from E.
99A..... from E.
100...... Nave
100A..... Nave and North Aisle
102...... Nave and South Aisle
103......Abbotsford, from the Tweed
104......Scott's Tomb—Dryburgh Abbey
105......The Tweed above Abbotsford.
107......Edinburgh, from the Calton Hill
108......Edinburgh—Old Town, from the Calton Hill
109......Calton Hill—Edinburgh
110......Calton Hill and High School—Edinburgh
111......Edinburgh Castle, from Princes Street
112......Edinburgh—Assembly Hall, &c.
114......Scott's Monument—Edinburgh
114A.....Scott's Monument—Edinburgh
116......Dugald Stuart's Monument—Edinburgh
117......Edinburgh—Waverley Bridge and Old Town
118......Edinburgh—Waverley Bridge and Old Town
124......Loch of Park
125......Loch of Park
129......Ballater
130......Ballater
131......Balmoral Castle, from S.
132...... from S.W.
133...... from N.W.
133A..... from N.W.
134...... from N.W.
135......Abergeldie Castle
135A.....Abergeldie Castle
136......Bed of the Garr-valt—Braemar
137......Upper Falls on the Garr-valt—Braemar

138......Lower Falls on the Garr-valt—Braemar
139......Lower Falls on the Garr-valt—Braemar
140......Upper Falls on the Garr-valt—Braemar
141......Craig Cluny—Braemar
142......Colonel's Bed—Braemar
143......Glen Ey—Braemar
144......Linn of Dee—Braemar
144A.....Linn of Dee—Braemar
145...:..Fingal's Cave—Staffa
145A.....Fingal's Cave—Staffa
146......Basaltic Rocks—Staffa
148......Fall of Foyers—Inverness
149......Fall of Foyers—Inverness
152......Waterfall in Glencoe
153......View in Glencoe
154......Glencoe, from above Clachaig
155......Upper Fall of Foyers—Inverness
163......The 'Pioneer' at Ballachulish
164......Iona Cathedral and St. Oran's Chapel
165......Pass of Beal-ach-nam-bo—Trossachs
166......'Bit' on Loch Katrine
167......'Bit' on Loch Katrine
168......Dunkeld Cathedral
170......Hermitage Bridge—Dunkeld
171......Falls on the Brann—Dunkeld
172......Falls on the Brann—Dunkeld
173......Upper Falls of Moness—Aberfeldy
174......Second Falls of Moness—Aberfeldy
175......Lower Falls of Moness—Aberfeldy
177......Hawthornden
178......Roslyn Glen and Castle
181......The Lady Chapel—Roslyn
181A.....The Lady Chapel—Roslyn
182......S. Door, Melrose Abbey
183......Abbotsford, from S.E.
185......Princes Street, Edinburgh—looking West
186......Princes Street, Edinburgh—Looking East
187......Princes Street, Edinburgh

188......Princes Street, Edinburgh
189......Princes Street, Edinburgh
190......Princes Street, Edinburgh
191......The Mound—Edinburgh
192......Westminster Abbey—The Nave
193...... Choir, looking West
194...... S. Aisle
195...... Poets' Corner
196...... Peel's Monument
197...... Wilberforce's Monument
198...... The Cloisters
199...... Henry VII's Chapel
200...... Roof of Henry VII's Chapel
201......Victoria Tower—Westminster
203......Interior of St. Paul's
204......Cornwallis' Monument—St. Paul's
207......Stonehenge, from E.
209...... from W.
209A..... from W.
210...... from S.
211...... from S.E.
212......Salisbury Cathedral—The Nave
213...... The Choir
214...... S. Aisle
215...... The Transept
216...... Entrance to Chapter House
217...... The Cloisters
220......The *Great Eastern*
221......The *Great Eastern*
224D.....The *Royal Albert*
225......The *Edgar*
225A.....The *Edgar*
238......The Stranded Collier
239......'Ebb Tide' at Ryde
253......Ben Nevis
253A.....Ben Nevis
254......Dunolly Castle, near Oban
255......Tobermory—Mull
256......Waterfall at Tobermory—Mull
257......Aros Waterfall—Island of Mull
257A.....Aros Waterfall—Island of Mull
258......St. Martin's Cross—Iona
259......Maclean's Cross—Iona
259A.....Maclean's Cross—Iona
260......'The Street'—Iona
263......Quiraing—Skye
264......Quiraing—Skye

Appendix Three

Wilson's *A Practical guide to the Collodion Process in Photography*, 1855

Reprinted by courtesy of King's College Library, University of Aberdeen

A PRACTICAL GUIDE

TO

THE COLLODION PROCESS

IN

PHOTOGRAPHY;

DESCRIBING

THE METHOD OF OBTAINING COLLODION NEGATIVES, AND OF
PRINTING FROM THEM.

BY

G. W. WILSON,

ARTIST & PHOTOGRAPHER.

LONDON: LONGMAN & CO.
EDINBURGH: A. & C. BLACK.
ABERDEEN: A. BROWN & CO.

MDCCCLV.

PREFACE.

THE object of the following pages is to give a clear and concise description of the method of producing Negative pictures on glass by the Collodion process, and of printing Positives from them upon paper.

It was written originally for the guidance of private pupils; because the author could find no good elementary treatise, not over-burdened with formulæ, or with too much purely scientific matter. He has been induced to give it a wider circulation than he originally intended, by the hope that, from its practical nature, it may be useful to others who are commencing to practise this fascinating art.

General Description of the Collodion Process

Before entering into the details of the collodion process, it may be well to give a summary, to enable the beginner to recognise the chemical changes involved in it, and to understand the few technical phrases which are unavoidably used in the lengthened description. This summary, and a few practical hints on the chemicals and instruments required, shall be given in as few words as possible.

The picture obtained on a plate of glass, in the first part of the process, when looked at by transmitted light, has the lights and shadows of nature reversed—the shadows being white, and the lights black. It is spoken of as a *negative picture*, or a *negative*.

The finished picture obtained from this negative in the second process, by super-position on paper, has its lights and shadows as they are seen in nature. To distinguish this from the negative, it is called a *positive picture*, or a *positive*.

The *negative* is thus produced. A clean glass plate is first coated with a solution of gun-cotton in sulphuric ether (Collodion), containing a small proportion of alcohol and iodide of potassium, and is then dipped into a solution of nitrate of silver. The iodine, of the iodide of potassium contained in the collodion, and the silver, of the nitrate of silver, combine and form a light yellow coating of iodide of silver, which remains on the surface of the plate with unchanged nitrate of silver. These salts render the collodion surface very sensitive to light, or rather to the invisible chemical rays which accompany the coloured rays of light.

A plate, thus prepared in a darkened room, is placed in a Camera Obscura, so that the image of some object placed in front of the camera may be formed on its sensitive surface. After exposing the plate in this way for a certain time to the action of the rays of light forming the image, it is again taken into the darkened closet; and although, on removing the plate from the frame which held it in the camera, no visible change is observed, a chemical change has nevertheless been produced on the collodion surface to an extent varying according to the amount and quality of the light forming the different parts of the image in the camera. To bring out or develop this latent picture, a developing solution composed of pyrogallic and acetic acids is poured on the plate. The effect of this is permanently to blacken the deposit on the collodion surface in the position of the image. The depth of tone in this black deposit varies with the intensity and quality of the light reflected from the different parts of the object, and, consequently, a picture or representation of the latter, embracing even its most minute details, is produced. But the lights and shadows are reversed when the picture is viewed as a transparency; for the light parts of the object which reflected a large number of rays of light have blackened the collodion surface very deeply, whilst the shadows which reflected but a feeble light have darkened the collodion surface but feebly.

When the blackening has attained sufficient intensity, the developing solution and the nitrate of silver are washed off, and the negative will then bear exposure to daylight without injury. Before it is fit for printing or producing a positive, the unchanged yellow iodide must be removed from the surface of the plate. This is accomplished by immersing it in a solution of hyposulphite of soda, which in a few seconds dissolves the yellow iodide of silver and leaves only the blackened deposit, which produces the representation of the object. The negative is then well washed with water to remove the hyposulphite, and, after being set aside to dry, it is finished.

The *positive picture* is obtained from the negative in the second process. A sheet of paper is coated first with a solution of common salt or of chloride of ammonium, and when this is dry, with a strong solution of nitrate of silver; a coating of chloride and nitrate of silver is thus formed on the surface of the paper which is again dried. Wherever the light shines upon this paper it exerts a chemical action, and gives the paper a brown or black colour, of an intensity varying according to the length of time the exposure has been continued and the character of the light at the time.

The negative is then laid upon a sheet of paper so prepared, and these are pressed into close contact by a plate of thick glass laid upon them, or by a frame with a glass front prepared for the purpose. In the position of the shadows of the object copied, where there is little or no deposit upon the negative, the light acts quickly upon the prepared paper and changes it to a deep brown or black colour, before the portions of the paper protected from the light by the more opaque parts of the negative are at all effected. If the paper were taken from beneath the negative in this state, and exposed to daylight, it would, in a short time, turn equally brown or black over the whole surface.

To prevent this, and to fix the positive picture, after it has become sufficiently dark, it is placed in a solution of hyposulphite of soda. This acts upon it as upon the negative, dissolving the salts of silver from those portions of the paper which were covered by the opaque parts of the negative, and consequently were not acted upon by the light, leaving only the permanent blackened chloride which forms the picture.

The hyposulphite is then removed from the paper by repeatedly washing it with clean water, and, after being dried, the picture is finished.

The Apparatus and Chemicals required in the Collodion Process

The following list comprehends the principal articles necessary for the successful practice of this branch of photography:

A double achromatic lens, for portraits
A single achromatic lens, for landscapes
Sliding camera on a tripod stand
Glass bath for holding solution of nitrate of silver
Flat porcelain bath for preparing paper
Pressure frames for printing
Glass funnel for filtering solutions
Graduated measure and small scales and weights
Pure nitrate of silver (crystallised)
Collodion
Pyrogallic acid
Glacial acetic acid
Chloride of gold
Spirits of wine
Plate glasses to fit the slides of the camera
Photographic paper
Piece of wash leather

PHOTOGRAPHIC LENSES

Beginners are often at a loss how to choose their lenses, owing to the great number of eminent opticians who have devoted their attention to their construction since the art became popular, and to the differences of opinion amongst photographers as to the comparative merits of particular lenses, even after they have made use of them for some time. Those manufactured by Mr Ross of London, judging from the eminence of the maker, and the high price he charges for them, appear to take the lead.

But, though unsurpassed in several important points, such as their quickness of working, and the coincidence of the foci of their chemical and coloured rays, Mr Ross's lenses will, in practice, frequently be found to give too sharp a focus. Thus, if in taking a half-length portrait with one of Ross's whole plate lenses, on a moderately clear day, you bring the eyes, nostrils, and mouth of the sitter in focus on the ground glass of the camera, you will find that the ear is slightly out of focus, and the hair at the back of the ear entirely so, the field being, as it were, only an inch or two in depth. Performing the same experiment with a lens of the same diameter by Lerebours and Secretan of Paris, the whole head is in focus, and the other parts of the figure are less distorted. Such lenses have the disadvantage, however, of being slower in their action than Ross's, but when rapidity is only of secondary importance, Lerebours' lenses, from their superiority in the important point before mentioned, are certainly to be preferred.

The lenses made by Voigtlander, and some other Continental and English makers, though possessing some good qualities, have different foci for their chemical and visual rays. These lenses are very troublesome to work with; for after focusing the picture produced on the ground glass by the visual rays, it is necessary to bring the lens nearer the ground glass, to an extent varying with the distance of the sitter from the lens, before the chemical rays, which are to act on the collodion surface, will be in focus upon it.

For landscapes, when the difference of a few seconds of time in the working is of little consequence, the lenses manufactured by known French makers are always to be preferred; as the general superiority of the views produced by these lenses proves. They have the additional recommendation of being cheaper in price.

THE CAMERA

The camera should be made of hard wood to prevent its shrinking, and it should be capable of adjustment both for portraits and landscapes.

It is essential that the frame of the camera holding the ground glass plate, and that which is to hold the collodion plate, be so fitted, that when in the camera, the inner surface of the ground glass on which the object is focused, and the collodion surface of the collodion plate, be precisely at the same distance from the lenses. If this is not the case, it is very difficult to obtain a good picture; because, a well defined image cannot be produced either upon the ground glass or the collodion surface, unless it be exactly in the focus of the lenses, and to allow for a difference in the position of the ground glass and collodion plate in an ill constructed camera is so difficult, that a good picture cannot be expected in the use of such an instrument except by mere accident.

To test a camera on this point, withdraw the ground glass frame after focusing the picture by its means, and insert the dark frame, containing another piece of ground glass, instead of the collodion plate. By opening the back of the frame and drawing up the front part, you can see at once if the image is as distinct upon this second ground glass as upon the first one, and if not, the dark frame must be altered accordingly.

When using the camera it must always be perfectly level, otherwise horizontal and perpendicular lines, such as occur in buildings, etc., would be drawn obliquely in the picture. A few perpendicular lines drawn in pencil on the focusing glass will be found useful; and if different sized pictures are to be taken by the same instrument, the exact dimensions of the various sized plates should be drawn in the same way upon the ground glass.

CHEMICALS

It is of great consequence that the chemicals be pure. The only way to insure this is to purchase them from a respectable dealer, and pay a suffcent price for them.

Economy in this matter tends only to create disgust with the art; for where impure chemicals are used none but inferior pictures can be produced.

It is especially advisable that collodion should be purchased from some person who has devoted considerable attention to its production.

Beginners often fancy that they have no merit unless they not only produce good pictures, but also manufacture their own chemicals. Painters find it better that their whole energies should be spent in designing their pictures, and applying the colours with effect on the canvas, than that they should waste their time in preparing and grinding their pigments. The latter departments they leave to the colour man, whose proper business and interest it is to see that they are properly prepared and perfectly ground. So should it be in photography, where the most expert manipulator finds himself taxed to the utmost to obtain perfect results, with every requisite prepared to his hand.

The collodion prepared by Mr Thomas, Pall Mall, is, undoubtedly, the best for negatives that has yet been manufactured in this country; and, though professional photographers say little about the matter, there is but little doubt that it is used in every establishment in the kingdom where first-rate pictures are executed. Messrs Horne and Thornthwaite, of Newgate Street, and some others, make good collodion at a much cheaper rate, but for certainty of working and uniformity of quality, the xylo-iodide of silver, sold by Mr Thomas, is still unrivalled; and, taking into account the number of failures, and the annoyance attending the use of second-rate collodion, I have little hesitation in saying that it will be found in the end to be the cheapest.

BATHS

The bath for holding the nitrate of silver solution may be either horizontal or vertical, but the latter form has so many advantages over the former that it is generally preferred. The collodion surface of the plates is inverted on the surface of the solution in the horizontal bath, and the plates are immersed in the solution when the upright bath is used, by placing them on a long slip of glass, with a cross piece fixed at one end to prevent them slipping off. The accompanying sketch shows the form of this

bath, with the glass dipper inserted. Its use will be more fully explained afterwards.

WORK-ROOM

Amongst the other things required in the practice of photography is a darkened closet; for, as light is the active agent employed to produce a picture, it will prove destructive if admitted during the process of dipping and developing the plate. The closet prepared for the purpose should be lighted only by a pane of yellow glass, or by one of common glass covered with three or four folds of yellow calico. It is more convenient if the light be admitted below the level of the hand in working, as the progress of developing the negatives can then be watched with greater ease and certainty.

Detailed Description of the Collodion Process

METHOD OF PRODUCING THE NEGATIVE PICTURE

Having described the various articles required in this branch of photography, it is necessary to point out, in the next place, how these are to be employed in the various steps necessary for the production of pictures.

SELECTED AND CLEANING THE PLATES

The plates selected should be of patent British plate glass. They should be free from striæ, and although it is not absolutely necessary, it is better that they should be ground on the edges before being used, as this prevents the film of collodion from tearing at the edges. The plates should be laid flat on a board covered with cloth, and cleaned by pouring on a few drops of spirits of wine and rubbing immediately in a circular direction with a soft cloth, polishing first one side and then the other. Remove them to a clean board prepared as above, lying the side of the plate first cleaned uppermost, and after a second application of the spirits of wine, take a piece of chamois leather, roll it up into a ball, and polish again, breathing upon the plate during the process, until you find that the vapour of the breath adheres equally over the whole surface. Turn the plate and treat the other side in the same way. The plates should then be put away in a box for use, taking care to handle them only by their edges.

New chamois leather should be well washed in a strong solution of common soda and water, to remove the oil and grease which it contains. The soda must then be well washed out by several changes of clean cold water. After the leather is dry, stretch and rub it until it becomes perfectly soft and flexible.

COATING AND EXCITING THE PLATES

When the plates are about to be used hold them in the left hand by one corner, as in the annexed diagram, covering with the thumb as little as possible of the surface of the glass, and with a clean dry leather wipe the surface lightly to remove any loose particles of dust which may adhere to it, and which would have the effect of causing small black specks and comet-like marks on the finished picture. Then, having taken the bottle containing collodion in the right hand, remove the stopper with the little finger of the left hand, and taking care that no dry collodion is sticking about the mouth of the bottle, immediately proceed to pour the collodion upon the centre of the plate in a full equal stream until there is rather more than sufficient to cover it. Depress the corner, no. 1, and allow the collodion to run to the edge; do the same with no. 2; then allow the collodion to flow towards no. 3, and if possible let it skirt the thumb without touching it; lastly let it drain into the bottle. To prevent the collodion running into streaks or furrows it is necessary, during the process of draining, to move the plate slowly to one side, by either depressing or raising the left hand; and if this is done carefully, the film of collodion will then present a smooth equal surface.

Soon after the collodion ceases to drip, replace the stopper of the bottle, and seizing the plate by its edges, and near the upper end, between the middle finger and thumb of the right hand, lay it on the glass dipper and plunge it slowly but without stopping in the following bath, and cover it to exclude the light.

Into a 16 oz stoppered bottle put

Nitrate of silver . . .	1 oz
Distilled water . . .	2 oz—*Dissolve*

Into another bottle put

Iodide of potassium . . .	4 grains
Distilled water . . .	2 drachms—*Dissolve*

Mix the two solutions and shake them until the precipitate which is formed is again dissolved, then add

Distilled Water . . .	14 oz

Allow the mixture to stand for half an hour, and then filter through clean white blotting paper, and add

Alcohol	2 drachms
Ether	1 drachm

After working sometime with this bath a little fresh solution of nitrate of silver (60 grains to an oz of distilled water) must be added to it now and then, to keep up its original strength. When it requires strengthening, it will begin to give weaker negatives than it did at first, and the plates will require longer immersion to take up a sufficient coating of iodide of silver.

The solution should be kept above the temperature of 50° Farenheit, and carefully excluded from the light whilst it is used.

Distilled water must be employed for every solution in which nitrate of silver is present, as the salt retained in common water decomposes it.

The hands should be washed and dried after fixing a negative, before the dipper or the iodised plates are again touched, to prevent hyposulphite of soda or any other foreign substance running down the dipper and spoiling the bath.

The dish containing the solution should be made of solid glass or of gutta percha, as those made of porcelain or stoneware soon become useless from the glazing giving way. It should be washed out when necessary with distilled water.

After the plate has been from 3 to 5 minutes in the bath remove the cover, and by means of the dipper lift the plate up and down in the solution, until the collodion surface ceases to have a greasy appearance, and the solution adheres smoothly and equally over it. These appearances indicate that the plate has received a sufficient coating of iodide of silver, and that it is ready to be placed in the camera. With Thomas's collodion, 5 minutes immersion in the bath in moderately warm weather, and 10 to 15 minutes in winter, will not be found too long. This lengthened immersion increases the quickness of action, and ensures the equal development of the parts of the picture after exposure in the camera.

EXPOSING THE PLATE IN THE CAMERA AND SUBSEQUENT DEVELOPMENT OF THE PICTURE

As no practical method has yet been discovered for testing the power of the chemical or actinic rays of light, no particular time can be specified for exposing the plate to the image in the camera.

The time varies so much with the season of the year, hour of the day, etc., that a different exposure may be necessary on particular days almost every quarter of an hour. In spring, summer, and autumn, the time of exposure will range from 2 to 30 seconds, and in winter from 10 to 100 seconds, when a double achromatic lens is used.

A diaphragm having a very small aperture is used in front of a single achromatic lens when it is wished to obtain a well-defined picture of near and distant objects at the same time. If the aperture of such a diaphragm be half an inch in diameter, and the focal length of the lens about 16 inches, the time of exposure of the plate will vary from 5 seconds to 5 minutes.

Those who have had a little experience can judge from the appearance of the image in the camera what period of exposure will be necessary within a few seconds; but so delicate is the operation of exposing the plate, that at times, even one or two seconds too long or too short, will be sufficient to spoil the beauty of a negative, which, had it been exposed the precise time necessary, at that particular hour or season, would have been perfect.

The plan most generally adopted is to expose a plate for a particular time, and then from the appearances which it presents during and after the development of the picture, one can tell almost to a second, the period of exposure necessary to produce a good negative on the second trial. As beginners, however, have often great difficulty in determining from the appearance presented by a finished negative, whether it has had *too short* or *too long* an exposure, and as this is a point of the greatest importance, I shall endeavour to be as precise as possible in pointing out how the two different effects may be distinguished.

Many a beginner has wasted his time, exhausted his patience, and blamed first the bath, then the collodion or lenses, as the cause of his failures, when, had he known from the appearance of his negatives, how long to expose the plates, he would have found everything in good working order, and produced capital pictures. Here lies the greatest difficulty in attempting to take views in the fields, upon collodion plates previously prepared; as out of 20 so treated, when brought home and developed, not one may be found which has been exposed so nearly the proper time that it may be rendered fit for use.

Supposing then that you have arranged your sitter or subject, say for a portrait of a lady dressed in a black silk dress and a white cap, and that you have gone through the operation of exposing the first plate in the camera; withdraw the dark frame containing the plate, take it into your darkened closet, remove the plate, and holding it in the left hand, as during the operation of coating it with collodion, proceed to pour on the surface as much of the following solution as will suffice to cover it, and keep moving the plate to make the solution flow from end to end without spilling.

Pyrogallic acid	.	.	.	1½ grains
Water	.	.	.	1 oz
Glacial acetic acid	.	.	.	½ drachm

Mix, and to every ten ounces of the solution add two drachms of spirits of wine.

If the plate has had *too short* an exposure in the camera, the highlights about the cap, hands, and face will soon make their appearance, and will go on increasing in blackness until they get *very intense,* before the figure and background make their appearance.

Should the developing solution be kept on for some time longer in the hope of bringing up the details of the figure, it will be found that before this result is obtained, the middle or *half tints of the face and hands will be merged in the lights, and consequently lost;* so that when the plate is used for printing, the proof or positive will present a very harsh picture, almost solely composed of bright lights and deep shadows.

On the other hand, if the plate has had *too long* an exposure, the image will appear quickly on applying the developing solution, but the whole will increase in intensity to nearly the same extent—that is to say, the dress, background, etc., will get as dark or nearly so, as the face and hands; but however long the process of developing may be continued, it will be found impossible to get a sufficiently deep negative to print from.

A plate thus treated will generally appear of a beautiful purple or crimson colour or looking through it, and it will *always present so thin a deposit,* that unless it has been but slightly overexposed it will prove useless as a negative. An impression printed from this plate would have quite an opposite effect from the first one; for instead of being composed of bright lights and deep shadows, it would be *almost all middle tint;* the face, dress, and background, being of a uniform grey colour, with very minute details. The negative will present the above-named indications in a greater or less degree, in proportion to the amount of over or under exposure of the plate to the rays of light in the camera. You may always calculate, however, that the plate has had *too short* an exposure if the face and cap become of *too intense a black before the details of the dress are distinct;* and that it has had *too long* an exposure if the *details of the dress are very distinct, and the deposit on the face and cap is too thin as a negative.*

It must be borne in mind, that in speaking of lights or shadows, reference is made, not to the lights or shadows as they appear on the negative, where they are reversed, but to the lights and shadows of the object in nature, or of the positive picture, printed from the negative upon paper, prepared with nitrate of silver.

If a plate has been but *slightly underexposed,* a tolerably good negative may be got by watching the lights narrowly, and stopping the development as soon as the half tints show the least indications of being lost in the lights. If the plate has been only *slightly overexposed,* a very good negative may be procured by keeping on the developing solution as long as it appears to act, and then having poured it off, by applying a fresh quantity of the developing solution, with two or three drops from the nitrate of silver bath added to it. Thus the intensity of the negative may be considerably increased.

In taking views, where minute detail is desirable, it is better that the plate should be rather *over-* than under-exposed, and then treated in the manner just indicated.

It will also be found that, in cold weather, a stronger solution of pyrogallic acid is required for the developing agent—sometimes as much as 3 or

4 grains to the ounce of water. A good plan, and one often adopted, is to prepare the developing agent thus:

Pyrogallic acid . . .	3 grains	
Water	1 oz	
Glacial acetic acid. . .	1 drachm	

Mix, and add 2 drachms of spirits of wine to each 10 oz. The spirits of wine added to the developing agent makes it flow evenly over the plate, and it should be added in greater quantity if the above is found not to be sufficient.

When about to use this solution, pour half the quantity necessary to cover the plate into a clean glass measure, adding water for the other half. If, after trial, this does not appear to be strong enough to develop the negative sufficiently, pour a little of the strong solution from the bottle upon the plate, and this will at once deepen it sufficiently.

If the plate has had the proper time of exposure, the image will appear more slowly; and soon after the lights make their appearance, the outline of the whole picture will be distinguished. As you continue the developing process, the highlights will grow intense; the lights about the hands and face will also continue to blacken; and, lastly, by the time the face is of such a depth as you desire, and before the half tints have become obscured, the whole of the details about the dress and background will have become sufficiently distinct, while the most intense shadows will retain their purity and clearness. An impression printed from this plate should present nearly a perfect facsimile of the sitter in light and shade, the highest lights on the cap and forehead, and the deepest shadows of the dress and background, being united by the soft gradation of middle tint seen in every well illuminated object in nature.

It taking a portrait, the sitter should be placed in a good light, which should be arranged so as to bring out the features to the best advantage, with neither too much nor too little shadow. The light from the north or east is preferable, from its being less liable to the influence of atmospheric changes. If direct sunshine were used, the shadows would be too harsh and black, and the strong glare would also be disagreeable to the sitter. It is sometimes necessary to work in sunshine when groups of figures or animals are under treatment, as they can thus be taken in a shorter space of time; and a sunlight effect is often desirable in landscapes and buildings, if care be taken to give the negative sufficient exposure. In placing a sitter, an easy and graceful position is almost all that is required;★ but this is often a matter of some difficulty, as from want of depth of field in the lenses, every

★ Those who are anxious for further information on this subject, may consult *Composition in Painting, Hints on Portrait Painting,* and *Light and Shade in Painting,* by John Burnet, or *Hints on Art,* by J. D. Harding.

part of the figure must be brought as nearly as possible on the same plane. The side should be turned to the instrument, so as to place the hands and head at nearly the same distance from the lenses. The distortion that would otherwise arise from objects within and beyond the focal distance, is thus in a great measure obviated.

It is in placing a sitter, and in choosing the best or most picturesque portion of a landscape, that a manipulator who has a knowledge of art, is superior to the mere mechanic; but beyond what has been already said, it would be needless in a short treatise like this to attempt to give useful instruction in a matter which after all that could be written upon it must be left in an great degree to the individual taste and judgment of the operator.

FIXING THE NEGATIVE PICTURE

The instant that the picture has been developed to the proper point, pour some clean water on the plate to remove the acids, and when this has been effected, you may remove it to the daylight, and proceed with the next operation.

Make a solution of hyposulphite of soda, by half filling a pint bottle with hot water, and adding the hyposulphite until no more will dissolve. Decant this into a flat gutta-percha dish, and immerse the plate in it. In a few seconds the whole of the yellow iodide will be removed, leaving only the blackened deposit, which forms the negative. Take the plate out of the dish, and continue washing it with clean water, by holding it horizontally and allowing a gentle stream to fall on the centre, until every trace of hyposulphite is removed, when the plate may be placed in the sun, or near the fire to dry.

If any hyposulphite is left on the surface, it will recrystallise and spoil the negative and every impression that may be printed from it, the hyposulphite forming dirty metallic streaks when placed in contact with the nitrate of silver on the surface of the paper. This cannot be got rid of in any after stage of the treatment.

When the plate has been thoroughly dried, it is better that the collodion side should be protected by a coating of varnish, if it is intended to print many copies from it, although with a little care twenty or thirty copies may be printed without this precaution. Amber varnish is the best for this purpose; and it may easily be prepared in the following manner. Pound in a mortar ¼ oz of pure amber, put it into a 4 oz bottle, and fill up the bottle with chloroform. Cork it tightly, and place it in a warm place for 12 hours, shaking occasionally; then, filter through blotting paper into a clean bottle, and it is fit for use. Although the amber does not appear to have lessened in bulk, there is still as much of it dissolved as will form a sufficiently strong varnish. Apply it on the plate in the same manner as collodion, but let it rest for a little on the surface of the glass before draining into the bottle,

that the chloroform may have time to evaporate, and leave a thicker coating of varnish.

The plate dries almost immediately; and it is then ready for printing.

METHOD OF PRODUCING THE POSITIVE PICTURES

These pictures have lights and shadows corresponding with those of natural objects. They are obtained by photographic printing on paper, specially prepared for the purpose, the negative picture being used in lieu of types, the chemical action of light in the place of the printers' ink, and the pressure frame instead of the printing-press.

PREPARING THE PAPER

Any white wove writing paper will answer the purpose, if of even texture and tolerably free from metallic specks. But, as many manufacturers have now turned their attention to the preparation of paper for photographic purposes, it is better to purchase this at once. Canson Frères', Turner's, and Whatman's are the papers most in repute, the first named being generally preferred for positives. I have recommended the beginner to purchase collodion for taking the negatives in preference to preparing it for himself, and I would now advise that the papers for taking positives should also be purchased ready salted and albumenised. Owing to the constant demand for such paper, it can be prepared cheaper and better on the large scale than any one can expect to prepare it for himself, except after repeated trials and great waste of material.

Pictures printed on albumenised paper have generally greater clearness and depth in the shadows, and more detail than those on simple salted paper. Many prefer the latter, on account of its peculiar softness of effect; and, therefore, a short account will be given of the method of preparing both kinds of paper, in order that those who wish to prepare either kind, may be enabled to do so with a fair chance of success.

ALBUMENISED PAPER

Take a sheet of Canson's thick positive paper; cut it into sizes a little larger than your negatives, and proceed as follows:

Into a basin put

The whites of	8 fresh eggs
Water	8 oz
Chloride of ammonium	.	.	200 grains		

Beat with a silver fork or a bunch of quills into a firm froth, cover the dish to keep out dust, and set it aside for 12 hours. When ready to proceed, pour off the clear liquid into a flat porcelain dish, and see that no air bubbles or dust are floating on the surface. Take one of the pieces of paper, and, having turned down half an inch, or dog-eared it at two opposite corners, hold the sheet by these corners, and bend it so as to allow the middle to touch the solution first; then gradually bring down the ends of the paper in turn, taking care that none of the albumen runs over the upper surface.

Take hold of the paper immediately afterwards by one of the bent corners, and lift it up sufficiently to allow you to see that no air bubbles prevent the albumen from coming in contact with the paper. If there are any bubbles, remove them with a soft camel's hair pencil, and float the paper again as before. After five or eight minutes, tear it up suddenly to bring a good coating of the albumen with it. Allow it to drain for half a minute, and then pin it up away from the fire to dry. If placed near a fire, or in a warm place, the albumen will set before it has drained sufficiently, and the surface will be streaked in consequence.

In preparing the albumen, the yolk and germ should be carefully excluded, and the eggs should never be more than a week old. After it has been frothed up and allowed to settle, the albumen will not keep more than a day or so, and it should therefore be used up at once. It will save time if sheets, twice or four times the size of the negatives, are prepared in a larger dish, as they may afterwards be cut to any required size.

Thus far the paper may be prepared in daylight, and it will keep in this state for months if, after being thoroughly dried, it is not allowed to get damp. When required for use, float the sheets by candle light in the same way as before, and for the same length of time, upon a solution of nitrate of silver of the following strength, and hang them up to dry in the dark:

| Nitrate of silver | . | . | . | 60 grains |
| Distilled water | . | . | . | 1 oz |

The chloride of ammonium on the surface of the paper and the nitrate of silver contained in the above solution combine and produce chloride of silver, which remains on the paper, with a little unchanged nitrate of silver. When light is allowed to fall on these salts, a chemical action ensues and the paper is blackened, therefore, after drying the paper, it must be kept in a portfolio to exclude the light until it is required for use. The best impressions are obtained after the paper has been prepared about 12 hours, but it will keep good for two or three days. After this it begins to blacken even in the dark.

PLAIN SALTED PAPER*

This may be prepared to print of any shade of black or brown that may be desired, by floating Canson's paper first upon a solution of common salt,

* Paper ready salted and albumenised in a variety of ways may be bought at a reasonable rate, from A. Marion & Co., 156 Regent Street, London. With each packet of this paper, directions are given as to the strength of the nitrate of silver bath which it requires.

or of chloride of ammonium, allowing it to dry, and then floating it upon the solution of nitrate of silver as before named, varying the strength of each according to the tint desired in the finished proof.

For a light sepia tint, float first upon a solution of

Chloride of barium, or	
common salt	10 grains
Water	1 oz

Allow the paper to remain for 5 minutes, hang it up to dry, and then float it on a solution of

Nitrate of silver . . .	50 grains
Distilled water . . .	1 oz

If a deeper colour be required, use for the first,

Chloride of ammonium . .	14 grains
Water	1 oz

And for the second,

Nitrate of silver . . .	80 grains
Distilled water . . .	1 oz

A black and white proof may be obtained by using for the first solution.

Chloride of ammonium . .	20 grains
Water	1 oz

And for the second,

Nitrate of silver . . .	120 grains
Distilled water . . .	1 oz

PRINTING FROM THE NEGATIVE

The annexed sketch represents the most convenient form of pressure frame for pictures less than 10 by 12 inches. It is a frame of hardwood, having a strong and fixed plate-glass front, and a wooden back hinged in the middle, for the convenience of lifting up one end to examine the progress of printing, without disturbing the paper upon the surface of the negative. The pressure is applied behind the back by means of two cross bars working in grooves, on the principle of the wedge.

This is all that is required, and it is certainly more simple than the cumbersome machinery of screws and levers, used for printing pictures of a larger size.

Take out the cross bars and the hinged back, which ought to be covered on the inside with cloth, lay the prepared paper on the cloth with its sensitive side uppermost, and over the paper place the negative with the collodion side touching the paper.

Raise the back with the paper and negative upon it by the right hand placed below the back, and then bring the frame with its glass front down upon the whole. Hold firmly, so as not to allow the negative to slip, and with a single movement of the wrists, turn the whole upside down. Lay the frame on a table, insert the cross bars or wedges, bringing them both home at the same time, and then remove to the daylight to print.

Although by placing the frame in the sunshine, in the summer time, the process of printing may be quickened, yet this never gives such clear impressions, as when the frame is placed in the shade, or in such a position as to command the maximum of clear blue sky. Better impressions are often obtained in winter when a whole day is occupied in the process, than can be got in summer even in the shade.

The depth to which the proofs require to be printed varies so much according to the strength of the fixing and colouring baths, and the tone of colour desired, that no definite directions can be given on this point; the deeper they are printed, however, the darker will the resulting tone be, and *vice versa*, whatever may have been the strength of the silver solution used in preparing the paper.

FIXING THE PROOFS

Having printed your pictures as deeply as you think necessary, remove them from the pressure frame and plunge them quickly into a basin of clean water and cover them up from the light. Soaking the proofs in water before placing them in the colouring bath, may be dispensed with, and many prefer immersing them in the latter at once; but I have always found that when they are thus treated, the shadows of the finished pictures are never so clear and transparent. After the proofs have been for about half an hour in water, remove them to the colouring bath, and in doing so, take care that your fingers are perfectly free from hyposulphite of soda, otherwise the proofs will be instantly spoiled by brown metallic streaks.

The colouring bath may be prepared in a variety of ways, but the following I have found to be all that is necessary, and the most simple—

Hyposulphite, of soda . . .	3 oz
Water	20 oz
Chloride of gold . . .	10 grains

The hyposulphite and water should be mixed first. The chloride of gold should be dissolved in about 1 oz of water and added gradually, stirring the bath during the operation.

This bath will colour rather slowly at first, but every additional proof fixed in it will increase the rapidity of its action by adding chloride of silver to it. When new and in its full strength, the proofs will be lightened in tone to a greater extent than after it has been for sometime in use, and they will require to be more deeply printed to allow for this reaction. After the bath

has been in use for some time, the proofs will bear to be less deeply printed, but in every case the highest lights ought to be allowed to assume a more or less intense violet tint before they are removed from the pressure frame. As after fixing a good many proofs, the bath will get weakened, both in chloride of gold and hyposulphite; these must be added in small quantities now and then to keep up its working qualities in perfection. When too weak in chloride of gold, the proofs will have to lie in the solution for a longer period before they assume the desired tone or lose the foxy brown colour. To remedy this, a few drops of solution of chloride of gold should be added.

When the bath is weak in hyposulphite the proofs often appear of a dirty yellow colour when finished, and in this case, the bath should be strengthened by adding a few crystals, or by pouring a little of the fixing bath into it. This yellowing will also take place if the proofs are allowed to remain *too long* in the colouring or fixing solutions. In general, they should be removed from the former when they begin to change to a slightly purplish brown colour.

When of this colour, wash them once or twice in clean water, and place them in the fixing bath, which is composed of a solution of hyposulphite of soda in water, in the proportion of three ounces of hyposulphite to twenty ounces of water. The proofs are partly fixed during the operation of colouring—the second bath is to insure their being perfectly fixed, by removing any soluble salt of silver that may not have been acted upon in the first bath.

The fixing bath also deepens the tint of colour of the proofs, which requires to be taken into consideration in removing them from the first bath.

The proofs should remain in the fixing solution from ten minutes to half an hour, being carefully watched that the lights and middle tints be not too much reduced. You then remove them into a large dish of clean water to be washed.

A fresh *fixing bath* requires to be made now and then, say after fixing fifty or sixty pictures, 10 in by 8 in. The old bath should not be thrown away, but poured into the colouring bath.

Although the process of printing and fixing becomes simple after a little practice, it always requires constant attention in every stage, for neglect of a proof for ten minutes while in the pressure frame or either of the baths, is often sufficient to ruin it.

WASHING THE PROOFS

Washing the proofs after they have been fixed is rather a slow operation, as you cannot depend upon their being free from the compound of the hyposulphite and silver, if the water in which they are immersed is not frequently changed for at least twelve hours, and it is better even to prolong this time. Place them in a clean flat dish, and wash them well for a minute, by allowing the water to run over them, or by filling the dish and then allowing the water to run off again. Let them lie in the water for about an hour, then take them out, drain them well by hanging them up for a short time, wash the dish well, and refilling it, place the proofs in it for another hour. Repeat the operation of draining the proofs, and renewing the water, every hour or so, for twelve hours or more; and then pin them up by the corner to dry. When the proofs have arrived at this advanced stage, great care must be taken not to touch them with fingers the least contaminated with hyposulphite of soda, nor allow anything which has touched this salt to come near them. The hyposulphite will infallibly eat out the impression wherever it touches it. The drying of the pictures may be hastened by holding them near a fire. When completed, their edges should be cut; and they may either be mounted on card by pasting them on the back with flour paste, or they may be kept unmounted in a portfolio.

Appendix Four

A DIALOGUE

ON

PHOTOGRAPHY.

OR

Hints to Intending Sitters.

BY

G. W. WILSON,

Photographic Artist,

25 OWN STREET, ABERDEEN.

ABERDEEN:

A. BROWN & CO.

MR. WILSON embraces this opportunity of expressing his thanks to the nobility and gentry of Aberdeenshire and neighbouring counties for their continued patronage. His late success at the International Exhibition, where he has gained the only medal for photography, awarded to competitors from Scotland; while it stimulates him to fresh exertions, encourages him to hope, in the words of the *Times*, that "Those who have singled themselves out from the multitude in such a competition, as the International Exhibition has afforded, may not unreasonably presume, that public patronage will attend upon a merit tested by such an ordeal."

A Dialogue

ON

PHOTOGRAPHY,

OR

HINTS TO INTENDING SITTERS.

BY

G. W. WILSON,

Photographic Artist,

25, Crown Street, Aberdeen.

Aberdeen :

A. BROWN & CO.

PREFACE.

A Portrait Photographer, in successful practice, must devote a considerable part of his time to mixing and keeping in order the chemicals which he employs, and to preparing and developing the plates of every portrait which he takes, the delicate manipulation of which ought to be superintended with care, and without interruption. In the midst of these labours, however, he is often called upon to attend his patrons, for the purpose of answering such questions as are usually asked by those who wish to sit for their portraits. In order to provide, as much as possible, against this distracting of his attention, Mr. WILSON begs respectfully to submit the following imaginary colloquy to the attention of those who propose honouring his studio with a visit.

DIALOGUE.

Lady.—I want my portrait photographed, and wish to consult you as to what sort of dress I ought to put on?

Photographer. — The material is of little consequence; but it ought to be of a dark colour. Black, brown, and green are the most suitable. Blue, pink, white, and lilac, or light purple, should be avoided, principally because in the photograph they look almost white, and cause the face to appear dark by contrast. A little white about the throat and wrists is an improvement, to prevent the picture from having a sombre look, but it ought to be as little as possible.

*Lady —*Must I come on a sunshiny day?

Photographer.—Sunshine is not necessary. When thin clouds intercept the rays of the sun, the light is better diffused, and, in such a day, portraits are often taken more quickly, and with a more natural expression, than in a cloudless day, when the sun is disagreeably strong.

5

Lady.—How long does a sitting usually occupy?

Photographer.—The arranging of the sitter requires some time, but the actual taking of the portrait occupies only a few seconds, varying from one to thirty or forty, according to the light and the season of the year. In spring and summer, the average time required for taking a small portrait is about four seconds, and in winter about fifteen.

Lady.—And in what position ought I to stand?

Photographer.—It is better to leave that to the photographer, who, if he has good taste and some knowledge of pictorial composition, ought to be able to arrange the position in a few minutes, while the plate is being prepared on which the portrait is to be taken.

Lady.—But I should like to see that I am in a nice position before I am taken.

Photographer.—It is impossible to show you this, even by means of a mirror, which would have to occupy the exact spot where the camera stands; and the slightest change of position, or even inclination of the head, may make all the difference between a graceful portait and vulgar caricature. It is better to trust to the photographer, than to a

6

mirror, for a natural position, unless you are satisfied that he knows little or nothing about this branch of his business.

Lady.—Should I not be pleased with the first portrait, do you continue taking others until I am satisfied?

Photographer.—If the first plate is not satisfactory, from any cause, it is customary to take another, although failures (except in a dark day) are almost always the fault of the sitter, and not of the artist, who, if he has a reputation to sustain, will have an interest in producing as good a portrait of each of his sitters as possible. Besides, the plate (technically called a negative), as it comes from the camera, is often too indistinct to enable any one not familiar with the process to judge how the portrait will look when printed

Lady.—I presume you will then print proofs from the different negatives taken, that I may choose the one I like best?

Photographer.—Yes; but it is understood that these extra proofs will be all kept and paid for, as copies, by the sitter, otherwise several portraits would have to be finished for the price of one.

Lady.—But printing is simple and inexpensive, is it not?

Photographer.—No; it involves a number

7

of expensive chemical operations, requiring considerable skill and great care.

Lady.—It is done quickly, however; and I hope you can let me have, at least, one copy home with me after the sitting, as I wish to send it abroad?

Photographer.—No; the process requires three or four days.

Lady.—Why, I thought when the sitting was over, the picture could be finished in a few minutes. I am sure I have heard some of my friends say, that they got their portraits home with them, immediately after the sitting?

Photographer.—These must have been collodion portraits on glass—a very different thing from portraits on paper.

Lady.—Well, I confess I am profoundly ignorant on the subject. Will you oblige me by explaining the difference?

Photographer.—With pleasure; but the description will be rather long.

Lady.—I am interested in the process, and will gladly listen.

Photographer.—A collodion portrait, after the sitting is over, has only to be dried and blackened on one side when it is finished, and is ready to be framed. But when a portrait on paper is wanted, the plate serves

8

merely as a type, from which the picture has to be printed afterwards, and is of no value as a picture by itself.

Lady.—I understand that this plate is what is called a negative.

Photographer —Yes; because, when held up between you and the light, the lights and shadows are reversed; *i. e.* the parts which should be white are black, and the parts which ought to be dark are transparent. This negative has to be first dried and coated with varnish, to prevent the film on the glass from being injured. A piece of drawing-paper is then coated on one side with albumen, or white of eggs, in which a little salt has been mixed. It is then dried, and afterwards the same side is floated for a few minutes in a solution of nitrate of silver, or lunar caustic, and again dried. In this operation, the nitrate of silver combines with the salt in the albumen, and forms, on the surface of the paper, a coating of chloride of silver, a substance which readily assumes a dark brown colour on being exposed to day-light. It must, therefore, be kept in the dark, or where gas or candle light only is admitted. The paper, being now ready for printing on, is placed upon a board, with the prepared side uppermost, and the negative is

9

laid upon it, and pressed into close contact with screws or wedges. It is then exposed to day-light, which, shining through the transparent parts of the negative, darkens the paper behind it, and forms the shadows of the picture, while the light and middle tints are produced by the opaque parts of the negative protecting the paper from the action of the light.

Lady.—And it is then finished?

Photographer.—No; the picture, if left in this state, would soon blacken all over, and become useless It must be soaked for a short time in clean water, and washed thoroughly, by changing it six or eight times from one pan of water to another. The picture has now a disagreeable brick-dust colour, which is changed into a more agreeable tint by immersing it in a solution of chloride of gold. It is then rendered unchangeable by light, by soaking it for twenty minutes in a solution of hypo-sulphate of soda.

Lady.—Then it must be finished, after all those washings and soakings?

Photographer. — No. The work is only half done yet; for, if left in this state, the picture would disappear in a few months. Every trace of the hypo-sulphate of soda

10

must be removed by washing the picture constantly for nearly twenty-four hours. The picture at this stage becomes very tender, and often gets torn, when the whole process has to be gone over again, thus causing great delay in executing orders. If it escapes this misfortune, it has to be dried and trimmed on the edges, pasted on card, dried again, and finally laid upon a polished steel-plate, and rolled with a heavy pressure between iron rollers.

Lady. — Photographic printing is much more tedious and complicated than I had any idea of!

Photographer.—The time it occupies can be much shortened by leaving out half the washings, and this is generally done by those who are obliged to supply the demand for cheap photography; but it is at the expense of permanency.

Lady.—But are photographs permanent, if they are properly fixed, and thoroughly freed from the chemicals used in fixing them?

Photographer. — Several discoveries have lately been made in the process of fixing photographs, and if the proper method is carefully and honestly followed out, the prints are now thought to be permanent.

11

Lady.—That is, they will be as good a thousand years hence as when newly finished?

Photographer —No; few things will last half that time without showing considerable change. An oil painting, after a couple of centuries, looks quite a different thing to what it did when just painted. A photograph, however, will stand as long as a water-colour drawing, if treated with the same care; but if it is fingered and tossed about, or especially if it is allowed to hang on a damp wall, the paper even on which it is printed will soon become rotten.

Lady.—Well, I shall be more careful of photographs in future, and don't hurry mine, please. I would rather wait a month for them, and have them properly done, for I understand now how they gain nothing by being hurried.

James Craighead, Printer, Aberdeen.

TERMS FOR PORTRAITS.

8 by 6 in., or Whole Plate size, 10s. 6d.

 Copies of do., each, 3s. 6d.

6½ by 4 in., or Half Plate size, 7s. 6d.

 Copies of do., each, 2s. 6d.

Carte de Visite size, 5s. 0d.

 Copies of do., each, 1s. 0d.

Bibliography

1 MANUSCRIPT SOURCES

Aberdeen City Archives: Aberdeen Valuation Rolls
Aberdeen Public Library: Journal of George Walker
Author's Collection, Sheffield: Wilson Family material
Humanities Research Center, University of Texas at Austin:
 Correspondence between Charles Wilson and H. Gernsheim
Public Record Office, London: Lord Chamberlain's List of Royal Warrant
 Holders
Scottish Record Office, Edinburgh: Census Returns

2 NEWSPAPERS, PERIODICALS AND JOURNALS

The Aberdeen Bon Accord and Northern Pictorial
The Aberdeen Daily Journal
The Aberdeen Herald
The Aberdeen Journal
The Aberdeen Post Office Directories
The Art Union
The Herald and Weekly Free Press
The Illustrated London News
The North British Review
Punch
The Scotsman
The Times
Transactions of the Aberdeen Philosophical Society

3 PHOTOGRAPHIC JOURNALS

American Photography
The Amateur Photographer
The British Journal of Photography
The British Journal of Photography and Photographer's Daily Companion
Functional Photography
Image
Journal of the Photographic Society of London
La Lumiere
The Liverpool and Manchester Photographic Journal
The Photographic Dealer
Photographers' Friend
The Photographic News
Photographic Notes
The Photographic World

4 EXHIBITION AND GENERAL CATALOGUES

*Horne, Thornthwaite and Woods, Catalogue of Photographic Apparatus
 & Chemical Preparations* (London, 1852; reprinted, Doncaster, 1974)
Catalogue of the Photographic Exhibition (Aberdeen, 1853)
*Catalogue of the First Annual Exhibition of the Photographic Society of
 Scotland* (Edinburgh, 1856)
The International Exhibition of 1862, 2 vols. (London, 1863)

The International Exhibition of 1862, Catalogue of Photographs (London, 1862)

Patent Office, Subject List of Work on Photomechanical Printing and Photography (London, 1914)

National Gallery of Scotland, *The Discovery of Scotland* (Edinburgh, 1978)

5 G. W. Wilson Catalogues

Stereoscopic Views (c.1856)
List of Stereoscopic and Album Views (1863)
List of Stereoscopic, Album and Cabinet Views (1871)
List of Stereoscopic, Album, Cabinet and Imperial Views (1873)
Catalogue of Imperial, Cabinet, Stereoscopic and Carte-de-visite Views (1877)
List of Permanent Photographs (c.1890)
Catalogue of Landscape and Architectural Views in England (1896)
Catalogue of Photographs in Scotland (1896)
Catalogue of Landscape and Architectural Views in Australia (c.1900)
Catalogue of Landscape and Architectural Stereoscopic Photographs (c.1900)
Catalogue of Landscape, Architectural and Figure Photographs in Gibraltar, South of Spain, and Morrocco (c.1900)
Catalogue of Photographs of Life and Scenery in South Africa (c.1900)
Catalogue of Photographs in England (1900)
Catalogue of Photographs in Scotland (1900)
Supplementary List of Photographic Views in England (1900)
Supplementary List of Views in England and Scotland (1902)
Catalogue of Landscape and Architectural Views in Scotland (1904)

6 Books Photographically Illustrated by G. W. Wilson

(i) Published by G. W. Wilson:

(a) Photographs of English and Scottish Scenery:

Aberdeen and vicinity (Aberdeen, 1856 and 1867)	12 plates
Edinburgh (Aberdeen, 1865; London, 1868)	12 plates
York and Durham (Aberdeen, 1865)	12 plates
Balmoral (Aberdeen, 1866)	12 plates
Blair Athole (Aberdeen, 1866)	12 plates
Braemar (Aberdeen, 1866)	12 plates
Dunkeld (Aberdeen, 1866)	12 plates
Gloucester Cathedral (Aberdeen, 1866)	12 plates
The Caledonian Canal (London, 1867)	12 plates
Staffa and Iona (London, 1867)	12 plates
Glasgow (London, 1868)	13 plates

Scottish Abbeys (London, 1868)	12 plates
Trossachs and Loch Katrine (London, 1868)	12 plates

(b) Photographs of Scottish Scenery:

Edinburgh (Aberdeen, 1870)	15 plates
Glasgow (Aberdeen, c.1870)	10 plates
Edinburgh and Rosslyn (Edinburgh, 1871)	15 plates

(ii) Books containing photographs by G. W. Wilson:

Anon. *Jim Blake's Tour from Clonave to London* (Dublin, 1867)	9 plates
Burns, R. *The Poetical Works of Robert Burns* (London, c.1860)	11 plates
Delamotte, P. H. *The Sunbeam, Photography from Nature* (London, 1859) Wilson, plate 14	20 plates
Howitt, W. and M. *Ruined Abbeys and Castles of Great Britain* (London, 1862)	8 plates
Michie, J. G. *History of Loch Kinnord* (Edinburgh, 1877)	2 plates
Scott, Sir Walter. *The Poetical Works of Sir Walter Scott* (Edinburgh, 1861)	11 plates
Lady of the Lake (London, 1863)	Frontis only
Lady of the Lake (Edinburgh, c.1866)	11 plates
Souvenir of Sir Walter Scott ([probably] Edinburgh, c.1870)	10 plates
The Poetical Works of Sir Walter Scott (London, c.1880)	
Victoria, Queen. *Leaves from the Journal of our Life in the Highlands* (London, 1868)	42 plates

7 Books and Articles

Abney, Capt. W de W. *A Treatise on Photography* (London, 1881)
 Photography with Emulsions (London, 1882)
Altick, R. D. *The English Common Reader* (Chicago, 1963).
Anon. *The Scottish Tourist and Itinerary* (Edinburgh, 1834)
Barbier, C. P. *William Gilpin* (Oxford, 1963)
Barclay, William. *The Schools and Schoolmasters of Banffshire* (Banff, 1925)
Bede, Cuthbert (pseud. of the Revd. E. Bradley). *A Tour of Tartan Land* (London, 1862)
Best, G. *Mid-Victorian Britain, 1851–1875* (St. Albans, 1973)
Black, Adam & Charles. *Black's Picturesque Tourist of Scotland* (Edinburgh, 1844, 1852).
 Black's Picturesque Tourist of England and Wales (Edinburgh, 1844)

Black's Picturesque Guide to Scotland (Edinburgh, 1852, 1868, 1876, 1892)

Black's Guide to the South Eastern Counties of England (Edinburgh, 1862)

Black's Picturesque Guide to the Trossachs (Edinburgh, 1866)

Black's Watering Places; Where shall we go? (Edinburgh, 1869)

Black's Road and Railway Guide to England and Wales (Edinburgh, 1884)

Boswell, James. *The Journal of a Tour to the Hebrides with Samuel Johnson, LL.D.* (London, 1786; reprinted, Oxford, 1979)

Burke, Edmund. *A philosophical Inquiry into the Origin of our Ideas of the Sublime and Beautiful* (London, 1835)

Cary, John. *Cary's New Itinerary* (London, 1806)

Coke, Van Deren. *The Painter and the Photograph* (Albuquerque, 1964)

Cook, Thomas. *Handbook of a trip to Scotland* (Leicester, 1846)

Cramond, W. M. *Illegitimacy in Banffshire* (Banff, 1888)

Cunningham, Peter. *Handbook of London* (London, 1850)

Defoe, Daniel. *A Tour through the Whole Island of Great Britain*. 3 vols. (London, 1724–6; reprinted, Harmondsworth, 1978)

Eder, Josef Maria. *History of Photography* (New York, 1978)

Gilpin, William. *Observations on several parts of Great Britain particularly the Highlands of Scotland*. 2 vols. (London, 1803)

Gernsheim, H. & A. *The History of Photography* (London, 1969)

Queen Victoria (London, 1959)

Groome, Francis H. *Ordnance Gazetteer of Scotland*. 6 vols. (London, c.1892)

Irwin, David and Francina. *Scottish Painters, At home and abroad, 1700–1900* (London, 1975)

Johnson, Samuel. *A Journey to the Western Isles of Scotland* (London, 1775; reprinted, Oxford, 1979)

Low, Sampson. *The English Catalogue of Books, 1863–1872* (London, 1873)

Maas, Jeremy. *Victorian Painters* (London, 1970)

Maddon, Lionel. *How to find out about the Victorian Period* (Oxford, 1970)

Marwick, Arthur. *The Nature of History* (London, 1971)

Millar, A. H. *John Bowman Lindsay and other pioneers of invention* (Dundee, 1925)

Murray, J. *Handbook for Travellers in Scotland*, (London, 1873, 1884)

Neaf, Weston J., and J. N. Wood. *Era of Exploration* (Boston, 1975)

Nelson, Thomas. *Nelson's Tourist Guide to the Trossachs* [sic] *and Loch Lomond* (London, 1857)

Pennant, Thomas. *A Tour of Scotland and a voyage to the Hebrides, 1772*. 2 vols. (Chester, 1774)

Tour in Scotland, 1764 (Warrington, 1774)

Perkin, Harold. *The Origins of Modern English Society, 1780–1880* (London, 1974)

Pimlot, J. A. R. *The Englishman's Holiday* (London, 1947)

Price, Sir Uvedale. *On the Picturesque* (Edinburgh, 1842)

Ripley, G., and B. Taylor. *Handbook of Literature and the Fine Arts* (New York, 1852)

Scharf, Aaron. *Art and Photography* (London, 1974)

Selincourt, Ernest de. *Dorothy Wordsworth* (Oxford, 1933)

Simmons, Jack. *The Railways of Britain* (London, 1968)

Smiles, Samuel. *Self-Help* (London, 1896)

Steegman, John. *Victorian Taste* (Cambridge, Mass., 1971)

Taft, Robert. *Photography and the American Scene* (New York, 1938)

Thomson, J. *The Traveller's Guide through Scotland*. 2 vols. (Edinburgh, 1824)

Towler, J. *The Silver Sunbeam* (New York, 1864; facsimile edition, New York, 1969)

Twining, Henry. *On the Elements of Picturesque Secenery* (London, 1846)

Vaughan, John. *The English Guide Book c.1780–1870* (Newton Abbot, 1974)

Victoria, Queen. *Leaves from the Journal of our Life in the Highlands, from 1848 to 1861* (London, 1868)

More Leaves from the Journal of a Life in the Highlands, from 1862 to 1882 (London, 1885)

The Letters of Queen Victoria. 3 vols. (London, 1908)

Walker, George. *Aberdeen Awa* (Aberdeen, 1897)

Warrack, John. *British Cathedrals* (Edinburgh, 1900)

Wilson, Charles A. *Aberdeen of Auld Lang Syne* (Aberdeen, 1948)

Wilson, Edward L. *Wilson's Photographics* (New York, 1881)

Wilson, G. W. *A dialogue on Photography or Hints to Intending Sitters* (Aberdeen, c.1863)

A practical guide to the Collodion Process in Photography (London, 1855)

Plate Index

All the photographs listed are either by G. W. Wilson or his company photographers unless otherwise stated. The original titles, with dates, are shown in italics. Whenever possible the Wilson Catalogue No. is given after each title. The numbers in parentheses are the author's researched additions.

Abbreviations

A.C. Author's Collection, A.C.A.G. Aberdeen City Art Gallery, A.P.L. Aberdeen Public Library, A.U. Aberdeen University, B.H.L. Bernard Howarth-Loomes Collection, R.A. Royal Archives, Windsor, H.R. Howard Ricketts Collection, V and A Victoria and Albert Museum, FW Estate of Fenton Wyness, c.d.v. *Carte-de-visite*

All sizes given in cms, height before width. Average sizes: *carte-de-visite* 8.8 × 6.0, stereoscopic 7.7 × 7.2, Album 10.7 × 8.2, Cabinet 10.7 × 16.6, Imperial 18.8 × 29.0.

Subject Index

Subjects and page numbers in italics refer to photographs, illustrations, ships, journals and books.